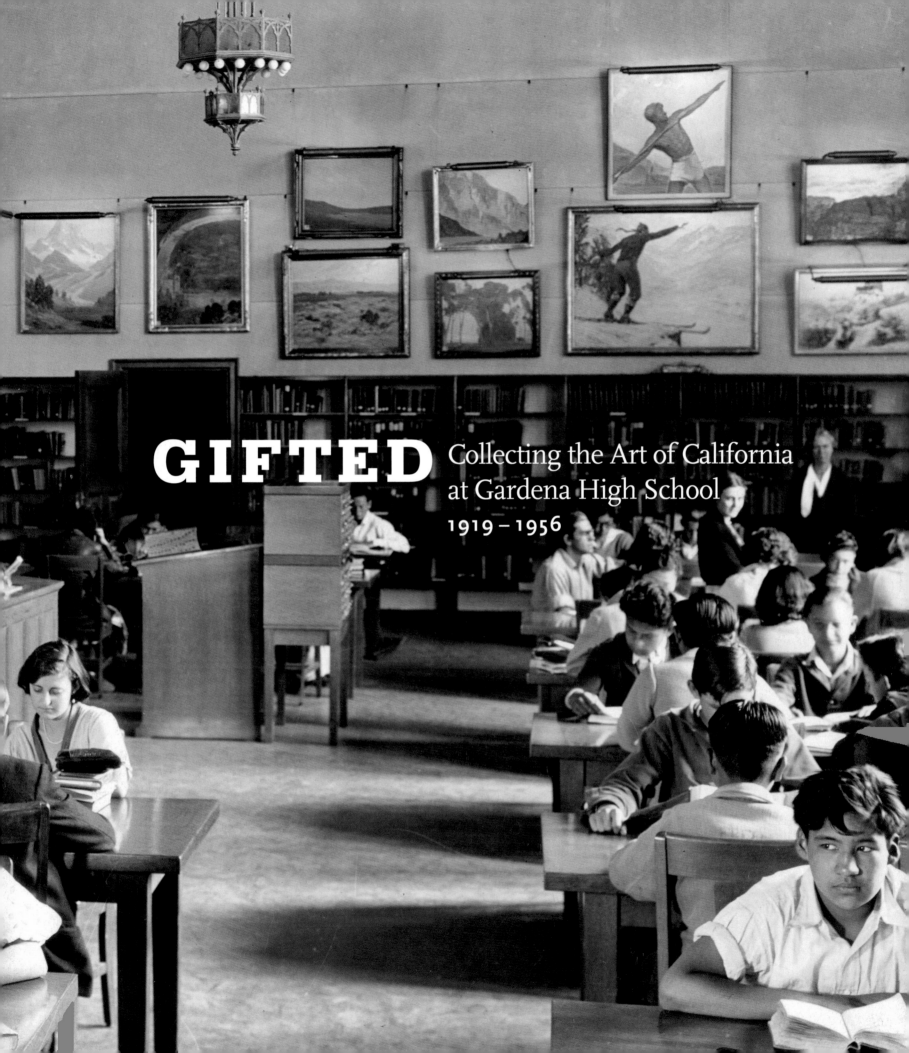

GIFTED
Collecting the Art of California
at Gardena High School
1919–1956

GIFTED

Collecting the Art of California
at Gardena High School
1919–1956

Susan M. Anderson

Pasadena Museum of California Art
in Association with GHS Art Collection, Inc.
and the Gardena High School Student Body

This book is published on the occasion of the Gardena High School Art Collection's 100th Anniversary and coincides with the exhibition *GIFTED: Collecting the Art of California at Gardena High School, 1919–1956.*

Schedule of the Exhibition:

11 May, 2019 – 19 October, 2019
The Hilbert Museum of California Art
at Chapman University

24 January – 28 June, 2020
Fresno Art Museum

18 July – 29 November, 2020
Oceanside Museum of Art

Editors: Cathy Curtis, textual; James Donnelly; Jean Patterson
Book design: Garland Kirkpatrick, gmatter.la
Photography: Gerard Vuilleumier (unless otherwise indicated)
Photo editor: Simon K. Chiu

Front cover: (detail) Jessie Arms Botke, *Cranes Under a Giant Fern*, c. 1943. Oil and gold leaf on canvas, 40 x 32 inches.
p. iii.: Gardena High School library with Purchase Prize Exhibit on display, 1933. GHS Scrapbook, 1929–1933.
p. iv: Hanson Duvall Puthuff, *Morning at Montrose*, c. 1922. Oil on canvas, 28 x 36 inches.
Back cover: (detail) John Hubbard Rich, *The Brass Bowl* (or *Señorita Lusoriaga*), 1922. Oil on canvas, 40 x 30 inches.

Printed in Germany by Cantz

Cataloguing-in-Publication Data is on file with the Library of Congress
ISBN 978-0-9770408-2-7

Table of Contents

Principal's Statement

Few people know that the Gardena High School student body has what is a preeminent art collection of Western landscapes, the product of an innovative collaboration between the students and the community that lasted for almost forty years. Each year from 1919 to 1956, Gardena High School seniors, following the recommendations of student art committees, purchased one or two works of art as class gifts. Artists gave the students price breaks, and the entire Gardena community joined in year-long fundraising drives to make the purchases possible. The goals of this hundredth-anniversary publication and exhibition are to document the remarkable history of community collaboration that formed the Gardena High School Art Collection and to preserve the collection for future generations.

The history of the collection is at the heart of the school's identity, providing the basis and rationale for expanded arts and technology programs at GHS. Our school encourages individual creativity and development of the skills needed to become productive members of a technologically evolving society. Equally important, we believe, is the development of moral awareness, including an understanding and appreciation of our social and cultural diversity. The legacy of the Gardena High School Art Collection is a prime example of how arts engagement and civic participation can promote social tolerance and strengthen the community.

It is my hope that every student who passes through Gardena High School learns about the art collection and its history. In this centennial year, 2019, our students and the public will finally be able to experience these works of art and to discover the extraordinary story of how they came to be part of our school's legacy.

Rosemarie Martinez
Principal
Gardena High School

3.
(detail) William Frederick Foster, *The Lily*, n.d.
Oil on canvas, 30 x 32 inches. Collection of GHS/LAUSD,
Gift to GHS from the artist. © 2018 LAUSD Art & Artifact
Collection/Archive.*

*Ownership subject to dispute by
Gardena High School Student Body.

Acknowledgments

With the opening of the new Gardena High School campus in the fall of 1956, a long tradition of selecting paintings as class gifts came to a close. The original campus (since 1904) became Robert E. Peary Junior High School, and most of the paintings collected by the GHS graduating classes were moved to the new campus. Some were temporarily hung in the halls, administrative offices, and library; but all were eventually stored in a closet, and were sadly forgotten by the student body. Now, through the efforts of many people who recognize the artistic value of this extraordinary collection, these paintings are on view collectively for the first time in decades.

I would like to express my sincere appreciation for the generosity of our supporters. I am especially grateful to the underwriting sponsors, Yvonne Boseker, Simon K. Chiu, Keith and Sue Colestock, and Craig K. Ihara. My wife, Bea Walker, and I are greatly appreciative of the opportunity to provide significant support, along with Emily Chiu, David Cohn, Glen S. Fukushima, Paul and Joanna Giuliano, Allen and Dottie Lay, David and Teruko Miyoshi, Eiko Kamiya Moriyama, Peter and Gail Ochs, Richard and Lynn Reitzell and their matching gift from Pfizer Foundation's Your Cause Trust, the Ralph Scriba family, Richard and Janet Perdew Sinclair, and Ruth Westphal, as well as the Gardena High School Alumni Association and the Historical Collections Council of California. Their deep understanding of this project's importance enabled us to make steady progress from start to finish.

In addition, I would like to thank the following alumni, friends, and organizations for their generous donations in support of this project: William D. Becker Esq., Bill and Rosemary Best, Elena Maytorena Boulter, David Cayton, Michael and Margie Draper, Carole Harris Garrett, Concetto R. Giuliano, Donald and Carolyn Grove, Robert and Nadine Hall, Josh Hardy Galleries, Jack Johnson, Carol Ginder Kofahl and Phyllis L. Ginder, Jim Lynn and Pauline Giuliano Lynn, Jeff and Maranda Moran, the Honorable Vincent Okamoto, Mrs. Barbara Moen Renton, James and Sharon Robinson, Pamela Nokes Rockwell and Richard Rockwell, Edmund Russ, Myron K. Schlegel, Earl N. and Cindy Terao, K. Ernest Terao, D.D.S., and Jane Tadakuma Tokubo, as well as the Los Angeles Breakfast Club Foundation, the GHS Reunion Committees for classes 1950–1954, John Moran Auctioneers, and the Los Angeles County Art Education Council.

Others who have contributed financially to this project include Susan Aleksich, Steven Allan, Linda Alverson Ayuso, Brian and Joann Bailey, Ernie Baptiste, Barbara Carlsen Bauer, Henry and Carolyn Bazak, Ann (Butts) Beeson-Leal, Carrie Blackaller, Elaine Oya Bolle, Bob Brannon, Francisco Briseno, Harold Brown, David and Ann Buxton, Madeline Carteron, Stephanie Cartozian, Constance and Robert Constant, Gail and Micario Cornejo, Steve and Marney Cox, George and Nelissa Cronin, Craig and Christy Curtis, Sandra Cynar, George Dabbs, Justin Daily, Brian Dalrymple, Lynne Thomas Deatrick, Ecluse Wines of Paso Robles, California, Richard and Marian Enright, Darlene Charles Fowler, Louis and Helen Friedman, Paul and Laura Fryar, Ken Fujimoto, Kelly Fujio, Ann Pennington Gaines, GHS Classes of 1957, Ruth Gee, Linda and George Gill, Dave and Jill Gregerson, John Gunde, Ralph Guthrie, Kathleen Harris, Don Horn, Susan Horne, Pearl Iizuka, James and Nancy Fushiki Imamura, Joyce Ishimoto, Ronny L. Jensen, William Johnston, Karin Svee Jones and Ronald Jones, Eiichi Kamiya, Harold and Reiko Kobata, Diana Kuriyama, Margaret Locarnini, GHS Principal Rosemarie Martinez, Stanley Matsumoto, Carol Matsuura, Carl Miyagishima, Russell Morimoto, the Motamedi Johnson family, Toshio Nakano, Evelyn Nall, Susan McDuffee Negrete, Andrew Oshiro, Chris Payne, Harold Payne and Susan Nakagama, Gary Peithman and Marilyn Gussenhoven, Nicholas Polizzi, Rose Clement Prentiss, Joel Primack, William Pullman, Lois Alverson Rabalais, Reback's Plumbing N' Things, Peter and Marie Richman, Joan Barck Ririe, Sharon and Russ Robinson, Mary Danch Rudie, Robert Rumbo and Audrey Medaris, in

4.
(detail) William Henry Price, *Towering Peaks, Sierras* (or *Towering Peaks*), 1933.
Oil on canvas, 39 x 33 inches.

memory of Deann Sampson, Linda Barck Shelton, South Coast Fine Art Conservatory, Mary Stark, Anna Steuwer, Lily Sugino, Lorraine Suzuki, Eleanor Symer, Gardena Mayor Pro Tem Rodney G. Tanaka, Anne Tardaguila, Jerry and Janice Tippin, Akiko Tomiyama, Douglas Tomren, Ernest and Jeanne Tsujimoto, Marilyn Van Oppen, Wall Trust, Donna Ward, Wendell and Lois Whitener, Deann Williams, Joyce Ichinotsubu Yamagishi, Ko and Nan Yoshida, and Jane Zampol. Thank you all for your support.

At the Pasadena Museum of California Art, we owe a debt of gratitude to Susana Smith Bautista, Executive Director, and Sarah Mitchell, Director of Exhibitions, as well as to Jay Belloli, former Acting Executive Director; Jenkins Shannon, former Executive Director; and Erin Aitali, former Director of Exhibitions, all of whom helped bring the hundredth-anniversary exhibition to fruition.

Several people have donated their expertise, resources, and time to this project. Jean Stern, Executive Director, The Irvine Museum Collection at UCI, graciously contributed an overview of recent milestones in the art of the state. Jeff Moran, Stephan Swan, and the art-handling team of John Moran Auctioneers generously provided professional packing and transportation support to help us relocate the collection to a professional art storage facility. Eugena Ordonez of Painting Conservation and Research and her assistant, Elizabeth Burton, did an amazing job of conserving and cleaning dozens of the paintings, as well as donating their time to evaluate the condition of the collection. Continued support has been provided by Kathy Zimmerer-McKelvie, Director, University Art Gallery, California State University, Dominguez Hills, who manages the fund for conservation previously provided by The W. M. Keck Foundation. At the Autry Museum of the American West, Amy Scott, Chief Curator, and Sarah Signorovitch, Registrar for Loans and Exhibitions, provided long-term care for a group of major works from the collection in recent years. Los Angeles Unified School District was also very helpful, especially Sharon L. Thomas, Associate General Counsel I, Dr. Steven J. McCarthy, Director, Arts Education Branch, Mireya Alonzo, K–12 Arts Specialist, and Cintia Romero, Curator/Archivist.

Thank you to the publication team of this remarkable catalogue. In a splendid job of researching and writing the essay for this book, Susan M. Anderson vividly portrays the unique story behind the collection. She also shepherded the book through production and provided the board with much-appreciated curatorial expertise. Gerard Vuilleumier generously provided photographic services, ensuring a well-illustrated book. Thanks also to editors Cathy Curtis and James Donnelly, indexer Jean Patterson, and book designer Garland Kirkpatrick for creating a substantial catalogue that will be cherished by our supporters, alumni, and friends.

I am grateful to the members of the GHS Art Collection Board of Directors for their devotion, passion, and hard work. Board members include Gardena High School alumni Janet Halstead-Sinclair, Craig K. Ihara, Carol Ginder Kofahl, Eiko Kamiya Moriyama, and Pamela Nokes Rockwell; the other directors are Simon K. Chiu, Keith Colestock, Justin Daily, and Bea Walker. Special thanks go to Eiko Moriyama, past President, whose leadership in 2009 helped establish GHS Art Collection, Inc.; to Janet Halstead-Sinclair, who has worked diligently since 1993 to preserve and protect the collection; to Craig K. Ihara for his generous contributions and service as Secretary for the GHS Art Collection, Inc.; to Jane Tadakuma Tokubo, alumna and former board member; to Frank Binch, who worked patiently to help us gain our nonprofit status; and to Russ Thompson, former Gardena High School Principal; to Marva Patton, Principal, and Adam Rivera, Plant Manager of Robert E. Peary Middle School; and to Rita Wilson at the Gardena post office.

Simon K. Chiu, Vice President of GHS Art Collection, Inc., has been particularly important to this project. He provided the vision and led us through the ins and outs of the

art world. He not only helped underwrite the project, but also arranged for the restoration and photography of paintings, raised funds, secured professional storage and insurance, and was involved in the planning for the catalogue. Without him, the exhibition and catalogue simply would not have become a reality.

Special recognition is due also to Rosemarie Martinez, Principal of Gardena High School, for entrusting this unique collection to the GHS Art Collection Board of Directors. Her unwavering support enabled the GHS Art Collection Board to preserve and restore the paintings and plan for the one-hundredth-anniversary exhibit.

And finally, I want to thank the thousands of graduating Gardena High School seniors from 1919 to 1956, and the teachers and administrators who left a remarkable legacy of art for future generations to enjoy.

Bruce Dalrymple

President, Board of Directors
GHS Art Collection, Inc.
Gardena High School Class of 1961

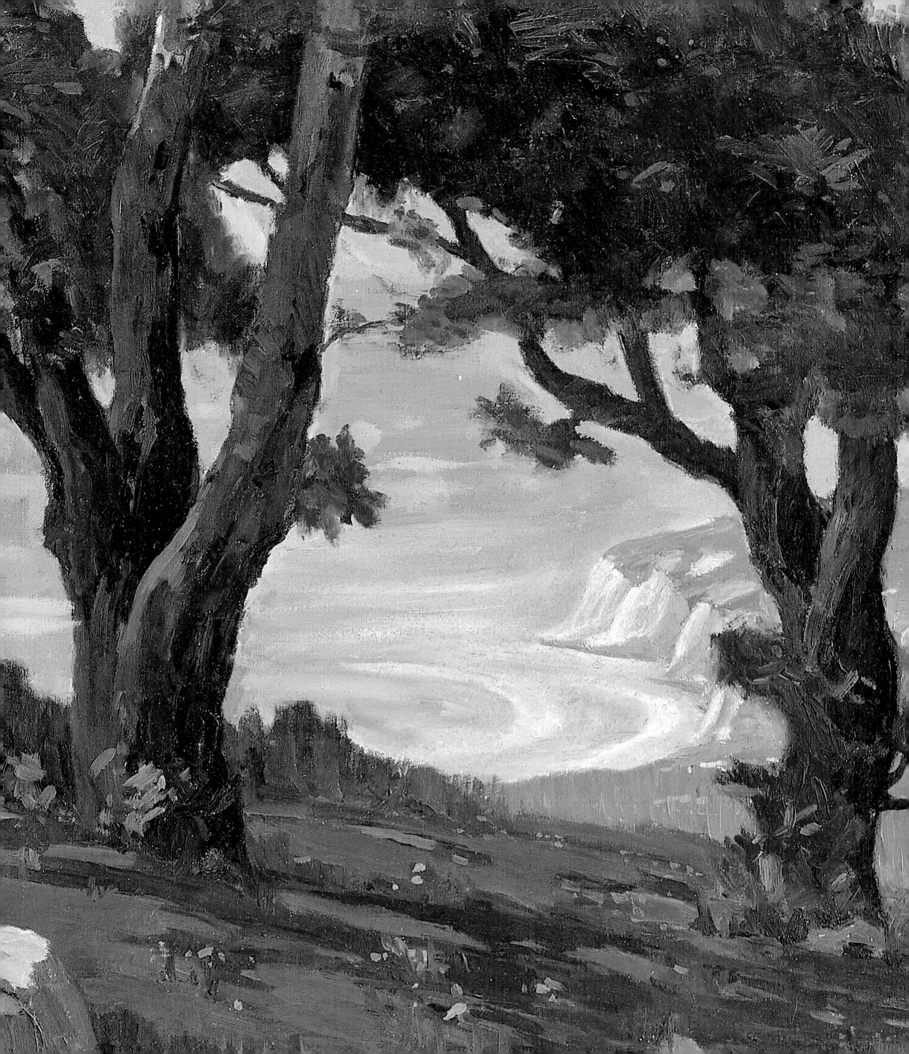

Recent Milestones in California Art

Jean Stern

Executive Director, The Irvine Museum
Collection at The UCI Institute and
Museum for California Art

The Gardena High School Art Collection is widely acknowledged as one of the country's outstanding collections of California Impressionism. Begun in 1919 as a lesson in art appreciation for the school's graduating senior class, the collection grew, semester by semester, until the outgoing seniors made their last acquisition thirty-seven years later, in 1956. The legacy left by the students was more than an exceptional permanent collection; it also developed into an art association and a cherished community tradition.

As time went by, a renewed interest in these enchanting but overlooked paintings began to stir. For many years, the Laguna Art Museum, founded in 1918 as the Laguna Beach Art Association, and the Oakland Museum of California were the two main museums focusing on California art and culture. While the paintings themselves were still extant, there was little published information about the largely forgotten or ignored artists who had made up the lively school of California Impressionism.

In 1975, Nancy Moure privately published a work in three volumes encompassing her research on Southern California art; this became an indispensable guide and led to renewed attention to the subject. In more recent decades, interest in the art of California has accelerated, prompting the establishment of new museums and the mounting of ambitious exhibitions.

In 1990, the Fleischer Museum, in Scottsdale, Arizona, became the first museum uniquely dedicated to California Impressionism. Regrettably, the Fleischer Museum closed in 2002. The Irvine Museum opened in 1993, devoted to the preservation, documentation, and exhibition of the style. It organized numerous nationwide traveling exhibitions and, in 2002, toured a show of California Impressionism in Europe, with venues in Paris, Krakow, and Madrid. Moreover, the museum published—independently or in conjunction with other museums—twenty books on various aspects of the style. In 2000, the Los Angeles County Museum of Art opened the blockbuster *Made in California: Art, Image, and Identity, 1900–2000*. The Pasadena Museum of California Art opened its doors in 2002, with a mission "to present the breadth of California art and design through exhibitions that explore the cultural dynamics and influences that are unique to California." The PMCA was the first Southern California museum to include "California Art" in its name.

The J. Paul Getty Museum launched its Pacific Standard Time initiative in 2011. The first of two programs, Pacific Standard Time: Art in L.A., 1945–1980, involved collaborations with more than sixty cultural institutions to document artistic innovation and social change in postwar Los Angeles art. The second program, Pacific Standard Time: LA/LA, explored Latin American and Latino art "in dialogue" with Los Angeles.

In early 2016, the Hilbert Museum of California Art opened at Chapman University, primarily dedicated to California Scene paintings of the 1920s through the 1960s. In December of the same year, The Irvine Museum Collection became the first component of the newly founded University of California, Irvine, Institute and Museum for California Art (UCI IMCA). In 2017, the widely heralded Gerald and Bente Buck Collection became the second component of UCI IMCA, thus creating one of the world's most comprehensive collections of California art.

All of these important developments have led to the recognition of California art as an important aspect of American art history. Started as a student effort in a small public high school miles from the city of Los Angeles, the Gardena High School Collection is now acknowledged for its rightful place in California art history. We are all grateful to the students and their advisors for the birth, development, and preservation of this remarkable collection.

5.
(detail) Elmer Wachtel, *The Santa Barbara Coast*, 1924.
Oil on canvas, 84 x 48 inches.

Preface

The Gardena High School Art Collection, widely acknowledged as an important collection of early twentieth-century California art, contains numerous sterling examples of California Impressionism, and stands as a leading exemplar of a high school art collection. From 1919 to 1956, students in the senior class selected, purchased, and donated some seventy-two works of art to the high school as class gifts. The high level of sophistication demonstrated by the students' choices was the result of the aesthetic discourse and collaboration nurtured by the school. Over the years, artists, the federal art projects, and other individuals and organizations also made many gifts of art to the collection. Gardena High School is also notable for establishing the first public art gallery in Southern California with a permanent collection of regional art.

In 1919, the year the Gardena High School Art Collection was founded, Gardena was a small farming community in the southwest corner of Los Angeles County with a low population density, a diverse populace, and a smaller wealth base than other parts of the county. So how did Gardena High School students develop an exceptional art collection?

This essay addresses questions prompted by a collection amassed under such unusual conditions. For example, what contributed to the consistent focus of the collection as a repository for California plein-air painting? How did the organization of the annual public exhibitions affect the students' choices? Why was the collection forgotten and nearly lost after having been at the center of the community for over thirty years?

Published to commemorate the hundredth anniversary of the Gardena High School Art Collection (GHSAC), *GIFTED: Collecting the Art of California at Gardena High School, 1919–1956* chronicles the history of the school's ambitious endeavor within the context of the wider cultural scene in Los Angeles. The collection traces the history of Southern California art and culture of the early twentieth century as it unfolded over thirty-seven years—beginning with the emergence of a small bohemian Arts and Crafts community in the Arroyo Seco at the turn of the twentieth century and concluding with the establishment in the 1950s of the thriving contemporary art scene we know today.

Gardena High School (GHS) established the collection when plein-air painting and the Arts and Crafts Movement flourished in Southern California, setting the tone for the high school's collecting emphasis during the following decades. The student body purchases demonstrate a level of cohesion and commitment similar to the collecting focus of a small museum. However, until the early 1970s, few art historians, museums, or collectors were seriously interested in the historical art of Southern California. Nancy Dustin Wall Moure, then Assistant Curator at Los Angeles County Museum of Art, was largely responsible for kicking off a succession of exhibitions and books on the subject that jumpstarted a market for California Impressionist paintings, which had been languishing in secondhand stores. In her 1972 exhibition, *Los Angeles Painters of the Nineteen-Twenties*, shown at Montgomery Art Center, Pomona College—generally considered the exhibition that ignited the new interest in regional art—over one-third of the paintings were borrowed from Gardena High School. The GHSAC was still one of the largest collections of California Impressionist paintings in Southern California. Although the Laguna Beach Art Association (now Laguna Art Museum) was the first institution in Southern California to define itself as a museum of California art, it did not start building a permanent collection until 1941.

The regional press and national publications referred to GHSAC as a permanent collection, and it was understood as such by the wider public. Because this collection was a well-known anomaly—Stanford University and the University of Southern California recognized the collection's importance as early as the mid-1930s—arts institutions and clubs throughout the region regularly requested loans of the paintings. Over the years, they have been reproduced in numerous museum catalogues, and in other publications

6.
GHS Campus, *El Arador*, 1954.

xvii

on regional art, including *California Design, 1910* (Pasadena Art Museum, 1974); *Plein Air Painters of California: The Southland* (Westphal Publishing, 1982); *Early Artists in Laguna Beach: The Impressionists* (Laguna Art Museum, 1986); *Carl Oscar Borg: A Niche in Time* (Palm Springs Desert Museum, 1990); *A Seed of Modernism: The Art Students League of Los Angeles, 1906–1953* (Pasadena Museum of California Art, 2008); and *Modern Spirit and the Group of Eight* (Laguna Art Museum, 2012).

Although the auditorium was designed in 1923 as the school's de facto art gallery, the collection eventually took over the library (also designed, in 1932, with the collection in mind) as well as the administration building and hallways. Works of art that had been donated rather than purchased as class gifts were added to the collection and incorporated into exhibitions displayed on and off campus.

In the pecking order of art collections, high school collections, while respected for their educational value, are not usually considered to have the same status as museum holdings. The resources, expertise, and expense of maintaining a permanent art collection are not part of a high school's educational mandate. For this reason, Los Angeles Unified School District and Associated Student Body funds cannot be used to support the GHSAC. Yet its mission—teaching from original works of art and using them as tools for learning about art as well as Southern California culture and the wider world—was consistent with the mission of a museum. In its function as a community center, one of the ways museums are defining themselves today, the GHSAC was ahead of its time.

The GHSAC's goals were similar to those of a college museum. For example, the current purpose of the Yale University Art Gallery is "to encourage appreciation and understanding of art and its role in society through direct engagement with original works of art." According to its mission statement, the gallery "stimulates active learning about art and the creative process through research, teaching, and dialogue among communities of Yale students, faculty, artists, scholars, alumni, and the wider public [and] organizes exhibitions and educational programs to offer enjoyment and encourage inquiry, while building and maintaining its collections in trust for future generations."[1]

In 1956, when Gardena High School moved to a new campus, the allotted gallery space for the art collection was too small to accommodate it. Beginning in the late 1970s, when the paintings' value increased dramatically, the few on display were removed from the walls and relegated to storage or administrative offices for safekeeping. The result was that the GHSAC became unavailable for viewing by the student body or the public. Shockingly, in 2014, when current GHS Principal Rosie Martinez began her tenure at the school, none of the faculty, staff, or students knew that the collection existed. According to Principal Martinez, "It was a mystery that nobody talked about."[2]

While the collection was on view at the school, it was known and appreciated by the wider community. Several generations of GHS alumni who had fond memories of the collection spearheaded grassroots campaigns to keep the legacy alive. Unfortunately, their well-meaning efforts were insufficient to ensure the long-term care of the collection in the absence of additional support by the larger community, including civic organizations.

Decades ago, many high schools across the United States had art collections. The ones that have survived intact have stayed relevant to the communities that helped develop and nourish them. The histories of these collections are full of defining moments in which community-based solutions had to be found or the collections would be lost, either to the ravages of time or to the auction block. Contributing to their staying power was their permanent status as publicly accessible collections. A final chapter of this book presents a brief survey of Gardena High School's influence on high school collections in Southern California and looks at other high school art collections across the country that have been able to ensure their legacy.

Today, the city of Gardena has fewer than sixty-two thousand residents in 5.9 square miles. The 2010 census shows an ethnically balanced community. Nearly 40% of residents identify as Hispanic or Latino, with the remainder more or less equally divided between African Americans, Asians, and whites. Latinos, Asians, and African Americans have achieved sustained representation on the city council and in city commission appointments, as well as an institutionalized presence in local government affairs. People of color have leadership positions in civic groups in Gardena such as the Elks, Chamber of Commerce, Kiwanis Club, and YMCA.

Defining what makes a city a good place to live involves basic quality of life issues, such as affordable housing, adequate transportation, and well-run public services. Quality of life issues related to well-being are subtler, harder to measure by the usual indices. Urban planners, community developers, and policymakers concerned with quality of place, diversity, and equity are increasingly asking questions aimed at identifying those more subtle characteristics of a community. For example, does it have cultural vitality and character? Is it distinctive, special, or interesting? Is there evidence of a community's capacity to be expressive, tell its own story, and control its own narrative? Is there evidence that people are civically engaged and care about their community? That they are proud of it and feel like they belong?[3] The City of Gardena's current five-year strategic plan includes placemaking strategies to help "promote a vibrant and sustainable community while improving vitality and livability." Ironically, one strategy—"creat[ing] visual interest and a sense of place through a Public Art Program"—was proposed without apparent awareness of the fact that the city had such a program at one time.[4]

Gardena High School's art education program and art-collecting activities foreshadowed a more recent trend. Today, partners from public, private, nonprofit, and community sectors attempt to strategically shape the physical and social character of a neighborhood, town, city, or region around arts and cultural activities. Unlike current efforts at so-called "creative placemaking" (which are sometimes negatively perceived as arts-led gentrification efforts), the history of the Gardena High School Art Collection reveals an example of a "creative community" arising through a grassroots effort of the community itself. Beginning in 1931—when the art program was nearly halted as a result of the Great Depression—hundreds of parents, citizens, clubs, and civic organizations joined together to support the continuance of the treasured annual tradition, already in its twelfth year. Education in the arts and vocational education were understood by the community as a necessary part of preparing students to make their way in the world. The GHS art program creatively utilized the hands-on method advocated by vocational education, which is now regaining importance as a valid approach to learning.

Some experts believe that "creativity"—the ability to use imagination to increase the value of an idea—is the defining characteristic of the twenty-first-century U.S. economy. According to the *2017 Otis Report on the Creative Economy of the Los Angeles Region*, "creativity and the innovations that flow from creative activity are two of the Los Angeles region's foremost economic assets."[5] A California State Department of Education grant has enabled the Los Angeles Unified School District to build partnerships among schools, employers, and community colleges, with the goal of creating student pathways to highly skilled, well-paying careers. The innovative STEAM (science, technology, engineering, arts, mathematics) program currently implemented at GHS— "Architecture, Construction, Computer Science, Engineering and Robotics"—was designed to help students achieve college and career readiness by teaching key skills in architecture, engineering, programming, and robotics while instilling problem-solving, creative, and computational thinking. Forward-looking training of this kind is vital at GHS, a Title I school that receives federal financial assistance for its high percentage of students from

low-income families. (The current student body population is approximately 65% Latino or Hispanic, 26% African American, and 8% Asian and Pacific Islander.)

Decades of research have shown a strong correlation between high-quality arts education and a wide range of impressive educational outcomes, such as problem solving and critical and creative thinking. The arts are also linked to the development of social competencies, including collaboration, teamwork, and social tolerance. Indeed, one of the taglines for career technical education is *Preparing our students for college and careers with twenty-first-century skills for brighter futures, a skilled workforce, and stronger community.* By exposing the students and the wider community to lessons in aesthetic discernment and art appreciation, the GHS arts education program and art collection became a catalyst for community pride, inspiring good citizenship and collaboration. The program was a model of arts engagement that encouraged civic participation and strengthened community ties. Its reach extended to other communities across Southern California, inspiring numerous other public high schools to collect art. Although it is difficult to document whether high schools in other parts of the country followed Gardena's lead, the art education program and art collection became well known nationally and were widely respected.

This publication and the hundredth-anniversary exhibition build on a previous effort to document the collection, *Painted Light: California Impressionist Paintings from the Gardena High School Art Collection.* Organized in 1999 by California State University, Dominguez Hills (CSUDH), the exhibition was guest curated by Jean Stern, then Executive Director of The Irvine Museum, where the exhibition subsequently traveled. The publication, exhibition, and its educational outreach were generously underwritten by a grant from the W. M. Keck Foundation, which also supported the restoration of thirty-one paintings and brought the collection back into public consciousness after four decades.

In March 2015 Simon Chiu, a board member of GHS Art Collection, Inc., contacted me with a proposal to write a study on the Gardena High School Art Collection for its hundredth anniversary. The Pasadena Museum of California Art (PMCA) joined the project in November 2016, aware that it was an important opportunity to showcase one of the very first public collections of regional art, one amassed under unusual circumstances and of the highest quality.

Reconstructing such a thinly documented history would have been difficult without the cooperation and help of many individuals. I would like to express my deepest thanks to all those who assisted in the realization of *GIFTED: Collecting the Art of California at Gardena High School, 1919–1956.* I'd particularly like to thank the board of directors of GHS Art Collection, Inc., principally Simon Chiu, for his vision, initiative, and pursuit of excellence, and his extremely generous assistance with photography and other details in taking the publication through production. Also unstinting with their time and their recollections were the members of the board I interviewed, including Eiko Moriyama, Janet Halstead Sinclair, and Craig Ihara, all of whom also made helpful comments on the publication manuscript. I am indebted to Bruce Dalrymple, who painstakingly gathered decades of articles on the art collection from the *Gardena Valley News*; and Keith Colestock, who was instrumental in tracking down and verifying the information in John H. Whitely's biography.

Alumni Rosemary Best, Roy Pursche, and Rassie Harper generously shared their recollections of the period and the art program at GHS in extensive interviews as well. Others who helped along the way include Nancy Dustin Wall Moure, Richard W. Reitzell, Sue Henger, Lilla Hangay, Tom Christie, and Jean Stern. I'd also like to thank my husband, Bolton Colburn, for his incredible support and insights throughout.

Many librarians, curatorial staff, and other individuals contributed important information or photographs that helped bring the history to life. I would like to thank Becky Romero, Deputy City Clerk, City of Gardena; Kelly Riddle, Digital Projects

Coordinator, County of Los Angeles Public Library; Robert Barron, Workman and Temple Family Homestead Museum; Kathy Zimmerer-McKelvie, Director, University Art Gallery, CSUDH; Gregory L. Williams, Executive Director, and Thomas Philo, Archivist, Archives and Special Collections, CSUDH; Jay Belloli, former Acting Director, and Erin Aitali, former Director of Exhibitions of the PMCA; Alexis Curry, Research Library, LACMA; Lindy Narver, Librarian/Archivist, Laguna Art Museum; Constantine Treantos, Librarian, Gardena High School; and Michelle Cairella Fillmore, former Curator, LAUSD Art & Artifact Collections & Archives.

In working on this publication and exhibition I had tremendous support from editors Cathy Curtis, James Donnelly, and Jean Patterson, who brought their expert eyes to the manuscript, and book designer Garland Kirkpatrick, who contributed his extraordinary design talent to the project. I would also like to thank all the staff at the PMCA, in particular Susana Bautista, Executive Director; Sarah Mitchell, Director of Exhibitions; and Leah Clancy, Education and Engagement Coordinator, for their contributions to the project.

One other individual deserves special mention. I would like to thank Rosemarie Martinez, Principal, Gardena High School, for her unfailing interest in and concern for the art collection and the gracious sharing of her time during the three years this Hundredth Anniversary Project was in the planning stage.

Finally, I'd like to thank all the Gardena High School alumni and residents of the city of Gardena who participated in this remarkable experiment in collaboration. What began in 1919 as a lesson in art appreciation for the graduating senior classes matured into an exceptional permanent collection, a community-based annual exhibit and art association, and a cherished tradition. The Gardena High School Art Collection enriched the life of an entire city over nearly four decades, leaving a tangible legacy of the community's ideals. As a teacher at the school observed in 1937, "Long ago was instilled in their hearts a love for art."[6]

Susan M. Anderson
Guest Curator

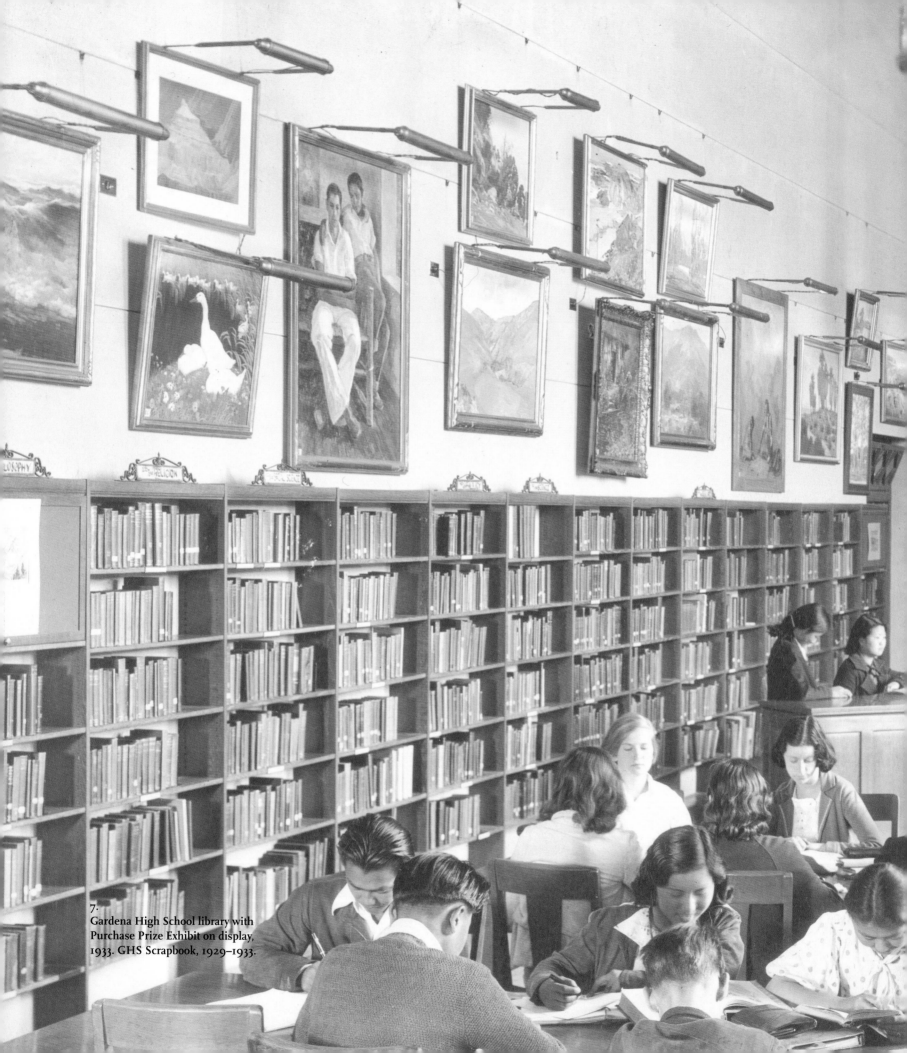

7.
Gardena High School library with
Purchase Prize Exhibit on display,
1933. GHS Scrapbook, 1929–1933.

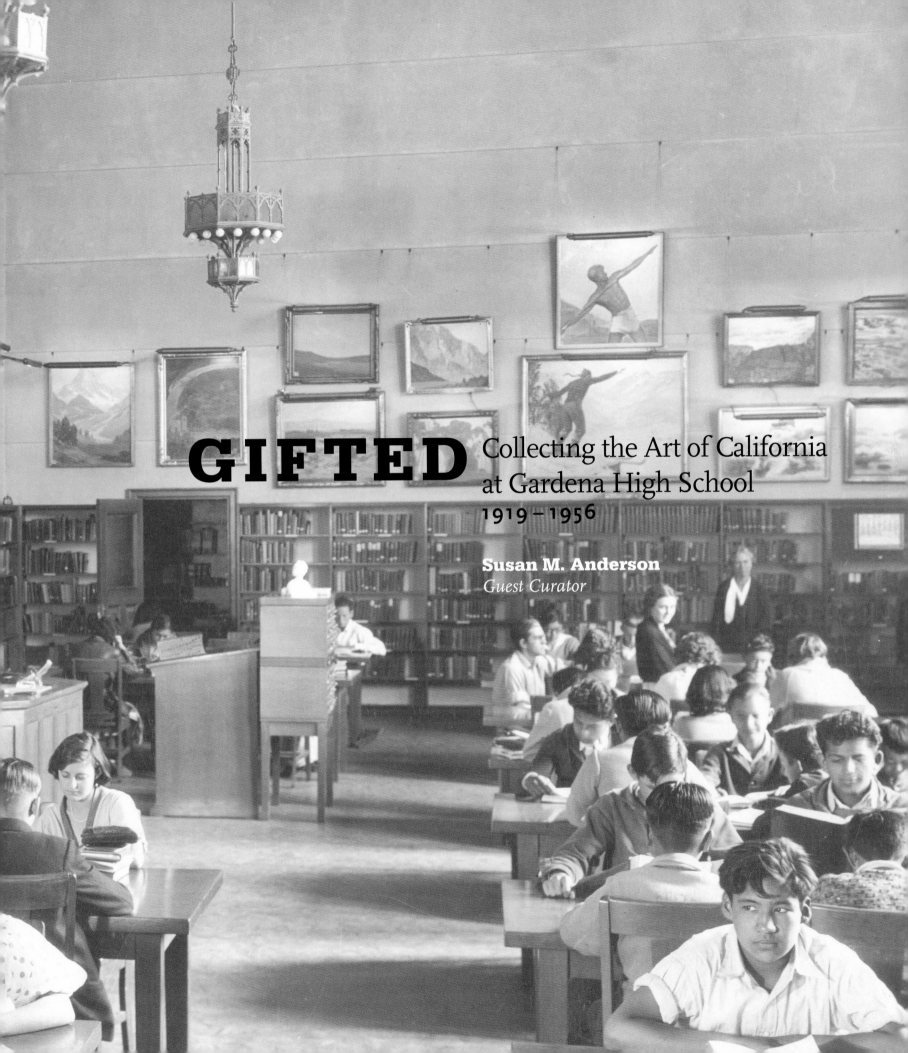

GIFTED

Collecting the Art of California
at Gardena High School
1919–1956

Susan M. Anderson
Guest Curator

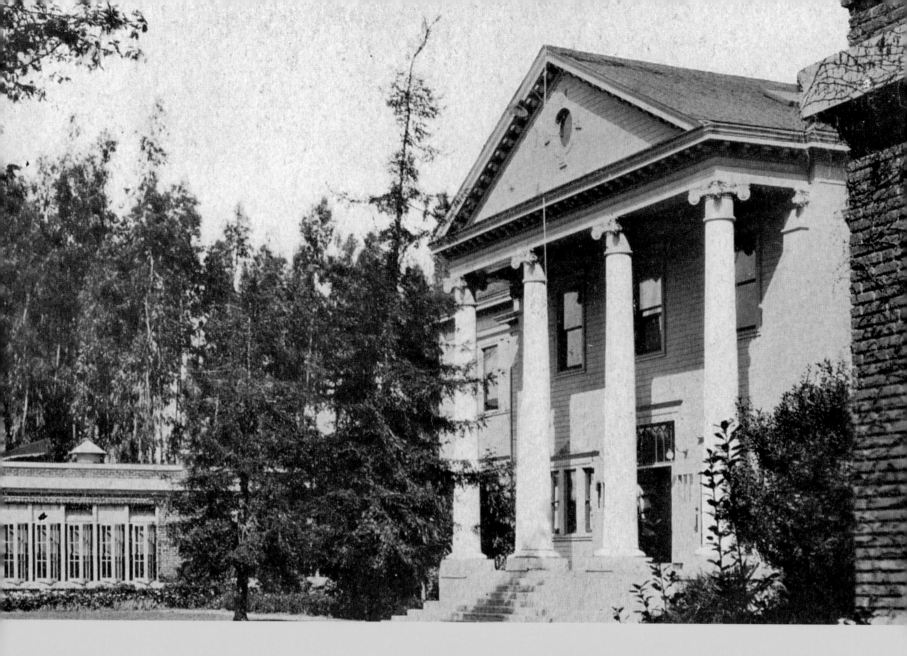

Silent Teachers

In 1919, Gardena High School Principal John H. Whitely embarked on a program for students in the senior class that was devised to lend crucial support to their cultural foundation. He encouraged the students to acquire works of art for the walls of the high school as their senior gifts, describing them as "silent teachers."[1] The students' first selection, made as a result of a visit to the artist's studio, was *Valley of the Santa Clara*, by Ralph Davison Miller. The moody

8.
GHS Campus, *El Arador*, 1921.

9.
GHS Logo, *El Arador*, 1954.

painting of storm clouds hanging over a rocky outcropping is of the lush agricultural river valley in Ventura County, running from the San Gabriel Mountains west to the Pacific Ocean. The students likely selected Miller's painting both for its aesthetic properties and because it was a landscape of a rural farming area not unlike the Gardena Valley.

The valley—the only fertile, green spot between the sea and what is today Los Angeles during the long dry season in Southern California—attracted Gabrielino (Tongva) Indians who hunted and fished centuries ago in a slough that wound its way to San Pedro's mud flats. The Dominguez Slough, which fed a lush oasis and inland freshwater lake, took its name from Juan José Dominguez, a Spanish soldier. In 1784, after receiving a Spanish land grant, Dominguez established Rancho San Pedro, which encompassed the Gardena Valley. Ranchers and farmers settled there during the Los Angeles housing boom of 1886–1887, made possible by the city's first railway lines. Civil War (Union) General William S. Rosecrans bought and developed fourteen thousand acres between Los Angeles and the sea, playing a key role in the foundation of Gardena. Japanese immigrants were also instrumental in establishing the city. They started farms that raised alfalfa, barley, and tomato crops, and planted extremely productive berry fields that gave rise to Gardena's nickname, "Berryland."

Valley of the Santa Clara is also an excellent example of California plein-air painting (works painted *en plein air*, or outdoors). The rationale for collecting a plein-air landscape would have been easily made by Principal Whitely, who seems to have strongly influenced the selection of paintings in the early years of the collection. After all, Gardena High School was in a rural setting surrounded by fertile farmland, and the school was nationally known for its agricultural program. The school's logo (fig. 9) showed a farmer plowing fields, the yearbook was titled *El Arador* (The Plowman), and the school football team was the Berry Pickers.

Miller's painting was also within the students' budget. Principal Whitely "suggested that the students find a good-hearted artist who would part with a good picture for the small sum the class had raised." This method was followed for the next few years, with "funds laboriously earned by class plays and other projects . . . [that] paid for pictures concerning whose worth the pupils 'were more or less foggy.'"[2]

Groups of senior students visited artist studios and art galleries to familiarize themselves with regional art and artists in order to make a final selection of paintings from which to choose.[3] Many artists lived in downtown Los Angeles, where the Los Angeles Museum of History, Science and Art had opened in 1913. The Blanchard Music and Art Building was a leading hub of activity, with its artist studios, Blanchard Gallery, Art Students League, and Ruskin Art Club. Across the street, in the Copp Building, were more artist studios, the Daniell Galleries, the Sketch Club, and the Los Angeles Academy of Art.[4] In 1919, the art critic for the *Los Angeles Times* was Antony Anderson, an artist and writer from Chicago who founded the Art Students League with artist Hanson Puthuff. Regional artists were also active in the California Art Club, which had formed in 1909, bringing together the leading artists of the day to exchange ideas and exhibit their work. Artist William Wendt was elected president in 1911, lending his considerable prestige to the club.

Two commercial galleries, J. F. Kanst and Steckels, were also situated downtown. On February 9, 1919, around the time the GHS students were visiting studios and galleries in preparation for their first purchase, Kanst had an exhibition of the Ten Painters Club of California.[5] It is possible that the GHS students saw this show, which featured some of Southern California's most prominent California Impressionist artists. The students also visited artists' studios in the Arroyo Seco area of Pasadena and eastern Los Angeles, the vast wooded canyon and dry wash that served as a conduit for rainwater flowing from the San Gabriel Mountains during the brief rainy season. Beginning in the 1890s, artists,

3

writers, and craftspeople had settled in the Arroyo Seco, attracted by the inexpensive land on the wild eastern bank, then considered dangerous to health and personal safety. Several of the first works the students selected were by painters who lived or had studios in the Arroyo, including Jean Mannheim, Puthuff, Elmer Wachtel, Wendt, Orrin White, and Miller. Over time, GHS students collected numerous works by artists who embraced "Arroyo Culture," as it was later called.[6] As a result, a number of the paintings in the GHSAC are scenes of the Arroyo and the bordering San Gabriel Mountains.

In an effort to lure people out West, civic, real estate, citrus industry, and railroad boosters were promoting California as a healthful, unspoiled land in which anything was possible. The promotion of California as a land of plenty and opportunity was one of the most impressive and longest-running advertising campaigns of all time, beginning in earnest in the 1880s and continuing through the 1930s. The boosters' advertising efforts, and those of national magazines like *The Craftsman, House Beautiful, and Ladies' Home Journal*, extolled the region's art as well as its climate and natural beauty, bringing an influx of new residents—including innumerable landscape painters—to Southern California at the turn of the twentieth century.

The region attracted a population driven by a utopian yearning for a life of simplicity and harmony, exemplified by the informal cultural community living in the Arroyo Seco. At the turn of the century, the untrammeled Arroyo was the cultural heart of Los Angeles and of the regional Arts and Crafts Movement, which loosely bound together the like-minded community of artists, craftspeople, architects, and others.[7] As architectural historian Richard Guy Wilson has written, the Arts and Crafts Movement in Southern California "was expressed not in a specific style but as a mood, an attitude, a sensibility. At its core, the Arts and Crafts Movement advocated a search for a way of life that was true, contemplative, and filled with essences rather than superficialities. . . . Process or how a thing was made, and its contribution to life were as important as the appearance of the object."[8]

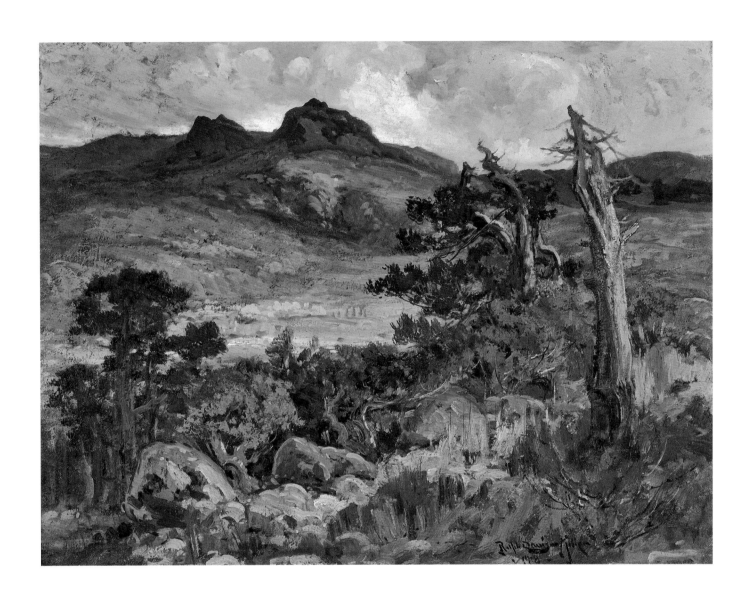

Ralph Davison **MILLER** | b. Cincinnati, Ohio, 1858
d. Los Angeles, California, 1945

Valley of the Santa Clara, 1918
Oil on canvas
30 x 40 inches

Class of 1919

According to Ralph Davison Miller's obituary in the *Los Angeles Times* on December 17, 1945, "One honor in which he took pride came to him in 1919 when the Gardena High School students, beginning their custom of selecting the best work of a California painter each year, chose one of Miller's paintings as the outstanding California product." The students had visited Miller in his studio in the Arroyo Seco, to which the Gardena High School art program made annual excursions. Subjective interpretations of nature such as Miller's reflect the Arts and Crafts ethos—intimate, poetic, and expressive of a deep engagement with nature. Such paintings were a perfect fit for the craftsman bungalows found throughout the Arroyo Seco and Laguna Beach art colonies.

Valley of the Santa Clara portrays the verdant agricultural valley irrigated by the Santa Clara River, which flows from the San Gabriel Mountains to the Pacific Ocean. The loosely brushed foreground gives an impression of wild, fecund nature. The middle ground, a luminous meadow—its brightness makes it the focal point of the painting—suggests a heavenly pasture and leads the eye upward. Clouds hanging over the rocky outcropping portend rain. The dead trees on the right, perhaps blasted by lightning, heighten the painting's moodiness and dramatic quality.

Engagement with Nature

Beginning in the late nineteenth century, American culture was influenced by the ideals of the Arts and Crafts Movement, as well as by the reformist ethos of the Progressive Era. Historian Robert Winter has described the Arts and Crafts community of the Arroyo Seco as composed of a "California variety of intellectual, productive, in tune with liberal ideas, cosmopolitan, and at the same time in

touch with nature, even folksy in his attitudes toward family and the good life."[1] Artists, designers, and architects sought to create an aesthetic suited to the climate, landscape, and emerging culture of the region. Rejecting Victorian excess and the artificial separation of art and craft, they strove to create art, craft, and architecture in harmony with nature. This close connection to nature was the key feature of the region's paintings and Arts and Crafts–inspired design.[2]

Championed by William Morris, the Arts and Crafts Movement developed in mid-nineteenth-century England and was adopted in the United States at the turn of the century. Responding to the negative aspects of urbanization and industrialization, the movement sought to reinvigorate daily life with traditional craftsmanship, sound design, and a back-to-nature philosophy. The movement advocated for the reform of art at every level and across a broad social spectrum, including the use of handmade objects in the home in place of manufactured goods. California became the center of the fullest expression of Arts and Crafts ideals.[3]

Numerous clubs devoted to the study, making, and exhibition of Arts and Crafts-related objects flourished from about 1905 to 1930 in Southern California. However, the underlying motivation had little to do with a rejection of urbanization or industrialization. The landscape surrounding the small city center of Los Angeles, with its deep canyons and hills, was still relatively untouched by development, as was the Gardena Valley. In its Southern California guise, the movement was an affirmation of an existing way of life—an attitude of oneness with nature, and a dedication to preserving it.

Charles Fletcher Lummis, an influential promoter of the Arts and Crafts Movement in Southern California, settled in the Arroyo and gathered a circle of artists around him. Another cultural arbiter and promoter of the movement, George Wharton James, published an article in 1909 about artist Hanson Puthuff. James saw in Puthuff and plein-air painting the expression of an essential freedom: "It is a part of the Western spirit as differentiated from the Eastern, the spontaneous as removed from the academic . . . man becomes a rebel—a natural rebel—against all things and methods that restrict his power, that clip his wings, that tie his hands."[4]

James's pronouncement, a manifesto of sorts for the plein-air approach, established a new paradigm for art in which former outworn values no longer held. Plein-air painting expressed the artists' interest in nature, contemplation, process, and quality of life, and became a genuine movement in Southern California—concurrent with and expressive of the ideals of the Arts and Crafts Movement.

Beginning in the 1890s, plein-air artists sought out the vast spaces and enormous distances of the West's arid deserts, majestic mountains, deep canyons, and rocky coastline. According to art historian Jean Stern, for this generation of painters in California, "landscape painting became the ideal vehicle for expressing the American spirit; it created a metaphor of the American landscape as the fountainhead from which sprang the bounty and opportunity of rustic American life. Moreover, landscape painting afforded an avenue for expressing God and Nature as one"[5]

Plein-air artists in Southern California either worked on canvases outdoors or finished paintings in their studios that were based on outdoor studies. Because the mild climate enabled artists to paint outdoors year round, the plein-air process itself became emblematic of California. As newcomers to the state from other parts of the nation and the world—bringing diverse artistic backgrounds and stylistic approaches from study in Chicago, Philadelphia, Boston, New York, and European centers of art—plein-air painters especially cherished the region's Edenic beauty. It's undeniable that the natural beauty revealed in the paintings reflected the point of view of the region's boosters. Yet the paintings are primarily records of the artists' personal engagement with the untouched

10.
(detail) William Wendt, *Along the Arroyo Seco*, 1912.
Oil on canvas, 40 x 50 inches.

nature they found. Some, like Wendt, expressed deeply held beliefs in the existence of the divine in nature. They rejected organized religion but believed in an underlying spiritual force. As cultural historian Bram Dijkstra has explained, "The still largely inviolate natural harmony of the California countryside spoke directly to the pantheistic mysticism of these painters."[6]

Although they are now often called California Impressionists, few of the artists employed the methods of Impressionism in the manner of the French Impressionists: conjuring ephemeral phenomena or capturing developing modern culture. Instead, they set out to capture the vivid colors and intense natural light of Southern California while working outdoors. While adopting the loose brushwork and some of the bold color harmonies of Impressionism and Post-Impressionism, they created a regional variant wholly their own that is now considered largely within the context of American Impressionism. However, according to the scholar William H. Gerdts, even the painters "who were the dominant figures in Southern California art at the end of the nineteenth century and in the first decade of the twentieth may not have considered themselves as belonging to the Impressionist movement, nor did critics specifically identify them as such."[7]

The Southern California artists developed a regional style that combined the design sensibility, craftsman ethos, and cultural values emblematic of the Arts and Crafts Movement. Although California Impressionist painters depicted specific, recognizable places like Laguna Canyon, the High Sierra, the Mojave Desert, and the Arroyo Seco, they amended and simplified landscape features to create compositions that were coherent, rhythmic, and decorative. The painters delineated light and dark landscape masses using visible, patterned brushstrokes. Some artists went a step further, negating the deep vistas in their paintings by allowing the brushstrokes to create a surface tension that was modernist in its essence.

Even after World War I, when Americans had to come to terms with unprecedented social, economic, and cultural shifts, California Impressionist painting endured as "the entrenched establishment." It was still popular during the boom culture that arose in Los Angeles during the 1920s, when the population more than doubled. While earlier civic and state boosters hoping to bring new residents and tourists out West had echoed the healthful environmental message of the promoters of the Arts and Crafts Movement, promotional brochures now disseminated images of a new California, one offering leisure activities, inviting aspects of modern culture, and thriving industries. As a result, according to historian Sarah Schrank, "art became a tool of elite boosters and other social groups competing for space and representation in an emergent metropolis."[8]

The region was flush with money, the result of a boom economy fueled by the growing film industry, real estate speculation, and oil production. Art clubs formed, art magazines were established, and art galleries opened. The artistic center of Los Angeles moved to Westlake Park, where Otis Art Institute was founded in 1918 and Chouinard Art Institute opened nearby in a carriage house in 1921. Newhouse Galleries, run by Dalzell Hatfield, and Cannell and Chaffin galleries were also close by.

However, California Impressionists only minimally portrayed this new vision of California. The bohemian intellectualism and environmentalism aligned with the Arts and Crafts Movement were deeply at odds with the brash materialism of the Southern California boom economy of the Roaring Twenties. Wendt, in particular, had a profound aversion to development and "the seductive charm of Hollywood"; he moved to Laguna Beach in 1918 and became a relative hermit, turning his back on the dominant storyline of the boosters and escaping the urban spread overtaking his precious paradise. Regardless of their feelings about development, Wendt and others were still able to sell their paintings

to affluent tourists and collectors who wanted paintings that reflected the idealized vision of California.

Even so, by the beginning of the 1920s, progressive painters—many of whom were women—were joining together in new clubs and artist groups to promote creative experimentation and individual expression inspired by modernist currents in art. In paintings by progressive artists like Mabel Alvarez, the human figure, still lifes, and genre scenes were rendered with techniques borrowed from Expressionism and abstraction. Diverse art circles began to overlap and even support one another. The primacy of the conservative California Impressionist painters began to break down, along with a gradual waning of the influence of the Arts and Crafts Movement. The internationally prominent abstract painter Stanton Macdonald-Wright began teaching at the Art Students League in Los Angeles in 1918; progressive painters began to infiltrate and even be elected to board positions at the conservative California Art Club. A major influence in these years was the extraordinary collection of advanced modern art—including work by Marcel Duchamp—that was brought to Los Angeles in 1921 by Walter and Louise Arensberg. It was at this historical moment that the Gardena High School Art Collection came into existence.

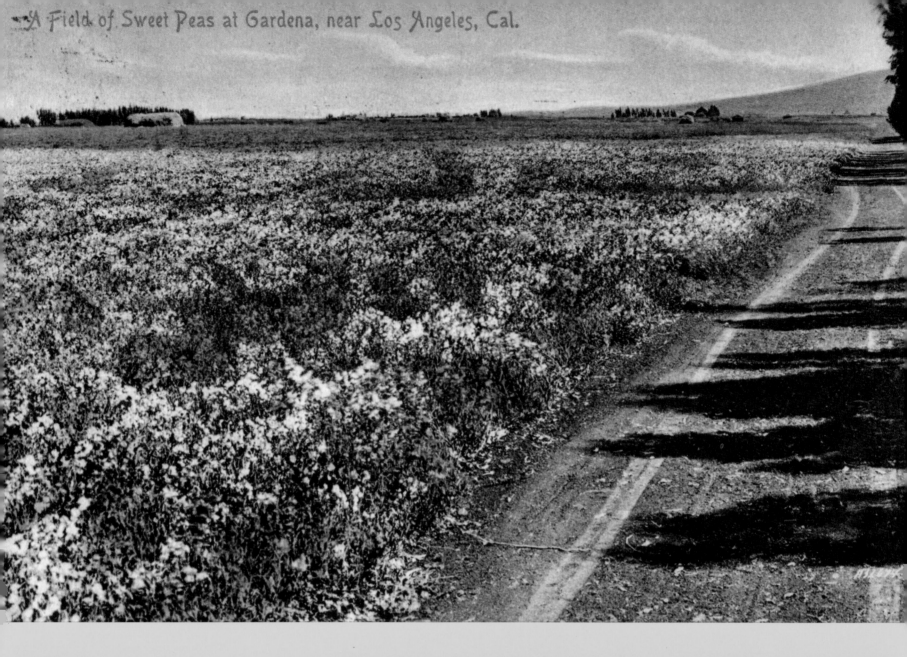

A Field of Sweet Peas at Gardena, near Los Angeles, Cal.

Cultivation

In order to understand Principal Whitely's reasons for starting an art collection at Gardena High School, it is important to look back at the origins of the school and the context in which it developed as an educational institution. On December 17, 1906, five hundred people attended the cornerstone-laying ceremony for the school, then called Jewell Union High School, which was to be "a large and commodious structure of stone, brick and frame, with full modern equipment." (fig. 12)

The school, the third to be built in the county after Los Angeles and Polytechnic high schools, had been founded in 1904 and housed in the Gardena Grammar School building.[1] The new high school was constructed as a "country school" for the neighborhoods of Gardena, Moneta, and Athens on land purchased from Rancho San Pedro, which was described in 1897 as having "dense forests of tall eucalyptus, orchards laden with citrus and deciduous fruit, large fields of full-eared corn and wide avenues bordered with ornamental shade trees. . . . [A] great variety of other products grow in this favored soil and climate, without irrigation."[2]

When the city of Los Angeles built an electric car line through Gardena to Redondo Beach and annexed the twelve-acre school property, Gardena High School became one of three Los Angeles city schools. By 1908, although it had a small student body of only sixty-nine students, the school had a sixteen-piece orchestra and enough senior students interested in acting to present the comedy of manners *She Stoops to Conquer*.[3] The six-year school served students in two shifts, with high school students attending in the morning and junior high students in the afternoon.

In 1909, Jewell Union became a full-fledged agricultural school under Principal Jeremiah B. Lilliard, and was renamed Gardena Agricultural High School (GAHS).[4] Although high school classes in agriculture were not unusual during this era, it was highly uncommon for a city high school to define itself as an agriculture school, with hands-on classes in planting and growing, along with science classes such as soil chemistry and botany. According to Agnes Emelie Peterson, a former English teacher of the era, "Because of its agricultural set-up, the school attracted many visitors. Reports of the uniqueness and practicality of the curriculum were widely published, and there was scarcely a day that did not bring visitors from all parts of California, and even from out of state." The school also attracted students from afar, including Europe, South America, and Mexico, as well as several other U.S. states.[5]

At this time, Gardena was still a small, unincorporated town of about one thousand people, yet it had two electric railway lines serviced daily by about sixty Pacific Electric Red and Yellow Cars. There were restaurants, real estate agencies, a bank, a newspaper office, general merchandise stores, a hardware store, bakery, and meat market, and a livery stable and feed mill.[6] (fig. 13) By the turn of the twentieth century, Los Angeles' urban population was ethnically heterogeneous, with sizable numbers of people of Mexican and Japanese descent, many of whom lived in Gardena, as well as African Americans. Renowned as the "garden spot of Los Angeles County," Gardena

11

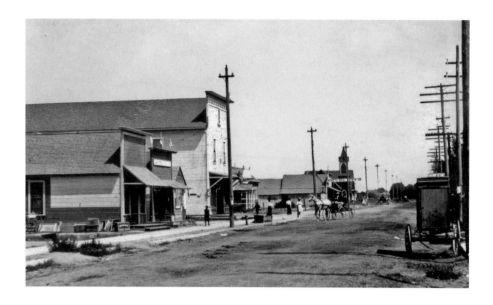

13.
Gardena looking north on Western Avenue, 1910s.
Courtesy of the City Clerk's Office, City of Gardena.

received especially high marks for berry production. More than 76,500 crates of berries a month—or $450,000 worth of berries a year—were shipped from the vicinity, as well as vegetables, barley, hay, eggs, and milk.

The Southern California berry industry originated in Gardena's Strawberry Park in 1895. By 1916, about five thousand acres of berries were cultivated and nearly all the growers were Japanese. Japanese women and children did most of the picking. (fig. 14) The bulk of the berries were carried to Los Angeles by a Japanese trucking company and shipped on railroad cars to distant markets. According to an article in the *Los Angeles Times* by garden and agricultural writer Ross H. Gast, "The prices and production of the crop are controlled by the Japanese Protective Association of Los Angeles, an organization of growers. They have the berry industry of the valley 'hog-tied,' so to speak, and their rule precludes any chance for the white grower to enter competition with them."[7] Banned from owning property under the 1913 Alien Land Law, the Japanese rented or farmed the land as sharecroppers. The tenor of the article seems to indicate anti-Japanese sentiments simmering beneath the surface. However, most school-age children in Gardena lived happily together without racial tensions. The large Japanese population was served by the city's many Japanese American organizations, including the Moneta Japanese Institute, founded in 1911, and the Gardena Japanese School (1916). There were also sizeable Latino and Hispanic populations in Gardena. Some of the children attended GAHS; others were students at the Spanish-American Institute, a boarding school founded in 1909 that taught vocational skills.

Although the main GAHS building, an old wood-frame schoolhouse, was expanded in 1912, Peterson recalled that "even then there was sometimes no scheduled room for a class," so her small third-year English class "met here and there—in a corner of the main hall, in the potting shed, on the outer stairs or the lawn when the weather was mild, and once—it happened when we were reading a Milton pastoral poem—on the 'tanned haycock in the mead.'"[8] The school was a lively place under Principal Lilliard. He ensured that "the wind of freedom blew," and that the teachers had the opportunity to develop their individual talents.

In 1914, Principal Lilliard wrote an article published in Boston University's *Journal of Education* in which he placed GAHS's agricultural program, already nationally respected at the time, within a regional context:

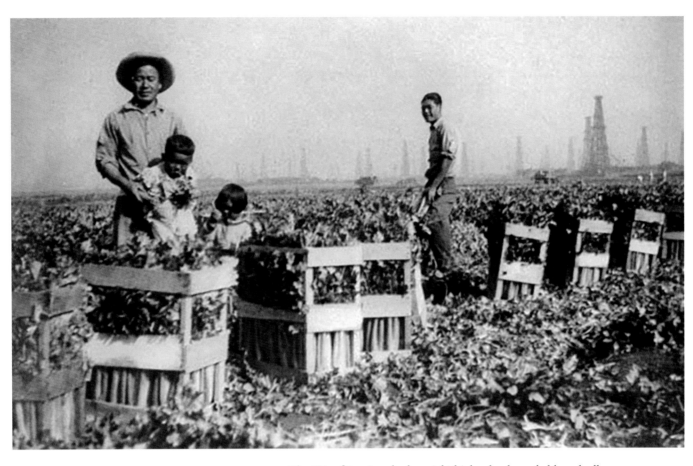

14.
Japanese farmers and children with the crop in Lomita,
1924. Sumitomo Bank Photo Album, Courtesy of the
City Clerk's Office, City of Gardena.

The City of Los Angeles has eight high schools, and although all are cosmopolitan in their courses of study, each has individuality of its own and stands for very definite things in education. The theory of the Los Angeles High School system is to give the largest possible number of boys and girls a comprehensive general education and to those especially interested in definite lines of work, a thorough training which shall not only be cultural but useful. . . . One specializes in classics, one in technical work, another in marine biology and so on. The Gardena Agricultural High School, as its name indicates, lays special emphasis on the study of agriculture.[9]

The idea was to match the high school to the existing community. GAHS saw itself in service to, or in collaboration with, small local farmers with five to fifty acres. "We will give a really useful and practical education," the school announced. "We will educate toward the farm rather than away from it, by showing . . . that it calls for a man of as much ability and intelligence to be a good farmer as to be a good lawyer or a good man of any other profession."[10] Ultimately, the curriculum included instruction in the structure and composition of soils, tillage and crop raising, crop diseases, crop marketing, the care and feeding of animals, and the use of farm machinery.[11] While serving as principal of GAHS, Lilliard also supervised the agricultural program in other Los Angeles city schools; he eventually became California state supervisor of agricultural instruction.[12]

Vocational education was already well established in Southern California. By 1891, Amos G. Throop had founded Throop University (later known as Throop Polytechnic Institute, and subsequently California Institute of Technology) in Pasadena, a remarkable college-level program in the manual arts.[13] Throop's theory of education was that

"it ought to fit men and women to do their actual work in the world, while providing them also with those refined tastes that turn much of the bitter of life into zestful enjoyment. . . . Character, culture, and good craftsmanship might well spell our creed."[14] Students at the school turned out well-made furniture in the manner of the American Arts and Crafts Movement promoted by Gustav Stickley through *The Craftsman*, an illustrated monthly magazine published in New York from 1901 to 1916.

GAHS's program, though centered on agriculture, was similar—a window into the era's belief in the value of manual training and the arts. Along with the teaching of English, Latin, mathematics, and science, the school was committed to a balanced education that included instruction in woodturning and carving, cooking and sewing, carpentry, forging, and pattern making. The school was an adopter of *sloyd* (or *slöjd*), a Swedish system of teaching handcrafts introduced to the United States in the 1880s. The educational aim of sloyd carpentry was holistic rather than vocational: "to utilize . . . the educative force which lies in rightly directed bodily labour, as a means of developing in the pupils' physical and mental powers[,] which will be a sure and evident gain to them for life."[15] Sloyd was thought to build character while encouraging moral behavior, intelligence, and industriousness.

In 1912, Principal Lilliard hired Agatha La Veta Crump, future girls' Vice Principal, whose dedication would be essential to the future art collection program. She had a secondary credential in sloyd and crafts, and had founded several sloyd programs in Southern California schools before becoming instructor of handicrafts at GAHS and briefly, head of the wood and machine shops.[16] Principal Lilliard also introduced a tradition that paved the way for the art collection program: graduating seniors left well-chosen prints to the school as class gifts, which were hung in the classrooms and remained on view until the early 1930s.[17]

Social reform was a component of the Arts and Crafts Movement in Southern California and an impetus for the vocational education movement, which sought to improve the lives of individuals and the community. One of the goals of *The Craftsman* was getting manual training into high schools; the magazine and the Arts and Crafts Movement it advocated helped foster a nationwide interest in applied arts programs and vocational education.[18] With the establishment of the Smith-Hughes Act in 1917, vocational education was formally introduced into U.S. public schools, providing the form and substance of vocational education as we know it today.

Arts and crafts programs and clubs for adults were popular throughout Southern California from the turn of the century, and they were also popular in the schools. In 1914, the *Los Angeles Times* covered an exhibition at Blanchard Gallery of arts and crafts from the schools of Los Angeles:

> Of particular value and interest were the exhibits of the various schools of the city. Each showed a characteristic aim, and each exhibit differed from the others. From the State Normal we had printed textiles and wood block printing, from the Manual Arts examples of enameling on copper, from Hollywood High pottery of delicate color, unglazed and showing remarkable restraint in arrangement and design, and from Los Angeles High glazed pottery of dignified design. The beauty of this work from young students in the schools, and above all, the keen appreciation and understanding of correct art principles, are cause for wonder. Such results, at so early a stage, give us unbounded hope for the development of the arts and crafts in Southern California.[19]

By 1916, the farm on the GAHS campus had grown considerably and was described as having "19 acres, a two-story central building, twin brick buildings about 56 x 200 feet, one for Farm Mechanics, the other for Domestic Science, a modern bungalow just completed for domestic science work, lath houses, potting shed, and greenhouse, a milking barn 40 x 60 feet including hay storage, oiled corrals and open cow shed, a modernly equipped dairy house, small new horse barn at a distance, a new 600-hen laying house, a cement incubator cellar covered by a brooder house, a blacksmith shop, and numerous others."[20]

Remarkably, students built all the structures except the bungalows and main school buildings. They did the blacksmithing, plumbing, and painting, most of the carpentering, and other work. A silo was planned for 1916, to be built by the boys. The crops the students grew included alfalfa, corn, beets and other vegetables, and orchard trees. The newly acquired four-acre athletic field also grew hay. The *Los Angeles Times* reported that "the orchard contains 'no two of a kind,' for variety is part of the school work."[21] All the junior-class boys spent six months off campus on a working ranch to gain practical experience.[22]

Perhaps unsurprisingly, the girls at the school were not involved in agricultural activities. In step with the times, the girls were groomed to be farmers' wives and took a series of practical courses in subjects including cooking, canning, sewing, tailoring, and running the school cafeteria. GAHS was the first high school in California to have an entirely student-run cafeteria, which was housed in the Home Economics building. Students did all the cooking and serving in the cafeteria and large dining room, where the other students purchased and ate their lunches. Raw ingredients were bought from the school farm at market prices, with students paying just enough for a meal to cover expenses.[23]

In March 1917, a few weeks before the United States entered World War I, a garden movement promoted by the National War Garden Commission and the U.S. Bureau of Education caused widespread demand for classes in agriculture in city schools and for the cultivation of "victory gardens" in the home. The program encouraged Americans to contribute to the war effort by planting, fertilizing, harvesting, and storing their own fruits and vegetables so that more foodstuffs could be exported to American allies. It urged citizens to utilize all idle land that was not already engaged in agricultural production—including school and company grounds, parks, backyards, and any available vacant lots.[24] As a result, the academic program at Gardena Agricultural High School was no longer solely dedicated to farming. Los Angeles high school students interested in a career in farming now studied agriculture in their own schools in ninth and tenth grade, interned on a working ranch or farm in their junior year, and then spent their senior year at GAHS to study advanced agricultural matters such as soil chemistry or animal husbandry.[25]

At this juncture, in September 1917, John H. Whitely was appointed principal of GAHS. Photographs of Principal Whitely show a dignified man, somewhat stern, usually attempting to repress a smile, who combed his white hair neatly to the side. (fig. 15) Principal Whitely moved to Los Angeles around 1909 and taught science at Manual Arts High School until at least 1913. Manual Arts, founded in 1910, would develop an advanced art department under the direction of modernist Frederick J. Schwankovsky, who taught at the school from 1919 until 1947. It had an art program as early as 1914, when the *Los Angeles Times* announced that William Wendt had donated two paintings to the school. Whitely was also a teacher and vice principal of Lincoln High School in Lincoln Heights, not far from where the Los Angeles River meets the Arroyo Seco.[26]

In March 1919, the Board of Education changed the name of the school to Gardena High School, and Principal Whitely introduced a new curriculum devoted to

15.

Principal John H. Whitely, *El Arador*, 1921.

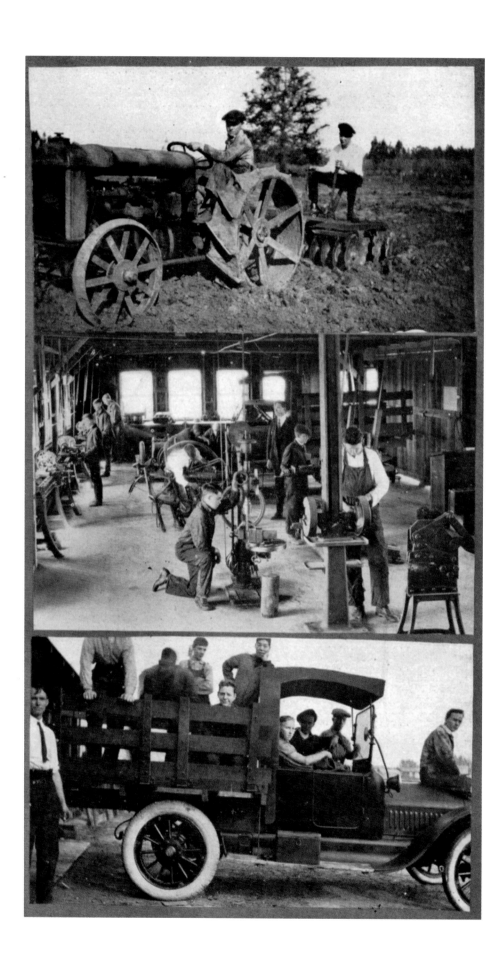

16.
Boys' vocational studies, *El Arador*, 1921.

industrial and commercial vocational studies in addition to agricultural training. This was not only a reflection of the national push for vocational programs in the schools but also a result of the rapid growth of the cities in the Gardena Valley—including Gardena, Torrance, Athens, Moneta, and Lomita, with its shipyards, iron shops, and oil refineries.[27] Gardena's population was now 1,100. GHS, with its motto "Gardena High for Gardena Boys," offered hands-on instruction, primarily in the wood and machine shops. Students were allowed to choose a project related to their area of interest, budget for it, and carry it out under the supervision of a teacher in preparation for a specific occupation upon graduation.

According to the 1920 yearbook, "The boys that are working for themselves have made three tables, two phonograph cases, two [M]orris chairs, three kiddie cars, a piano bench and a number of things that are equally as good." The school was going to be adding cabinetry instruction soon, because the junior high class in sloyd "leads up to this work." Students in the machine shop overhauled three autos and a gas engine, and converted a seven-passenger touring car into a truck for the school's use (the truck would later serve to pick up art). Equipment included three lathes, twelve forges, a drill press, an emery wheel, a screw press, an electric tool post grinder, and a milling machine. Soon there would be five shops, with the addition of a drafting room, a print shop, and an electric shop. (fig. 16) In addition to cooking and serving the lunch meal to students and teachers in the cafeteria, the girls ran a candy shop and bookstore on campus as exercises in business practices. The girls also made all the costumes for the operettas and plays, including the hats. In the art department, they produced a series of posters displayed in the halls of the campus as a commercial art project.[28]

In 1919, the student body was recovering from the influenza pandemic, which caused the school to close for an "enforced influenza vacation." At least one student died. The seniors, in particular, were undergoing a period of adjustment and introspection after the devastating effects of World War I, in which they lost three of their former classmates. Students were feeling the weight of their future responsibility as men and women in a changed world. The yearbook opened with a roll call of the students who had died and an editorial: "Last Spring—the uncertainties of war. This Spring the uncertainties of Peace. War revealed us unto the world. Peace will reveal us unto ourselves. . . ."

Majoring in Art

Principal Whitely's vision for the Gardena High School Art Collection embodied the ideals of the Arts and Crafts Movement, with its holistic approach to education using hands-on teaching methods. Among the tangible results of his leadership were the student-designed yearbooks, conceived as works of art and reflecting a curriculum rich in visual and performing arts, literature, and technical training.

17.
(detail) Cover of the 1926 *El Arador* yearbook with student art.

18.
Mason in front of new houses on Gardena, 1920s. Courtesy of the Workman and Temple Family Homestead Museum, City of Industry, California.

Students contributed the abundant interior art—tipped-in wood-block and silkscreen prints—published their own stories and poems, and reproduced photographs of the many student drama productions and operettas they produced and starred in. Beginning in 1925 (with one page printed upside down), the students produced the yearbooks in the school print shop. Elaborate, often handmade, covers graced the volumes (fig. 17). Each yearbook generally had a theme, such as "The Glory that was Greece," when the 1932 Olympics were held in Los Angeles. Eventually, with the growth of the student body in the 1940s, the yearbooks would be commercially printed and manufactured. However, even the 1950 volume had student drawings and silkscreened endpapers showing a moonscape with a silhouette of Saturn (the theme of the year was a futuristic take on space exploration). Yearbooks also featured photographs of the senior class art purchases, an annual tradition that began in 1923.

Other signs of Principal Whitely's leadership were the students' choice of artists based in the Arroyo Seco and an enduring focus on Southern California plein-air landscape. While the students left few explanatory notes, one senses a deep appreciation of the California landscape, as well as awareness that the region was undergoing inescapable changes after World War I. By the end of the decade, the Los Angeles population—five hundred seventy-seven thousand in 1920—would double, reaching 1.2 million. Soon, the Gardena Valley would undergo staggering growth, the lush slough would be drained, and the agricultural fields would give way to oilfields, then to suburban sprawl and business centers. (fig. 18)

1920

And so, after much discussion, the senior students decided to carry on the tradition of buying a plein-air painting to leave as a class gift in 1920. They raised the money for the paintings by selling tickets to class plays and operas, and by organizing other senior class activities. For the first nine years of the collection, students visited artists' studios in small groups, accompanied by a teacher. These field trips enabled the students to learn about art from the artists themselves. For the 1920 gift, the students selected Jean Mannheim's *On the Road to San Gabriel*, a loosely rendered, light-filled view of a rustic lane winding though a stand of eucalyptus trees, with the San Gabriel Mountains in the distance.

19

Mannheim had lived in the Arroyo Seco since 1909, when he designed his craftsman-style studio home, handcrafted inside and out of redwood, with a gabled roof and decorative brackets under the eaves. Over the years, senior classes would select and purchase three paintings from Mannheim, and the Gardena Art Association commissioned him to paint a portrait of Principal Whitely in 1938, the year the principal retired. Their interest and support of the artist reflect the deep appreciation they had for his work as a result of becoming personally acquainted with him. According to a former librarian, Mannheim welcomed numerous classes to his studio and "showed them his many canvases, favored them with rich reminiscences of his long career, and divulged tricks of the trade, as he described certain illusions he gets by the witchery of color under his skilled brush."[1]

Contact with living artists enlivened the lessons in art appreciation. Meeting artists in their working environments and seeing paintings hanging on a studio wall or in process on an easel would have been an unforgettable experience. As a teacher later recalled: "It was a stimulating experience for the students meeting the artists in their studios, enjoying their gracious hospitality, often seeing the artists themselves in the process of creating their work, and perhaps setting their hearts on the very canvas that was being created."[2]

1921

As part of their education in art appreciation, the students also visited museum exhibitions of Southern California art. In October 1921, the art classes took a field trip to the Los Angeles Museum of History, Science and Art in Exposition Park, where the *Twelfth Annual Exhibition of the California Art Club* was on display. The trip was on the 1921 school calendar published in the yearbook, evidence that it was considered an important component of the students' education.[3] The California Art Club exhibition was one of only three full-scale exhibitions of regional art at the time. The other shows, of the California Water Color Society and the *Annual Exhibition of the Painters and Sculptors of Southern California*, were also at the Los Angeles Museum.

The senior gift that year was Edgar Alwin Payne's *Rockbound*, a coastal scene of Laguna Beach, where Payne had a second studio and, in 1918, cofounded the Laguna Beach Art Association. Like the Arroyo Seco, Laguna Beach was an artist enclave, a rustic haven remote from the urban center of Los Angeles. According to an article in a 1926 issue of *Laguna Beach Life*, residents were compelled "to wade through mud, to plow through dust, to import water, to cook with kerosene, to pant up steep hills."[4] Wendt's move there in 1918 was a sign that the coastal community and its art association were establishing an important regional center for art.

1922

In 1922, the students selected Hanson Duvall Puthuff's *Morning at Montrose*, a painting of the San Gabriel Mountains and the rolling Verdugo foothills. Puthuff became highly respected by the students, both for his work and for the key role he would play later in changing the direction of the art education program.

The creation of an exhibition space for the paintings was imminent. The 1922 GHS yearbook, *El Arador*, announced, "At last our dream is about to be realized. A dream that many old Alumni and students thought hopeless, soon will be seen in Gardena a new and wonderful building." Along with enthusiastic descriptions of the library and classrooms, the article explained that the auditorium would be designed with the art collection in mind: "Along the walls will be space reserved for the pictures that are customarily given to the school by the graduating classes, for the windows will be elevated 9 to 12 feet from the floor."[5] Soon, students and the Los Angeles community would refer to this auditorium as the Gardena High School art gallery.

1923

The value of the GHS Art Collection to the school and the larger Los Angeles community was first recognized in 1923, when an editorial written by Fred Hogue appeared in the *Los Angeles Times*, later reprinted in the 1923 *El Arador*. Hogue lauded the collection hanging in the school auditorium as the finest high school art collection in the state, which indicated there were others at the time. Noting that the class had just purchased *Lingering Snows,* by Jack Wilkinson Smith, he wrote that "the local artists have entered into the spirit of this annual presentation; and they place on the canvases desired for the school a price that brings them within the reach of the purses of the students. In fact, the artists are starting to compete for the honor of being selected to paint the memorial canvas."[6]
A former Gardena High School teacher later recalled: "When the class of 1923 visited the studio of Jack Wilkinson Smith, he was painting a High Sierra scene of dazzling lights and melting snow. The students were so interested in the picture that the artist promised it to them, and some months later, in the school auditorium, Mr. Smith unveiled *Lingering Snows*. It has become one of the most admired pictures in the collection."[7]

Hogue also referred to the material value of the five paintings in the collection, all of them by local landscapists with "national reputations." Presciently, if exaggeratedly, he speculated that "by the time a new high-school building will be erected fifty years hence, a single one of those paintings will be worth as much as the entire building and the ground it occupies." He opined that the canvases of one of the regional artists "will reach their greatest value 500 years after his death."[8] Smith was nationally known for sketches he had made on the front lines of the Spanish-American War before moving to Los Angeles in 1906. He became regionally prominent as the founder of the Biltmore Salon, established to exhibit and sell the work of local artists.

Hogue also emphasized the educational, aesthetic, and inspirational value of the GHS project, making a plea for other high school students in Los Angeles and beyond to follow suit and "do something that will cause them to be remembered in the halls where they have labored and dreamed."[9]

According to an article by H. O. Stechen in *California Graphic Magazine*, it was initially difficult for Principal Whitely to interest the students in the project. He suggested it for several years before the 1919 class agreed to it. The following three senior classes needed convincing as well.[10] The newspaper article may have contributed to the students' change of heart in 1923, and it was smooth sailing after that.

Beginning in 1923, the seniors were divided into A and B classes: a Winter Class that graduated in January and a Summer Class that graduated in June. As a result, they began to purchase a minimum of two paintings every year. Until 1940, the graduated Winter Class was called back to the school to vote on their purchase when the students had completed their fundraising efforts.[11] The student body president presented both paintings to the school as class gifts at the graduation exercises in June. The Winter Class's purchase was Smith's *Lingering Snows*; the Summer Class purchased Jean Mannheim's *The Magic Moment*.

1924

The winter classes were always much smaller than the summer classes. A close study of the GHS yearbooks shows that many students did not make it past eighth grade, because they were needed to work in the agricultural fields or in other occupations, and child labor laws had not yet been enacted. As a result, only about 15% of the high school students graduated.[12]

Perhaps due to the increased number of attendees at the student fundraising events following the *Los Angeles Times* editorial on the collection, the forty-nine students

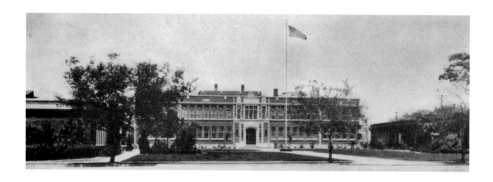

19.
Gardena High School, *El Arador*, 1924.

in the Summer Class purchased two paintings: William Wendt's *Along the Arroyo Seco* and John Hubbard Rich's *The Brass Bowl* (or *Señorita Lusoriaga*).[13] The Winter Class selected Orrin White's *The High Sierras*.

Rich's *The Brass Bowl* was the students' first purchase of a figure study. Art circles in Los Angeles were developing a broader approach to style and subject matter at this time, incorporating portraiture, still life, and genre painting, after years of focusing almost exclusively on plein-air landscape. Even after the 1915 Panama-Pacific International Exposition in San Francisco and Panama-California Exposition in San Diego—both of which presented a smattering of advanced modern European painting styles—until the late 1920s, progressive artists in Southern California mainly experimented with conservative strains of plein-air Post-Impressionism or Robert Henri's "truth above beauty" realism. More advanced modernists in Los Angeles rallied around Stanton Macdonald-Wright at the Art Students League. Rich exemplifies the collegial atmosphere of 1920s Los Angeles, when conservatives and moderns commingled and largely supported one other. He experimented with the color theories of Macdonald-Wright, taught at the progressive Otis Art Institute, and was a member of both the California Art Club and the Group of Eight, an early modernist group in Los Angeles influenced by Henri. However, *The Brass Bowl*, with its iconic image of a young Hispanic woman, is most interesting as a reflection of Los Angeles' cultural legacy and the large Latino population of Gardena and its high school.

With very few exceptions, the artists the students met with and collected were men. However, by the 1910s, women were active in the Los Angeles art community as exhibitors and founders of most of the early modernist groups, such as the Los Angeles Modern Art Society (established in 1916). These early progressive artists built on the California plein-air tradition, melding it with various forms of pre-Cubist modernism. About one-third of the artists invited to participate in the annual exhibits at Gardena High School were accomplished women. However, as we will see, few gained the attention of the student population until World War II.

1925

By 1925, Los Angeles was in the throes of a booming economy. While the Gardena Valley was still largely a rural environment, some areas were rapidly developing.[14] Gardena's population more than doubled from 1923 to 1925, concurrent with the extension of Vermont Avenue, a main thoroughfare that passed through Gardena and would soon reach all the way to the port of Los Angeles.[15] A new high school building, completed in 1925 (fig. 19), was already deemed inadequate the following year.[16] The work added to the collection by the Winter Class in 1925 was Franz Bischoff's *A Cool Fog Drifting*; the Summer Class purchased Paul Lauritz's *The Mountain Brook*.

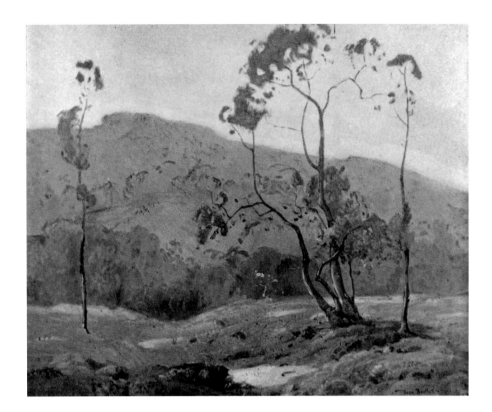

20.
Dana Bartlett, *The Blue Hill*, c. 1926. Class
Gift Winter 1930. Destroyed in a campus fire
in 1975.

1926

In his regular *Los Angeles Times* column "Of Art and Artists," Antony Anderson listed
current exhibitions in museums, clubs, and galleries in greater Los Angeles and wrote
brief descriptions of outstanding shows of interest. Less a critic than a booster of regional
art, he was a tremendous supporter of Gardena High School's art program. The newspaper
regularly covered the purchases at the school and ran a photo of the 1926 Winter Class
donation—*Montecito Coast* (or *The Santa Barbara Coast*), by Elmer Wachtel—noting that
Wachtel was "among the first artists to break away from painting European landscapes
and to show the beauty of California's deserts, mountains, and arroyos."[17] Also purchased
that year, by the Summer Class, was *The Blue Hill,* by Dana Bartlett (fig. 20), which was
destroyed by a fire at the school in 1975. The Summer Class of 1925 and Winter Class
of 1926, senior classes that studied concurrently at GHS, commissioned mural-sized
canvases by Lauritz and Wachtel for placement on either side of the stage in the high
school auditorium.

In 1926, Arthur Millier replaced Anderson as art critic for the *Los Angeles Times*;
although Millier was a more objective critic, with an art historian's perspective, he would
prove to be as big a proponent of the GHS art collection.

1927

In 1927, the California Art Club took over Aline Barnsdall's Hollyhock House and turned
it into a vibrant and eclectic community center under the leadership of Edwin Roscoe
Shrader, a progressive artist and member of the Group of Eight. A center for liberal
inquiry, it fostered the commingling of conservative and modernist artists until it closed,
in 1942.

This year, the students consciously or unconsciously collected according
to a theme—paintings of the massive grandeur of the Southwest. Carl Oscar Borg's

The Grand Canyon (Winter Class 1927) shows a sweeping view of the canyon receding into a profound misty distance, with a boldly painted outcropping of rocks bathed in sunshine in the foreground. James Swinnerton's *Betatakin Ruins* (Summer Class 1927) is a view through the monumental cave opening of the Anasazi cliff dwellings in the Navajo National Monument in Arizona. It took the students three or four telegrams to New York to convince Swinnerton to part with his canvas for the few hundred dollars they had, but he finally relented.[18] According to California State Senator Ralph C. Dills, an alumnus who reminisced in 1989 about his senior year at GHS, "We looked at this picture, and it was in the Biltmore Hotel. He wanted fifteen hundred dollars for it, so we explained to him what we were doing with it. We were leaving it there [at the school], and it would be on exhibit along with all the others. . . . So, he let us have it for five hundred dollars."[19] Had the artists not agreed to such significant price reductions, the students could not have built the Gardena High School Art Collection. The artists were supportive of the project because the school featured the paintings in a well-conceived educational program and in a prominent collection of regional art on permanent display at the school. Five hundred dollars in 1928 would be the equivalent of about seven thousand dollars today.

This was the last year that the students' involvement in their purchases consisted solely in visiting artist studios and galleries in small groups. In 1928, when Principal Whitely decided to launch the GHS annual *Purchase Prize Exhibit*, he could not have foreseen its far-reaching consequences. The annual would become a primary venue for Southern California artists for more than a decade.

Jean **MANNHEIM**

b. Kreuznach, Germany, 1862
d. Pasadena, California, 1945

On the Road to San Gabriel, c. 1920
Oil on canvas
48 x 36 inches
Conservation funded by the Historical Collections
Council of California

Class of 1920

Jean Mannheim moved to Los Angeles and built a craftsman studio-home on the Arroyo Seco in 1908. Beginning around 1906, Mannheim had taught at the Brangwyn School of Art in London for a year or so, indicating that he was sympathetic to the Arts and Crafts ethos. Frank Brangwyn had been a protégé of William Morris and prepared designs for many aspects of Morris's Arts and Crafts output.

On the Road to San Gabriel depicts a quiet country road winding through a eucalyptus allée. Mannheim contrasts the soft abstract treatment of the sunlight and shadow with the painterly texture of the trees' peeling trunks and jumbled masses of bright green and blue leaves. The bright Southern California light seemingly obliterates everything that lies in its path,

including the trees on the other side of the road. In the far distance is the atmospheric purple of the San Gabriel Mountains.

Wild yet accessible, this rugged area north of Mannheim's home in the Arroyo Seco was a favorite painting spot for artists. Mannheim made a series of studies and paintings of roads leading through similar stands of eucalyptus against a mountain backdrop. *On the Road to San Gabriel*, like many of his small studies, is loosely painted and has the same feeling of being completed in one sitting *en plein air*.

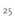

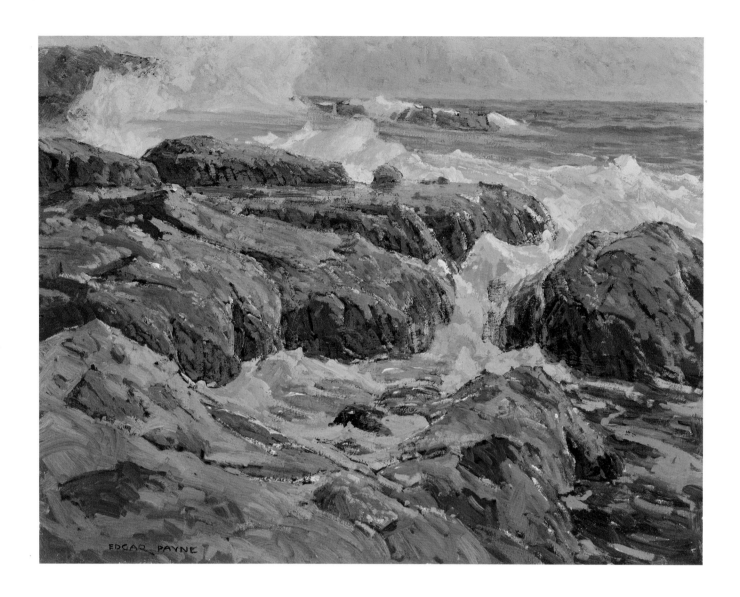

Edgar Alwin **PAYNE**

b. Washburn, Missouri, 1883
d. Hollywood, California, 1947

Rockbound, c. 1921
Oil on canvas
31 x 40 inches

Class of 1921

Edgar Payne achieved great fame during his lifetime despite being essentially self-taught, after six months of study at the Art Institute of Chicago. Much of his knowledge about plein-air painting and its vivid portrayal of color and light came from his work as a scene painter for early Hollywood films. Payne was the founding president of the Laguna Beach Art Association in 1918, and was intimately associated with the then remote art colony.

Rockbound is one of few extant large-scale seascapes by the artist painted in the environs of Laguna Beach. Like the seascape *Eternal Surge* in the collection of Laguna Art Museum, *Rockbound* was most likely based on plein-air sketches Payne made at Coward's Cove, just east of the Twin Points promontories in North Laguna, and completed in the studio.

In his influential primer, *Composition of Outdoor Painting*, published in 1941, Payne recommended focusing on breaking waves and spray as a point of interest in marines. As seen in *Rockbound*, he used warm colors in the rocks to unify and balance the cool greens and blues of the sea. He wrote that a "warm foundation" kept the composition from appearing cold. Here water pools in and glistens over the tide pools lit by the bright midday sun. The dynamic composition is designed to lead our eye in an s-curve from the glistening rocks on the lower right, to the waves and spray on the left, and finally to the open sea.

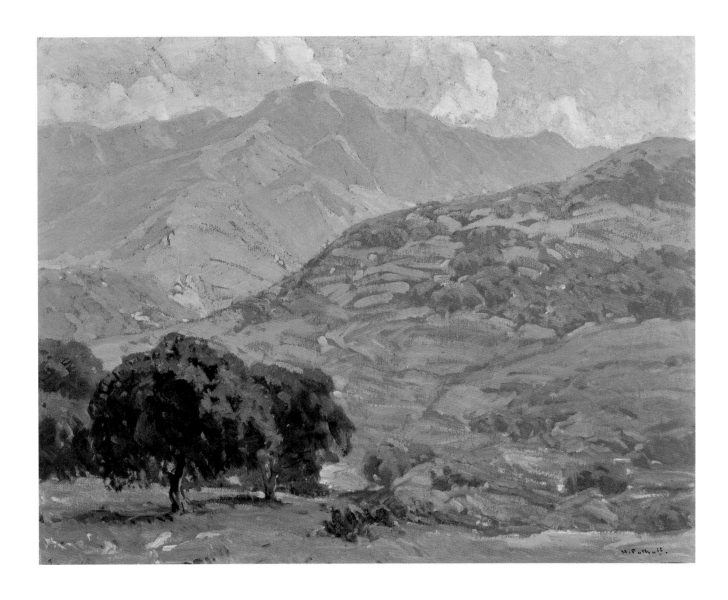

Hanson Duvall **PUTHUFF** | b. Waverly, Missouri, 1875
d. Corona del Mar, California, 1972

Morning at Montrose, c. 1922
Oil on canvas
28 x 36 inches

Class of 1922

When Hanson Puthuff arrived in Los Angeles in 1903, he had been making a living as a commercial artist painting murals, posters, and billboards. By 1905, the artist was successfully exhibiting his landscapes. Plein-air artists often finished works in the studio based on sketches and studies made outdoors on the land. Puthuff, however, strove to complete his paintings in the field in order to capture fleeting effects of atmosphere and light. He was heralded as quintessentially embodying freedom in his art, following the Western code of the individual.

In *Morning at Montrose*, he brilliantly captures the shimmering effect of Los Angeles sunlight on the land, in which visibility is reduced due to a flattening glare. There are few light and dark contrasts; rather, a bleaching out of the color and detail turns landscape features into solid masses and shapes. *Morning at Montrose* expresses Puthuff's design sensibility, here almost reminiscent of the flattened and simplified forms of a woodblock print. He lived in La Crescenta, not far from Montrose. This chaparral country dotted with coast live oak lies just south of the San Gabriel Mountains and is surrounded by foothills. The painting may show the view looking north toward the Tujunga Wash in the Glendale area.

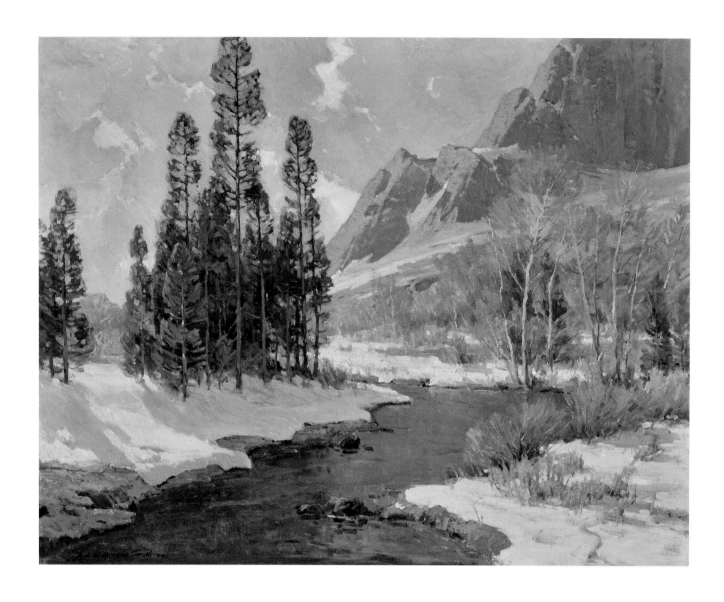

Jack Wilkinson **SMITH** | b. Paterson, New Jersey, 1873
d. Monterey Park, California, 1949

Lingering Snows, 1922
Oil on canvas
32 x 42 inches

Class of Winter 1923

According to Olive Hensel Leonard, former librarian at Gardena High School, when senior students visited Jack Wilkinson Smith's studio in 1922, they were determined to own *Lingering Snows*, the unfinished painting on his easel. They went into a huddle and before the astonished teacher could stop him, the class president walked up to Smith and said, "We have two hundred dollars; will you take it?" Smith grinned and said, "Yes." That was the end of the discussion.

Smith was nationally acclaimed before moving to Los Angeles around 1906. The *Cincinnati Enquirer* had hired him in 1898 to make front-line sketches of battles in the Spanish-American War, for which he won an award. Smith was prominent and well liked in the Los Angeles art community, and was largely responsible for founding the nonprofit Biltmore Salon in 1923. He lived in the San Gabriel

Valley city of Alhambra in the eucalyptus grove known as Artists' Alley. His neighbors included Clyde Forsythe, Sam Hyde Harris, and Frank Tenney Johnson.

Lingering Snows' dynamic composition shows a running brook zigzagging between two stands of trees, surrounded by snow melting under a bright spring sky. With the clouds drifting overhead and the deep green stream flowing through the landscape, Smith introduces implied movement, creating a memorable interpretation of nature's serenity and vitality in the High Sierra.

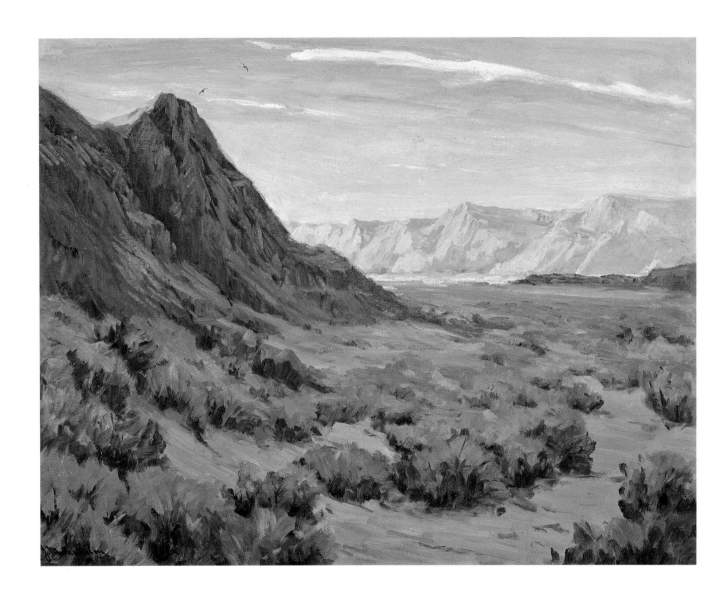

Jean **MANNHEIM**

b. Kreuznach, Germany, 1862
d. Pasadena, California, 1945

The Magic Moment, c. 1923
Oil on canvas
28 x 36 inches

Class of Summer 1923

Jean Mannheim made his first trip to the desert in 1919, when he visited a friend's ranch, most likely in the Mojave Desert. Mannheim returned many times thereafter on painting trips, enjoying the immensity of the land, and its solitude and quiet.

The Magic Moment is a quickly painted record of a vision Mannheim experienced in the desert when the setting sun gloriously illuminated a distant mountain ridge. In the deeply shaded foreground, dominated by a rocky slope and permeated with the chill of twilight, a sandy wash, filled with creosote, curves into the distance.

A high horizon and a study of the play of shadow and light on a shadowed expanse of dunes surrounded by a sunlit ridge frequently figured in Mannheim's portrayals of desert scenes. Yet, although he may have instinctively imposed a well-used compositional device as well as a complementary color scheme of reddish browns against greens, one senses the artist's urgency to capture the moment and the emotional impact it is having on him before it fades from memory. This was the third of four paintings that the Gardena High School students purchased from Mannheim, who was one of the most beloved of their artists.

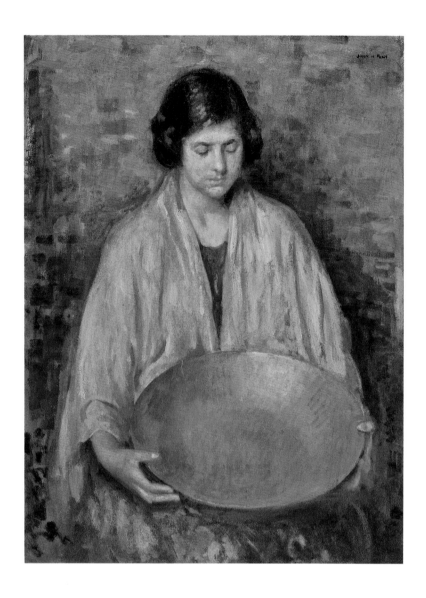

John Hubbard **RICH** | b. Boston, Massachusetts, 1876
| d. Los Angeles, California, 1954

The Brass Bowl (or *Señorita Lusoriaga*), 1922
Oil on canvas
40 x 30 inches

Class of Summer 1924

John Hubbard Rich exhibited *The Brass Bowl* (originally titled *Señorita Lusoriaga*) in a Group of Eight exhibition at the Franklin Galleries in Los Angeles, from December 7, 1922, to January 1923. He was part of the Los Angeles modernist group, formed in tribute to New York painter Robert Henri, which focused on creative experimentation and individual expression. Henri had a large following in Los Angeles after he exhibited a portrait series of ethnically diverse subjects against brightly colored backgrounds in 1914 at the Los Angeles Museum.

In this painting, a young woman gazes downward toward the large brass bowl she holds. Her dark hair is coiled in loose braids and accented with the same bright turquoise daubed throughout the composition. A simple pink shawl drapes her shoulders. Her many-colored dress merges with the background—an impressionistic mosaic of color signaling Rich's study from 1902 to 1905 with Edmund C. Tarbell and Frank Benson, members of "The Ten American Painters." These leading American Impressionists specialized in lusciously painted portraits of women of leisure, often shown engaging in intellectual pursuits such as reading, in well-appointed rooms.

In *The Brass Bowl*, Rich created a synthesis of his influences from Henri and Benson. He presents us with a quietly exotic and iconic figure lost in thought, suggesting a possible ritual quality of the brass bowl. The painting's inclusion in an important exhibition and its reflection of regional culture and the large Hispanic community in Gardena may have prompted the students' selection.

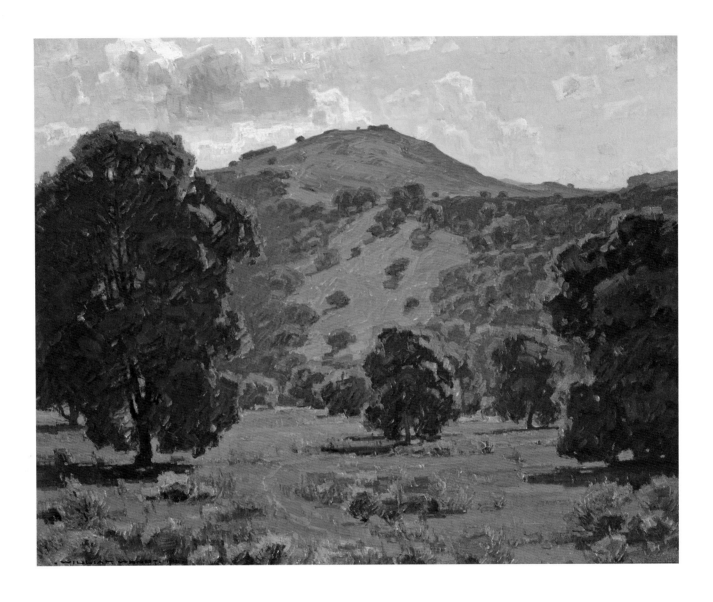

William **WENDT** | b. Bentzen, Germany, 1865 | d. Laguna Beach, California, 1946

Along the Arroyo Seco, 1912
Oil on canvas
40 x 50 inches

Class of Summer 1924

William and Julia Bracken Wendt's home and furnishings, as well as their lifestyle and beliefs, reflected an integrated attitude toward art and life that was in sync with the Arts and Crafts aesthetic. Their studio home, like the homes of many of the plein-air artists, was a simple bungalow, a common architectural style of the Arts and Crafts Movement, and symbolic of the "back to basics" lifestyle possible in California.

Along the Arroyo Seco is an exemplary Wendt painting, full of green, the color of hope and of spring. A sense of new beginnings and divine abundance is implicit in the artist's work—making it a quintessential expression of California's bounty. The high horizon created by the canyons lends both monumentality and intimacy to Wendt's paintings. His landscapes express a state of sustained

immersion in nature that produces a quiet emotion akin to awe, articulating his deeply held beliefs about God and nature.

Wendt's composition in *Along the Arroyo Seco* is rhythmic and dynamic. He leads our gaze to the peak of the mountain by incorporating a zigzagging line through the center of the painting in a way that encompasses the whole composition—as if seen by God's omniscient eye. The landscape is bathed in the strong bright light of Southern California. Foreground, middle ground, and background are all treated with tremendous depth of field. However, our gaze continually returns to the small tree placed slightly below center in the painting, around which the composition slowly turns.

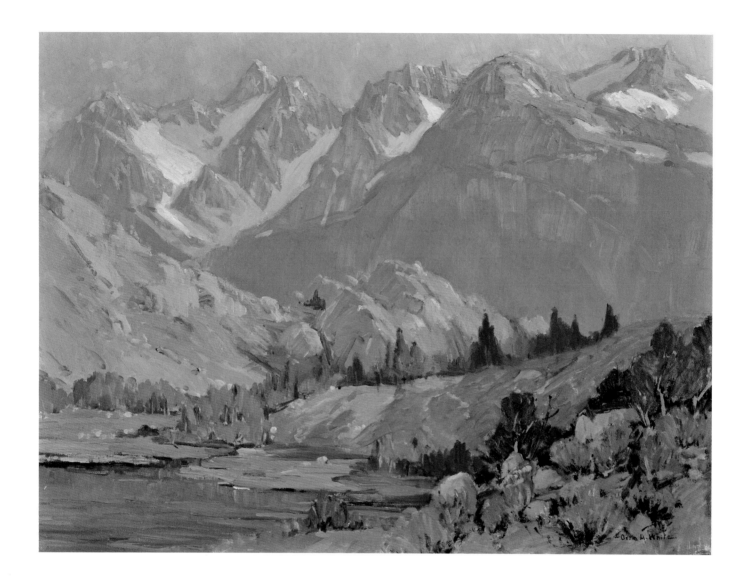

Orrin Augustine **WHITE** | b. Hanover, Illinois, 1883 d. Pasadena, California, 1969

The High Sierras, c. 1917
Oil on canvas
24 x 32 inches

Class of Winter 1924

Orrin White had just married and built a studio home with spectacular views of the Arroyo Seco when the Class of Winter 1924 selected *The High Sierras* as the class gift. He may have completed the painting that year on a trip to the High Sierra with Alson Skinner Clark and John Frost. However, Antony Anderson described a similar painting with that title in a review of a group exhibition of Pasadena artists showing at the Old Throop Academy in 1917, before White enlisted in the U.S. Army. Soon thereafter, White became a lieutenant in the 40th Engineers, serving as a camouflage artist in World War I alongside Grant Wood, with whom he would later exhibit.

Over his long artistic career, White made many paintings of mountains. He could even set up an easel in his backyard and paint the steeply rising, rugged peaks of Mt. Wilson and the San Gabriel Mountains. In *The High Sierras*, the artist has captured distant snow-capped mountains and an ice-cold lake in spring, when the snow has melted at the lower altitudes. Bright sunlight highlights the greens, oranges, and blues of the lower foothills and meadows on the verge of the lake, with quickly painted chaparral and rocks in the foreground. This fairly small-scale painting may have been completed *en plein air*.

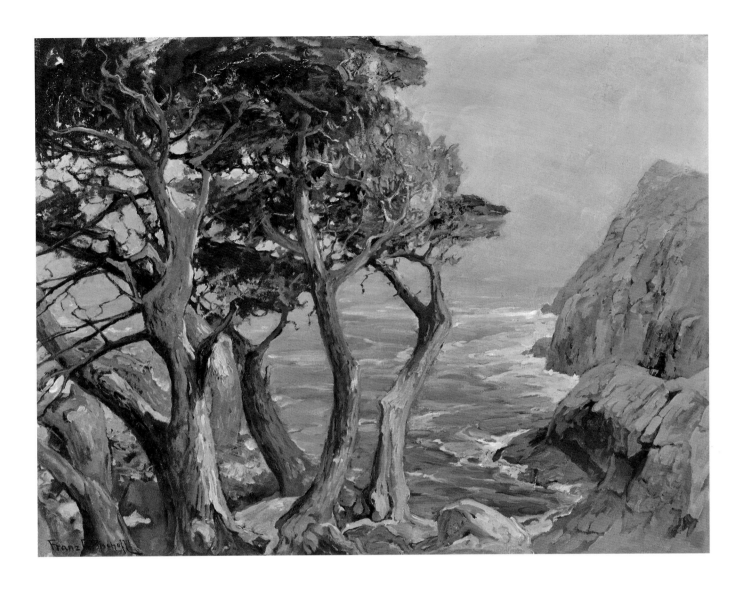

Franz A. **BISCHOFF**

b. Steinschönau, Austria, 1864
d. Pasadena, California, 1929

A Cool Fog Drifting, 1924
Oil on canvas
30 x 40 inches

Class of Winter 1925

One of the foremost porcelain painters of his day, Franz Bischoff was known as the "King of the Rose Painters." Bischoff apprenticed to a china painter at a local craft school before going to Vienna in 1882 to study applied design, watercolor painting, and porcelain decoration. From 1885 to 1890, he traveled around the East Coast of the United States as a china decorator, aligning himself with, among others, Mary Leicester Wagner, correspondent for *Keramic Studio*, a pioneering periodical for ceramic artists and potters working in the Arts and Crafts style. In 1908, Bischoff moved to Southern California and built a grand home and studio with an extensive flower garden on the banks of the Arroyo Seco, home of the annual Rose Parade. Regional nurseries developed and grew hybrid roses with spectacular, large-sized blooms, used to lavishly decorate Rose Parade floats. Bischoff continued as a porcelain painter, successfully capitalizing on the wave of interest in roses, while transitioning to plein-air painting.

The Monterey Peninsula, three hundred miles to the north, would become one of Bischoff's favorite painting locations. In *A Cool Fog Drifting*, he proves himself a master of color and composition. He captures the mesmerizing beauty of Point Lobos, near Carmel, with its twisted cypress trees, sheer cliffs above a surging sea, and ethereal fog. The composition juxtaposes the foreground trees, lit by a soft winter light, with the deep space of the Pacific Ocean view. A rocky outcropping painted in warm oranges and browns recedes into the distance, balancing the cool turquoise of sea and sky.

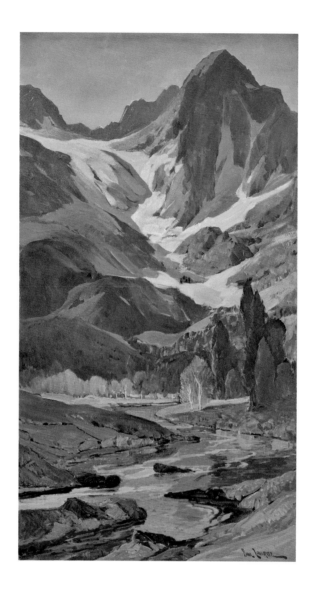

Paul **LAURITZ** | b. Larvik, Norway, 1889
d. Glendale, California, 1975

The Mountain Brook, 1924
Oil on canvas
84 x 45 inches
Conservation funded by the Historical
Collections Council of California

Class of Summer 1925

Paul Lauritz, who was a good twenty-five years younger than the first generation of California Impressionists, came to Los Angeles in 1919. He had worked his way west from Norway as a commercial artist. The Class of Summer 1925 at Gardena High School commissioned Lauritz's *The Mountain Brook* for the newly built high school auditorium, completed in 1923. The painting was intended to grace the wall on one side of the stage, with Elmer Wachtel's *The Santa Barbara Coast* on the other. Lauritz's mural-sized painting shows a mountain stream winding through a spring landscape, leading the eye up to craggy, snowy peaks of blue.

At around this time, he returned to Norway and apparently stayed for several years. In 1928

the king commissioned a painting for the royal residence. Returning to the United States, Lauritz taught at Chouinard Art Institute beginning around 1928 and at Otis Art Institute somewhat later, and was active in the Los Angeles art community. He was president of the California Art Club from 1942 to 1944 and served on the Los Angeles Municipal Art Commission. Beginning in 1944, he organized the commission's first five citywide art exhibitions at the Greek Theatre in Griffith Park. The shows were open to all trends in art, with conservative, intermediate, and modern juries judging the shows in an effort to be inclusive. Lauritz, who acted as a moderating influence between conservative and modern artists in Los Angeles, was often asked to speak at Gardena High School.

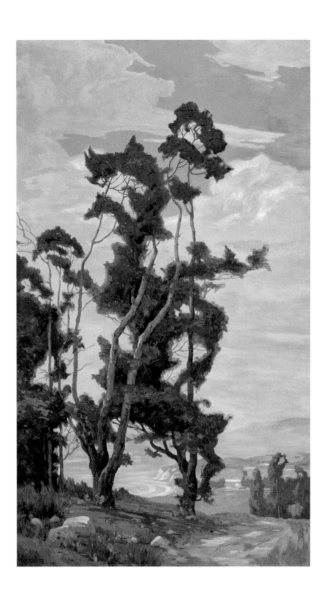

Elmer **WACHTEL** | b. Baltimore, Maryland, 1864 \ d. Guadalajara, Mexico, 1929

The Santa Barbara Coast (or *Montecito Coast*), 1924
Oil on canvas
84 x 48 inches

Class of Winter 1926

Elmer Wachtel was one of the leading landscape painters of his day in Los Angeles. Wachtel arrived in the city in 1882, initially working in a furniture store by day and playing violin in the Philharmonic Orchestra by night. He was also an illustrator for *Land of Sunshine* and *Californian* magazines. In 1895, he studied briefly at the Art Students League and with William Merritt Chase in New York; in 1900, he attended the Lambeth School of Art in London. Wachtel had prodigious skills in furniture carving, metalwork, and sculpture in addition to painting and illustration. He and his wife, the artist Marion Kavanagh Wachtel, built several craftsman bungalow-studios—one on Sichel Street, not far from where the Los Angeles River meets the Arroyo Seco, which was later bought by William Wendt and Julia Bracken Wendt.

Reflecting Wachtel's grounding in the Arts and Crafts Movement and Art Nouveau at the Lambeth School, *The Santa Barbara Coast* is decorative and lyrical, with flattened shapes and an asymmetrical composition. According to Nancy Moure, Wachtel often used "a shadowy, arboreal foreground to frame a lighted distant landscape." The senior students commissioned the painting for pride of place in the newly built high school auditorium. Wachtel's outsized focus on the clouds and trees was probably meant to compensate for the painting's placement high on the wall. He was beloved by the Gardena High School students; they were greatly saddened when he suddenly passed away in Guadalajara, Mexico, while on a painting trip. This painting, one of the most prized in the collection, is undergoing extensive conservation and currently cannot be exhibited.

James Guilford **SWINNERTON** | b. Eureka, California, 1875
| d. Palm Springs, California, 1974

The Betatakin Ruins, c. 1927
Oil on canvas
60 x 48 inches
Photo courtesy of the Autry Museum
of the American West

Class of Summer 1927

During the early decades of the twentieth century, artists looking for inspiration in new experiences and vistas often journeyed to the far reaches of the American Southwest. Others ended up in the region seeking to recuperate from such ills as tuberculosis. James Swinnerton was a celebrated cartoonist for Hearst newspapers, based in New York and best known for the strip *Little Jimmy*, when he was diagnosed with tuberculosis and told he had just weeks to live. Around 1903, he relocated to the desert near Palm Springs, which restored his health and impelled him to become a landscape painter while continuing to draw his popular comic strips.

Swinnerton traveled to the Southwest on extended painting trips often enough that a rock formation in Monument Valley, Arizona, is named after him. Located in the extreme southern end of the tribal park, Swinnerton Arch is so remote that it must be visited in the company of a Navajo guide.

Betatakin ("house built on a ledge" in Navajo) is a preserved cliff dwelling built in an enormous alcove by the ancient Anasazi people between 1267 and 1286. Swinnerton's painting balances light against shadow, cool against warm, showcasing a monumental arch that frames a sky filled with billowing clouds. A golden light coming through the arch illuminates the sanctified space of the cliff dwelling, expressing a quiet sense of order and harmony.

Carl Oscar **BORG**
b. Osterbyn Ostra, Grinstads, Sweden, 1879
d. Santa Barbara, California, 1947

The Grand Canyon, c. 1927
Oil on canvas
30 x 34 inches

Class of Winter 1927

On the Gardena High School students' first trip to Carl Oscar Borg's studio, he spent hours showing them his collection of medieval weapons. Pleased by the students' interest, Borg invited them back to see his collection of Egyptian treasures, acquired during his years with an archeological expedition to the Valley of the Kings, funded by his patron Phoebe Apperson Hearst.

Born in Sweden, Borg was apprenticed to a painting contractor at the age of fifteen. In 1899, he went to England, where he painted stage scenery, portraits, and seascapes. He arrived in Los Angeles in 1904 and found work as a decorator and scene painter. Idah Meacham Strobridge, a bookbinder and writer who had been raised in the Nevada desert, was the first to show

Borg in the "Little Corner of Local Art" gallery she established in her bungalow in Garvanza. It was a popular meeting place for the denizens of the Arroyo Seco; Charles Lummis was a close friend who encouraged Borg's interest in the Native Americans of the Southwest.

The Hopi and Navajo Indians fascinated Borg, who undertook a long-term project with Hearst's support to document the tribes' daily activities before acculturation destroyed their way of life. The artist painted in Arizona and New Mexico each spring from 1916 to 1932. He completed Gardena High School's *The Grand Canyon* on one of these sojourns. Borg considered the Grand Canyon his home, and had his ashes scattered there upon his death.

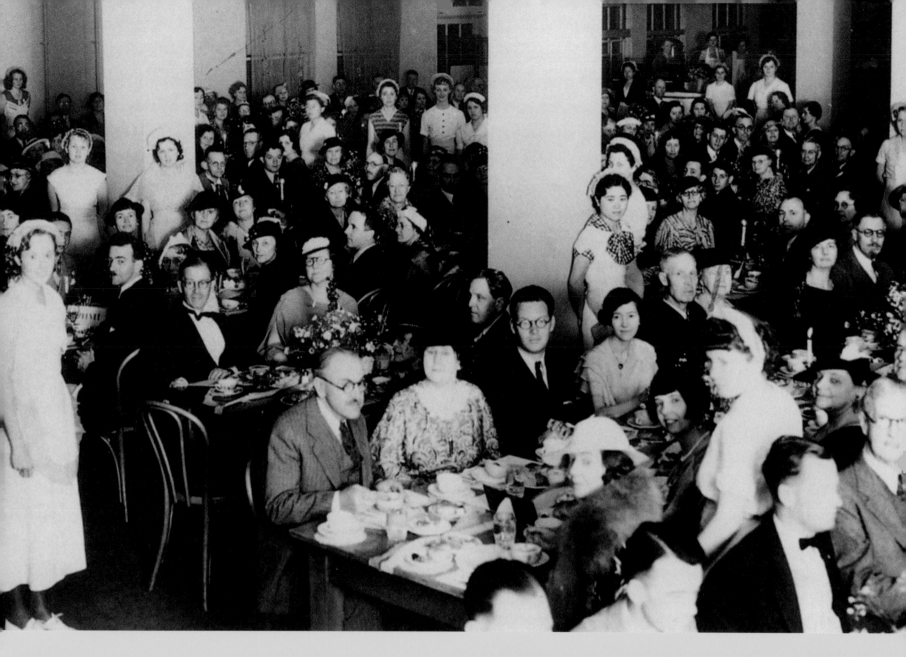

Art for the People

By 1928, the Arts and Crafts Movement's influence was no longer dominant in Southern California. Aesthetic responses to the landscape, climate, and history of Southern California were no longer bound up with the ideals of the movement. Spanish Revival architecture was giving way to what *Los Angeles Times* architecture critic Christopher Reynolds called "a new sensibility that was neither brashly modernist nor predictably old fashioned."[1] Painting was

undergoing a roughly parallel transformation. Led by Millard Sheets, the California School of watercolor was emerging as a regional iteration of the burgeoning national American Scene movement. As Dijkstra has written, the onset of the Great Depression brought a new stress on social responsibility and "a revaluation of the moral significance of labor in the growth of American society."[2] Yet, just as the reformist spirit of the Progressive Era was a forerunner of the coming New Deal, the ethos of the Arts and Crafts Movement, with its stress on the value of design and social programs, lingered during the Depression era.

In 1928, Principal Whitely decided to act on a suggestion from the painter Hanson Puthuff and his wife, painter May Longest Puthuff.[3] Their idea was to invite eighty to one hundred well-known artists to send paintings to an annual invitational purchase prize exhibition. It would be held at the school in April, following spring vacation. In addition to sending groups of seniors (and, sometimes, the whole senior class) to galleries and artists' studios in Los Angeles—a practice that would continue—the art world would come to the students. Along with artists, galleries also sent paintings to the school. Stendahl, Hatfield, Cowie, and Kievits galleries (the latter based at the Vista del Arroyo Hotel) were major contributors to the success of the exhibition.[4] The annual two- or three-week exhibition made it possible to introduce a course in art appreciation that would develop over the years into a full-fledged program required for graduation.

Another modification to the program, which lasted for only one year, was the introduction of a jury of art world experts and educational authorities that selected ten paintings from the eighty-nine submissions. This method was intended to insure "mature judgment" and to strengthen the students' critical faculties. It would also prevent the students, who were often "foggy" on matters of value, from selecting lesser works or those valued far below the purchase price.[5]

The jury of selection comprised artist William Wendt; Susan Dorsey, superintendent of Los Angeles city schools; Mrs. Herbert Clark, a member of the Los Angeles school board; Antony Anderson, former art critic of the *Los Angeles Times*; Arthur Millier, current art critic of the *Times*; and Mrs. Edward T. Mobarry, a member of the Wednesday Progressive Club, a philanthropic social club in Gardena. The students selected two paintings from the jury's ten choices, Puthuff's *Mountains of Majesty* (or *Hills of Majesty*) for four hundred dollars and John Frost's *Desert Twilight* for three hundred dollars.[6] Frost, a leading painter of the era, was ill with tuberculosis (he died nine years later), making his paintings somewhat rare. The jury understandably would have included a painting by Puthuff, a mover and shaker in the plein-air community and originator of the *Purchase Prize Exhibit*. He was also largely responsible for the formation of the two most important arts organizations of the period, the California Art Club and the Art Students League of Los Angeles.[7]

An important component of the *Purchase Prize Exhibit* was the annual dinner, served by the senior students on opening night in the school cafeteria and accompanied by musical entertainment. Profits from the dinner supported the purchase of works of art. At the conclusion of the dinner, the exhibition opened with fanfare, lending a thrill of anticipation to the event. The students also hosted various community organizations, clubs, and groups during the run of the show, creating a tradition of public service. Although students held many fundraising activities over the history of the project, it is not known how often a community organization or private individual stepped in to help the students complete a sale. An article in the *Gardena Valley News* described the students' fundraising efforts:

> Money pledged for their purchase is to be raised by plays and dinners. Profits on the dinners given last Tuesday and Saturday evenings will be applied on the fund, also all money raised from the sale of art catalogs during the exhibit. Quite a sum remains yet to be raised, it was stated this week, but the seniors feel sure

21.
(detail) *Gardena Art Association Banquet*, 1935. Photo by Churchill Gardiner Studios.

22.
Jean Mannheim, *Passing Ships*, reproduced in
Purchase Prize Exhibit Catalogue of Paintings, 1929,
GHS Scrapbook, 1929–1933.

Jean Manheim's portrait of his daughter was exhibited in '28, and was so well liked, the student body bought it to augment our collection of Senior gift pictures.

they may rely on the support of the community in future activities, sufficiently to reach their goal. It is hoped that the sum required to finish their pledge may be augmented sufficiently to permit buying a third picture, "Passing Ships" by Jean Mannheim of Pasadena. The student body generally believes that this picture should not be allowed to leave the high school and the entire organization is behind the movement to retain it. Among visitors at the exhibit was one art expert who stated that the painting is worth about $1000 in the open market."[8]

A rare extant "Catalogue of Paintings" for the 1929 exhibition, a small brochure, reproduces *Passing Ships*, showing it as a Class of Summer 1928 gift, indicating that the students were able to purchase the painting for the GHS art collection after all.[9] (fig.22)

The students most likely had coveted the painting of a young woman at the edge of the sea by one of their favorite artists even though it was not one of the ten selected by the jury.

1929

And so, the following year, and this time on the advice of art critic Arthur Millier, the exhibit continued without a jury; the students were again responsible for the final selection and final choices. In 1929, GHS invited 115 artists to send paintings for the *Purchase Prize Exhibit*, on view April 5–23, with prizes of three hundred and four hundred dollars. The Board of Education paid for the installation of lights above each painting.[10] Several schoolrooms were turned into exhibition spaces filled with paintings sent by prominent Southern California artists, as well as a "sprinkling of older paintings generously loaned by art dealers for the exhibition."[11] The 1920s boom was still on, huge crowds from all over the Southland attended the annual exhibition, and regional art dealers realized that it offered an ideal opportunity to promote their artists. This year, the senior students selected Clarence Hinkle's *Quiet Pose* (Winter Class 1929) and Maurice Braun's *California Hills* (Summer Class 1929).

The significance of the new program was immediately apparent. The *Purchase Prize Exhibit* was an educational opportunity for students and the community as well as a lesson in civic cooperation—a virtue that was highly regarded at GHS. *The Argus: A Journal of Art Criticism*, a San Francisco monthly that reported on regional, national, and international modernist developments, with correspondents in Paris and Berlin, announced the winners of the first annual exhibition in 1928. The journal noted that the exhibit was for "the purpose of stimulating art in the community served by the school, as well as among its students," which suggests that the exhibit was designed as a community-building exercise from its inception.[12] A *Los Angeles Times* writer described the renowned garden program at the school in a similar vein in 1928: "Almost every nationality is represented in the school gardens. They all work side by side. The spirit of cooperation and team work is emphasized and through it a better home life and better community life are sought." The children made the walks, laid out the borders, prepared the soil for planting, and did the actual work of planting, cultivating, irrigating, and caring for the plants.[13] As noted in the *Gardena Valley News*, the *Purchase Prize Exhibits* "were pioneering in a coming widespread movement to give art and art appreciation a loftier and more permanent place among schools all over the land."[14] GHS soon became known as "the high school that has the art gallery."

According to alumnus Roy C. Pursche (Winter 1943), Principal Whitely also earned the respect of the student body in a different way, as the result of a prank played on him by "some of the husky farm boys," who picked up his Model T Roadster and wedged it between two eucalyptus trees. Whitely returned to the campus, walked right up to the perpetrators, and said, "Boys, I need a little help." They moved the car, and they were never punished for their practical joke.[15]

Sadly, the 1929 exhibition was soon followed by the Wall Street crash on October 29, which triggered the Great Depression. Life would soon change for artists in California and for students at Gardena High School.

1930

By June 1930, breadlines were forming in Los Angeles. By 1931, an estimated ten thousand transients were arriving in Los Angeles County every month. Three hundred fifty thousand desperate farmers and their families would head west in an epic migration in the mid-1930s, seeking work.[16] Given these facts, it is not surprising that questions arose about the viability of continuing the art exhibition. In April 1930, Rev. Kaler of the First Methodist

23.
George Sherriff, *Palms of Coachella*, c. 1930. Oil on canvas, 30 x 40 inches. Collection of Gardena High School, Class Gift Winter 1930. The beauty of this painting is marred due to excessive fading of the colors, which cannot be restored.

Church of Gardena invited school leaders and the public to a sermon that asked:

> What is an art exhibit worth to this community? Is a high school making any worth-while contribution to the life of a community by bringing such an exhibit to us? What does a "highbrow" interest such as art have to do with folks who are trying to make a living in these strenuous times? Has art a place of equal standing with science, for instance? Should Principal Whitely be commended or condemned for his interest in this matter?[17]

Even so, the 1930 *Purchase Prize Exhibit*, held from April 23 to May 11, was by all accounts successful. By now, the GHSAC consisted of twenty paintings, and the annual exhibitions were well established, regionally prominent, and a source of pride for the community. According to Lee Shippey of the *Los Angeles Times*, the exhibition was considered "the cultural event of the year." Artists and dealers throughout the state sent paintings, and large crowds of artists, art lovers, educators, and community members turned out for the official opening ceremony. This year, Lieutenant Governor H. L. Carnahan made a speech, and 1,200 people attended.[18]

The exhibition consisted of ninety-two paintings, with additional works by artists no longer living and East Coast artists, sent by several art dealers. The impressive list of artists who participated in the exhibition, most of whom were personally invited by Principal Whitely, included Anni Baldaugh, Maurice Braun, William Merritt Chase, Eleanor Colburn, Nicolai Fechin, Lillian Genth, Anna Hills, N. Brooker Mayhew, Ruth Peabody, Charles Reiffel, William Ritschel, Guy Rose, Paul Sample, Millard Sheets, Frederick Schwankovsky, Luvena Vysekal, and William Wendt. Some works lent by the galleries, including the Rose and Chase paintings, were not available for selection by the students.[19]

From this year's *Purchase Prize Exhibit*, the Winter 1930 class chose George Robert Sherriff's *Palms of Coachella*, a desert scene in pastel shades of pink and yellow.

24.

A corner of the Purchase Prize Exhibit, 1931. GHS Scrapbook, 1929–1933.

(fig. 23) The Summer 1930 students selected Carlo Wostry's *Beethoven*, one of the most popular paintings in the collection among alumni today. Three graduating classes tried to purchase the painting before Wostry agreed to sell it for a fraction of its value. Soon after the students acquired it, the Hollywood Bowl Association asked to display *Beethoven* throughout the summer season at Pepper Tree Lane at the Hollywood Bowl, and the painting was occasionally reproduced on the Bowl's programs.[20]

The City of Gardena was incorporated in 1930, combining the rural towns of Gardena, Moneta, and Strawberry Park into a single small farming community. Gardena alone had a population of 3,110.[21]

1931

By 1931, the students were suffering the effects of the Depression. Their determination to continue adding to the permanent collection despite the economic difficulties of the era led to greater involvement by the Gardena community. Whereas the Gardena Board of Education had previously assisted with the exhibition expenses—including the elaborate lighting system—members of local clubs and civic groups organized as the Patrons committee helped with fundraising and the organization of the fourth annual *Purchase Prize Exhibit*. Press reports regularly commented on the collaboration of the Gardena community.

The following year, Arthur Millier wrote: "Gardena is the most conspicuous example of Bringing Art to the Peepul, and that little community through its high school, has won national fame as a place where one can live close to nature and raise a

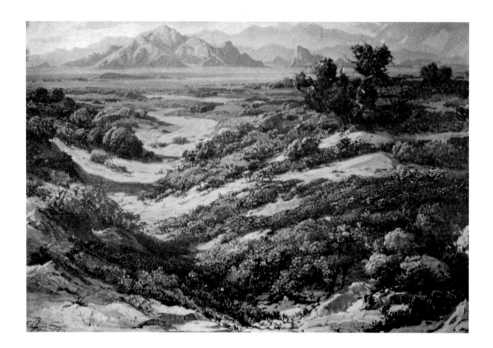

25.
F. Grayson Sayre, *Desert in Bloom*, c. 1931. Class Gift
Summer 1931. Destroyed in a campus fire in 1975.

few chickens and salad greens without sacrificing the contact with art which is one of
the compensations for life in the roaring metropolis. . . ." He described the procession
of speakers, beginning with Mayor Wayne Ayers Bogart, who told the crowd that the
exhibitions had given Gardena a national reputation as a cultural community. "And bear
in mind," Millier continued, "that these organizations not only paid expenses of trucking,
installing, and individually lighting 122 framed oil paintings, collected from all over
the Southland—they must have paid their share toward the $750 collected by the year's
graduating classes with which the students will purchase . . . two pictures So these,
patently, were no empty words."[22]

The populist gesture of bringing art to the people noted by Arthur Millier was a
common theme during the Depression era. Regionalism, with its recognizable imagery,
was easy to understand and, therefore, accessible to all, unlike modernism. The success of
Gardena's "art for everybody" movement led to widespread interest among other cities, and
other schools began to follow Gardena's example. In addition to inspiring art-collecting
programs, Gardena High School directly fostered other high school collections by making
it possible for them to purchase paintings from the annual exhibitions at the same lower
negotiated price that GHS paid, if agreed upon by the artist. This was a boon for artists
during an era in which few were selling their work. In just the first week of the exhibit,
1,500 people visited the school to see it.[23]

The Winter Class selected Dan Sayre Groesbeck's *Loading the Barge*, and the
Summer Class purchased F. Grayson Sayre's *Desert in Bloom* (fig. 25), a painting that was
lost in a 1975 campus fire.

The school invited two art world luminaries to give lectures at the school. Harry
Muir Kurtzworth, Curator of Art at the Los Angeles Museum, spoke on "Appreciation of
Art," and Michel Jacobs, a noted teacher of color theory and director of the Metropolitan
Museum School in New York, spoke on "Color." Jacobs promised to spread the word about
the collection to art and education circles in New York. Kurzworth sent a follow-up letter
to the president of the Lions Club, praising the civic organizations: "Many European cities
have become famous in the arts with a less auspicious beginning than yours. What a fine
opportunity for your churches, clubs, lodges, and other groups to make Gardena the most
attractive city between Los Angeles and the Pacific Ocean by using the arts in giving the
city character."[24]

While the city did not take this approach to urban development, the Patrons committee, composed of Gardena City Council members and heads of clubs and civic organizations, had begun to take a more active role in the exhibition. They met annually at a special luncheon held at the school to discuss ways to defray costs and organized annual benefits to raise funds for exhibition expenses and to assist with purchases. In 1931, they organized Community Stunt Night, a comedic talent show presented by prominent members of the community in the high school auditorium. When benefits were not successful in raising all the funds needed, representatives of various civic organizations would meet at the high school "to consider further means of clearing the necessary expenses."[25]

The Patrons group provided a bonding experience for its members, who shared common experiences, heard new perspectives, and began to understand one another better. The high school became a community center for several weeks every year.

1932

In 1932, the Board of Education closed five Los Angeles city schools under an "economy program" that redistributed students to other schools. The old library at Gardena High School was torn down and replaced with a brick building with Gothic windows and high ceilings designed for the hanging of the art collection. A new physical education building and additional classrooms were also built.[26] Students at the public schools in Gardena joined in relief efforts, raising funds to provide nourishment for needy children during the summer months, when schools were closed. The Depression was darkening in Southern California; in one month of 1932 alone, the Southern Pacific Railroad evicted an estimated eighty thousand transients from its boxcars.[27]

Still, despite the worsening economic situation, the community considered the art program at GHS a priority because of all the attention it was getting from the press and public. After all, few small suburban schools had an art gallery full of paintings worth some twenty-five thousand dollars. During the run of the show, a continuous stream of visitors visited the gallery, which was open to the public every night.[28] The opening night of the 1932 *Purchase Prize Exhibit* was an elaborate affair. The Patrons were city officials, headed by Mayor Wayne A. Bogart, and representatives of all local civic organizations; students served as official hosts.[29] This was the first year residents of the Gardena Valley were invited to the dinner and opening reception. Formerly, invitations had been extended only to the Patrons, the California Art Club, participating artists, the Board of Education, the Superintendent of Schools and his staff, and the Secondary Principals Association.

The purchases in 1932 were Kathryn Leighton's portrait *Chief Bullchild* (Winter Class) and Benjamin Chambers Brown's *Mt. Lowe in Winter* (or *Opalescent Morning, Mt. Lowe, California*) (Summer Class). Leighton's painting was the first by a woman to be selected by the students. The school also won a painting by Millard Sheets this year. (fig. 26) A Gardena High School contestant took the prize for an essay evaluating Sheets's exhibitions of paintings at the Dalzell Hatfield Galleries, submitted to an all–Southern California high school competition.

Gardena High School's unwavering commitment to education through the art collection was widely acknowledged. With the introduction of the *Purchase Prize Exhibit*, a series of notices in the regional press announced the forthcoming exhibition, the dinner and opening of the exhibit, and the purchases, with descriptive overviews of accompanying activities. This media attention easily amounted to a minimum of ten articles a year in the *Los Angeles Times* alone. The *Times* treated the exhibitions with the same seriousness as those in art galleries and museums. The list of small regional newspapers that regularly covered the exhibition is long, including the *Long Beach Press-Telegram, San Diego Evening*

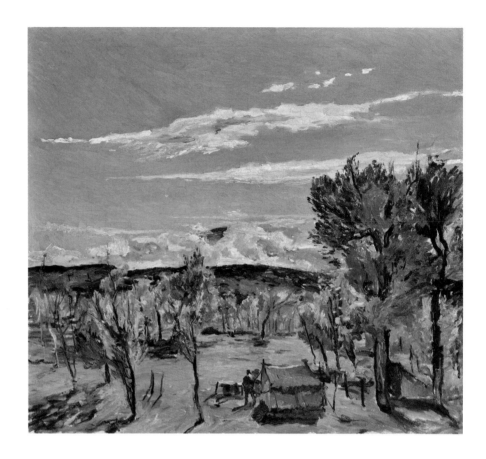

26.
Millard Sheets, *Desert Life*, 1932. Oil on canvas, 32 x 36 inches. Collection of GHS/LAUSD, Gift to GHS as Essay Contest Prize, 1932. © 2018 LAUSD Art & Artifact Collection/Archive.*

Tribune, Los Angeles Evening Express, Sierra Educational News, and the Laguna Beach-based *South Coast News*.[30]

 Prominent newspapers and periodicals around the country also took note. *California Arts & Architecture*, a sophisticated, nationally circulated magazine, occasionally included stories about the exhibitions and purchases; so did the *Christian Science Monitor*, published in Boston. In April 1932, soon after the annual dinner, *The Art Digest*, the most widely read art magazine in the country, published an article about the GHS art collection. A few weeks later, Editor Peyton Boswell sent Principal Whitely a letter asking for more details and photographs of the student purchases.[31] A notice about the collection in the June 1932 issue of *The American Magazine of Art* said in part, "The students select the paintings after having training in art analysis; it gives them a chance to try for themselves the methods presented to them in the classroom. They have a chance to develop independent judgment."[32]

 As a consequence of the widespread publicity, Gardena High School embarked on an extensive archival project, saving every letter received from the artists and every article published about the event, and binding them into volumes kept in the library.[33] Sadly, these historic volumes have been lost, with the exception of one, which surfaced at a Southern California art auction in 2015. It is a scrapbook for the years 1929 through 1933, providing detailed information about the GHS community project that cannot be gleaned from newspaper clippings alone. Fittingly, the cover of this large, four-inch-thick leather-bound volume is elaborately hand carved with a decorative Arts and Crafts design. (fig. 27)

1933

The 1933 annual exhibition was postponed for a month due to damage to the school auditorium after a 6.4 magnitude earthquake hit Long Beach on March 10 and "shook

*Ownership subject to dispute by Gardena High School Student Body.

27.
Gardena High School Scrapbook, 1929–1933 (back).

many of the walls to the ground."[34] With the auditorium unusable for the students' fundraising activities, the students and their supporters created a one-day after-school carnival—held in classrooms, a week before the opening reception—with programs, booths, concessions, and entertainment. In 1935, a new earthquake-proof building would be constructed with the assistance of the Public Works Administration. (fig. 28)

An article in the *Gardena Valley News* described the incredibly rapid organization of the exhibition of 154 paintings following the approval of the Superintendent of Schools during the second week of April. On April 20, the newspaper announced: "Seniors at the high school, working under the direction of committee chairmen, are preparing to begin the collection of pictures Monday morning. On Tuesday and Wednesday evenings between 4 and 10 p.m. the pictures are to be hung. Lighting will be finished Thursday and final preparations for the opening completed on Friday."[35]

This brief description belies the astonishing level of organization and participation by hundreds of students, teachers, and community members. After the founding of the Patrons in 1931, Gardena Valley civic organizations and clubs, a GHS faculty committee, and senior class delegates usually met in March to discuss preliminary plans for the annual exhibit. This included deciding who would chair and serve on the fourteen organizing Art Committees: Auto Parking; Checking, Collecting, and Return

28.
Gardena High School, 1936, rebuilt by the Public Works Administration to comply with a new California code requiring earthquake protection for schools. Collection Simon K. Chiu.

of Pictures; Decoration; Dinner; Reception and Guarding; Invitations; Programs; Publicity and Tickets; Badges; Check Rooms; Tea Committee; Entertainment; Receiving; and Hanging.

In 1933, 236 people were responsible for the organizing committees, which were headed by teachers and community members and assisted by senior students. However, the number of people involved in each activity was often far greater. For example, students and teachers guarded the paintings after school from 3:00 to 5:00 p.m., evenings from 8:00 to 10:00 p.m., and on Saturdays and Sundays from 1:00 to 5:00 p.m. Thirty-one teachers and 142 students were needed to carry out this activity alone. Five hundred to eight hundred people worked on the dinner and exhibition every year.

One of the first tasks of the year was to mail a personal invitation from Principal Whitely to artists and dealers. (He also asked the artists for names of new artists to invite. This year, Roscoe Schrader, president of the California Art Club, listed three women and three men: Annie Baldaugh, Ruth Bennett, and Dorothy Dowiatt; Frank Zimmerer, Clarence Hinkle, and Charles Reiffel.[36]) Accompanying Whitely's invitation was a small two-fold prospectus, designed and printed by the students. It described the purpose and

dates of the exhibit, the prizes, the hours of operation, and the locations and schedules of the places where the paintings needed to be dropped off. The primary location in 1933 was the California Art Club, with secondary drop-off points at any art gallery in Los Angeles. (Paintings also could be collected at the artist's studio, if necessary.) The prospectus included other useful information; for example, a special guard paid for by the Board of Education would protect the paintings on campus, because the school was "unable by law" to insure the paintings. The back of the prospectus listed the student body purchases to date. Artists also received a mimeographed "notice of participation" form to fill out with the title of the painting they wished to enter and the location they favored.

After waiting a suitable length of time for a reply, the students sent a follow-up note they designed and printed to artists who had not yet returned the notice of participation, alerting them to the painting drop-off schedule and urging a response. Artists almost invariably misplaced, lost, or missed receipt of the invitation because they were away on painting trips. They would send short notes apologizing for the delay in responding, or asking if they could switch one painting for another or have the truck stop at their studio because they were unable to travel to one of the designated locations. Coordinating the drop-offs of 134 paintings in 1933 was no small feat, especially because—due to the high cost of shipping—the students picked up most of the work themselves.

Some artists sent elaborate handwritten responses to Principal Whitely's invitation. On March 21, 1929, Benjamin Brown expressed unusual displeasure with the idea of a purchase prize exhibition, although he still chose to participate: "My pictures do not look as well in a general exhibition as they do in the studio or on the walls of a school or home where they are not placed in juxtaposition with others of various styles. I have been told that my pictures 'grow' in appreciation as the years go by—and therefore I think that they do not have instantaneous if ephemeral appeal. I like much better the idea of a selection made in the studio—with the desire to get the best 'Brown' painting—the work of a painter of 30 years' experience in depicting the California landscape."[37]

Before the opening of the annual exhibition, the school sent an elegant printed invitation to members of the California Art Club, participating artists, members of the Board of Education and other school officials, and member organizations of the Gardena Art Association. Clubs and civic organizations that belonged to the association included the Gardena Chamber of Commerce, Gardena Lions Club, Spanish-American Institute, Wednesday Progressive Club, National Business and Professional Women's Club, Gardena American Legion Post, Gardena Civic League, Legion Auxiliary, Veterans of Foreign Wars, V.F.W. Auxiliary, Gardena Valley Improvement Association, and the GHS PTA and Alumni Association. The mayor of Gardena and the *Gardena Valley News* and *Long Beach Press-Telegram* were also association members.

In addition to joining the organizing committees and planning and sponsoring the event, members of these groups distributed about 250 tickets to the broader community. In 1933, a one-dollar ticket for the opening night dinner also included an annual membership in the Gardena Art Association. Proceeds from ticket sales helped defray expenses and contributed to the senior students' painting purchase fund.

Every year, the students created an elegantly designed and printed *Catalogue of Paintings* (fig. 29), sold to attendees of the exhibit opening. Few of these catalogues are extant. They were small brochures with photographic reproductions of the previous years' purchases and an alphabetical list of the participating artists, with the titles of the paintings they submitted.

The opening night dinner was another annual tradition, scheduled for 6:30 p.m. on the first Tuesday after Easter. For the first few years, the students did all the cooking in addition to decorating the room, arranging the table settings, and serving the food. In later years, hired cooks took over. Before the opening, the seniors would become acquainted

Prospectus of
The Second Annual Exhibit
of Paintings

To be held from
April 5 to 23
1929

at

GARDENA HIGH SCHOOL
Corner of Normandie and Palm Avenues
Gardena, California

Via Auto:

South on Western, Vermont, or Main to 165th
Street. The High School is midway between
Western and Vermont on 165th Street.

SECOND PURCHASE PRIZE EXHIBIT
SENIOR CLASSES 36

You will find my painting at *my studio 1151 N. Serrano ave*

Name of painting *"Beethoven"*

 Carlo Wostry

 1151 N. Serrano ave. Hollywood

Purchase Prize Exhibit of Paintings

Y̵OU AND YOUR FRIENDS ARE CORDIALLY
INVITED BY THE SENIORS AND FACULTY OF GARDENA
HIGH SCHOOL TO ATTEND THE OPENING OF A SECOND
PURCHASE PRIZE EXHIBIT OF PAINTINGS

GARDENA HIGH SCHOOL
FRIDAY AFTERNOON, 4 TO 6 P. M.
FRIDAY EVENING, 7 TO 10 P. M.
APRIL FIFTH

Purchase Prize Exhibit

Catalogue of Paintings

GARDENA HIGH SCHOOL
APRIL 5TH TO 23RD — 1929

with the paintings on display in the exhibit, so that they could act as hosts in the gallery. The master of ceremonies was always a leading artist who knew all the members of the art colony. He would humorously introduce and "roast" the artists in attendance, a routine that, as one observer noted, gave the "outlanders a pleasurable sense of intimacy with the great and near-great."[38]

In 1933, a ticket to the dinner cost fifty cents. The class planned to buy one painting for three hundred dollars, with hopes of buying another. Merrill Gage, a noted sculptor and president of the California Art Club, was master of ceremonies. For several years, CAC presidents served either as master of ceremonies at the dinner or as principal speakers, underlining the close relationship of the school with the organization and its artists. Most of the artists in the collection had been CAC members at one time or another. They welcomed the students into their studios, giving them an insider's view, and also made their paintings available to the students at prices well below market value. The organization's office acted as a drop-off location in Los Angeles for any artist, member or not, who wanted to enter the *Purchase Prize Exhibit*. The close connection between the GHS and the CAC naturally led to a continuing propensity to collect the members' California Impressionist landscapes. Principal Whitely and his wife, Alberta Munro Whitely, developed many relationships with the artists over the years. In 1932, the principal joined the California Art Club, making official a relationship that was already well established.

After the opening celebration, and throughout the three-week run of every exhibition, numerous local groups and clubs held spring functions, annual dinners, afternoon teas, and other special events at the school. The senior students served as hosts, which gave them experience in dealing with social settings and plenty of practice in talking about the art on display. School groups included senior students from surrounding high schools, teachers from the five Gardena Valley elementary schools, high school teachers and principals of the Harbor District, art teachers in the Los Angeles school system, PTA groups from across Los Angeles, members of the Bay League, and the Los Angeles City Schoolmasters' Club. Other groups included the Wednesday Progressive Club, Los Angeles District Division of Art, Pacific Art Association, World Friendship Club, and Japanese clubs across Los Angeles. Additional annual gatherings during the exhibit were the tea for the senior mothers and the annual GHS alumni homecoming, for which 650 invitations were sent to alumni and their families. As one of the biggest school events, it helped to perpetuate alumni interest in the art collection and the annual exhibit, creating a longstanding connection to the Gardena community.[39]

In addition to their visits to artist studios and galleries, the students took a required class called Senior Problems, which devoted weeks of instruction to the issues involved in choosing a class painting. Students attended talks by artists and critics, and applied a list of questions to the paintings in order to learn how to perceive not only color and draftsmanship, but also, as a laudatory *Los Angeles Times* writer noted, "that indefinable feeling which a masterpiece done in oil always inspires in one."[40] Ten paintings were chosen for extended examination. Students learned to analyze the elements of light and shade, composition, centers of interest, and other aspects, such as the vibration of colors.[41] Exposure to the paintings for three weeks afforded the students, teachers, and visiting artists sufficient time to discuss the essential qualities of these works. Besides cultivating a genuine appreciation of art, the collection also offered practical benefits to students studying painting techniques in art classes and to students in English classes, who wrote essays about the works. Heated debates about the merits of the paintings spilled into the hallways and the students' homes.

According to a former librarian at the school, the balloting was a critical time. Although the students were usually thoughtful and serious, there were some "individuals

29.
Left to right, clockwise: Ephemera from the GHS Scrapbook dated 1929 including the propectus, Carlo Wostry's notice of participation form, the cover of the *Purchase Prize Exhibit Catalogue of Paintings*, and the printed invitation.

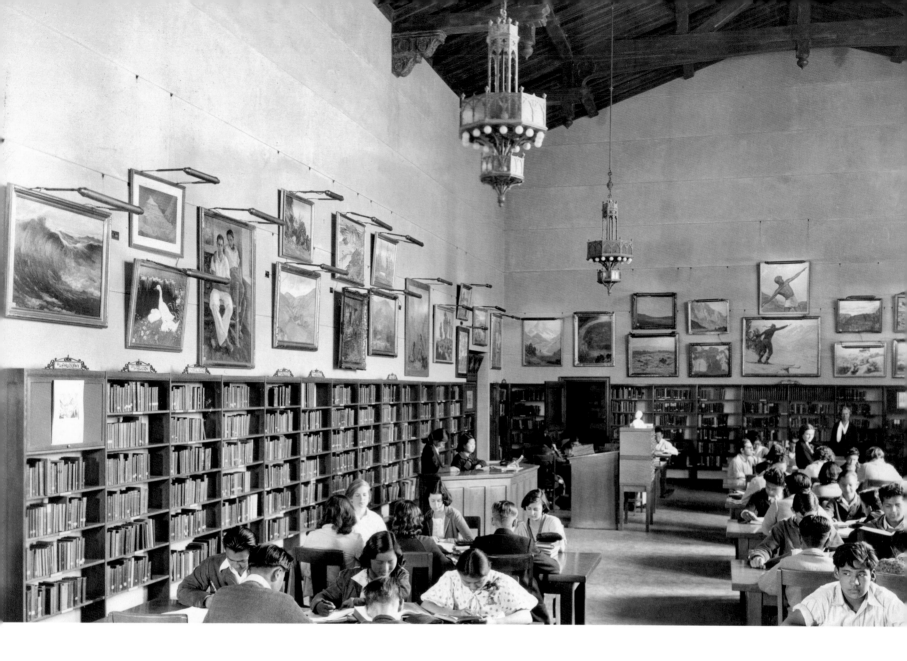

30.
Gardena High School library with *Purchase Prize Exhibit* on display, 1933. William Henry Price's prize winner is in the corner above the bookcases. GHS Scrapbook, 1929–1933.

with more leather-lunged leadership than appreciation of art. A 'bally-hoo' several times almost stampeded a class into buying a mediocre painting, when we had the chance of getting a magnificent one. We have always been magically saved from such a catastrophe."[42] The senior students of the Summer and Winter Classes voted separately, about a week apart, selecting their first three favorite choices. Then the students contacted the artists to see if they were amenable to receiving the amount of the purchase prize. The students were sometimes disappointed; not all the artists felt they could accept three or four hundred dollars for paintings that might be worth two thousand dollars. Formal presentation of the Class Gift by the two class presidents occurred at the conclusion of graduation ceremonies, just before the recessional, "God of Our Fathers."

The weekly student newspaper, *The Lark*, often had a special Exhibit Edition, detailing the events surrounding the show or art festival, as the production was sometimes called, and the outcome of the senior students' votes. This year, Summer and Winter classes presented William Ritschel's *Making Port* (listed as the Summer Class 1933 gift) at the outdoor commencement ceremony in May, signaling that they had difficulty raising money for a second purchase.[43] In December 1933, Max Wiekzorek, President of the Foundation of Western Art, donated a pastel portrait of Ted Shawn, a pioneer of modern

dance, to the GHS permanent collection.[44] This was the first donation of a painting to the permanent collection that was not a class gift. Alberta Munro Whitely donated a large porcelain Asian vase to the collection, noting in a letter to the school librarian, "It will be a 'high harmonic' of color against its dignified surroundings. Also, complementing 'specially the Japanese students—of whose gifts and attainments we are all so justly proud."[45]

After the close of this year's exhibition, the Gardena Chamber of Commerce and Civic League called a special meeting for all those interested in "placing [the *Purchase Prize Exhibit*] on a permanent self-supporting basis without the necessity of drives for funds to defray expenses."[46] This was the first public appeal to ensure the legacy of the GHS Art Collection—a testament to the community's pride in the permanent collection— but it would not be the last. The meeting contributed to the founding of the Gardena Art Association, formalized in 1935, but operating as the Patrons of the exhibition since 1931. The public appeal may have made possible the Winter Class students' purchase of William Henry Price's *Towering Peaks, Sierras (or Towering Peaks)*. A photograph of the library taken in 1933 shows a study hall full of ethnically diverse students talking and studying; above them, hanging on the walls, is part of the annual exhibit, including Price's painting in the corner of the room. (fig. 30)

In addition to landscape paintings, the 1933 exhibition included some of Southern California's modernists as well as rising stars of the American Scene movement, including Anni Baldaugh, Hugo Ballin, Loren Barton, Val Costello, Maynard Dixon, Lorser Feitelson, Nicolai Fechin, Jean Goodwin, Emil Kosa Jr., Luigi Lucioni, Stanton Macdonald-Wright, Fletcher Martin, Alfredo Ramos Martinez, Knud Merrild, Ivan Messenger, Agnes Pelton, Paul Sample, Frederick J. Schwankovsky, Millard Sheets, and Don R. Smith.[47] Sales were rare during the very worst year of the Depression, when some artists bartered their work to survive and others turned to scenic painting for the film studios, commercial illustration, or billboard painting. Some of these artists may have participated because of the national attention the exhibition was receiving. Some of the artists may have had their work sent by a gallery that represented them. However, few of the advanced modernists—such as Merrild, Macdonald-Wright, Feitelson, Pelton, and Martin—continued to send works of art regularly to the GHS exhibitions. Painting styles were undergoing major changes, but it would be some time before there was even a ripple of interest in modernist experimentation among the students at Gardena High School.

Jean **MANNHEIM**
b. Kreuznach, Germany, 1862
d. Pasadena, California, 1945

Passing Ships, 1918
Oil on canvas
39 x 34 inches
Photo courtesy of the Autry Museum of the
American West

**Collection of GHS/LAUSD Gift Library
and Class of Summer 1928. © 2018 LAUSD
Art & Artifact Collection/Archive.***

*Ownership subject to dispute by
Gardena High School Student Body.

After his wife died suddenly in 1910, Jean Mannheim moved his painting studio to his home so he could care for his young daughters. Although he had many lucrative portrait commissions, Jeanne and Eunice naturally became the subject of many of his paintings. Mannheim exhibited *Passing Ships* widely, and it received considerable critical attention. In 1918, *Los Angeles Times* art critic Antony Anderson described the painting featuring Mannheim's daughter Jeanne, then sixteen years old, as "the girl in the orange blouse and white gown who sits on the sand and looks out at the sea, her green veil floating like a gay pennant in the spanking wind."

Fred Hogue of the *Los Angeles Times* and Alma May Cook of the *Los Angeles Express* both commented on the painting when it was shown at the Los Angeles Museum in 1922. Hogue called the painting "a rare example of California art at its best." In an article comparing "conservatives" and "moderns," Cook cited the painting as an example of "one phase of modernism—the elimination of unnecessary detail, the bigness and broadness of technique and the brilliancy and truth of color and sunshine." This iconic image is expressive of regional culture after World War I, when nature was held to be sublimely restorative. The young woman's gaze out to sea invites us to ponder her thoughts about the future and inspires faith in the potential of youth. The painting is also a metaphor for the passage from adolescence to womanhood.

Hanson Duvall **PUTHUFF** | b. Waverly, Missouri, 1875
d. Corona Del Mar, California, 1972

Mountains of Majesty (or *Hills of Majesty*), 1928
Oil on canvas
36 x 40 inches

Class of Summer 1928

Hanson Puthuff was a mentor of sorts to the Gardena High School students and Principal Whitely; he and his artist wife, May Longest Puthuff, suggested founding the annual Purchase Prize Exhibit in 1928. It is fitting that Puthuff's *Mountains of Majesty* won first prize in the inaugural exhibit.

Many of the early California landscape painters were drawn to the mountains, seeking an experience of rugged nature and a scene of grandeur to record. Puthuff was one of those who, according to art historian William H. Gerdts in *Masters of Light*, "excelled in the depiction of soaring mountain forms, from the Malibu range and the Verdugo Mountains just beyond his Los Angeles home in La Crescenta, to the Sierras in the north." Here sunlight highlights the green of

spring on massive mountain forms, while deep blue shadows define their monumentality. In the foreground a mass of quickly painted chaparral and bright green trees suggest the semi-arid landscape out of which the mountains, most likely the San Gabriels, ascend. The contrast between the distant mountains enveloped in a cool and flattening atmospheric haze and the well-defined though rather minimal nature below, reinforces the mountains' power and grandeur.

John **FROST** | b. Philadelphia, Pennsylvania, 1890
d. Pasadena, California, 1937

Desert Twilight, c. 1928
Oil on canvas
27 x 32 inches

Class of Winter 1928

The highly respected California Impressionist John Frost died of tuberculosis at an early age, making his paintings somewhat rare. Frost was the son of Arthur B. Frost, a well-known illustrator. Contact with French and American Impressionists in Paris and Giverny, as well as a close family friendship with the California Impressionist Guy Rose, inspired his commitment to the style. In 1918, he moved with his family to the healing environment of Pasadena, with its warm, dry climate. After winning a prize in the first annual *Purchase Prize Exhibit* for *Desert Twilight*, Frost subsequently participated nearly every year until his death.

Desert Twilight, painted with delicate brushstrokes and soft pastel colors, is a poetic interpretation of the desert near Palm Springs. It shows the last light of day as a cold, dark shadow spreads across the desert floor. The sky and distant low horizon are not illuminated by visible sunlight; rather, they seem lit by the afterglow of a sun that has already set or is obscured by the magnificent clouds from which a light rain seems to fall. Although Frost was still some years away from death, the painting balances a sense of earthly mortality and melancholy with hope and joy in the spiritual afterlife.

Maurice **BRAUN**

b. Nagy-Bittse, Hungary, 1877
d. San Diego, California, 1941

California Hills, c. 1924
Oil on canvas
36 x 42 inches

Class of Summer 1929

Maurice Braun was a deeply philosophical painter for whom nature was an expression of the divine. The leading California Impressionist based in San Diego, Braun moved to the area in 1909 due to his interest in theosophy. Braun lived at Pt. Loma and was affiliated with the Theosophical Society, which looked upon art as a way to educe transcendental ideas.

Braun had studied with William Merritt Chase, who introduced many painters to the broken brushwork and palette of French Impressionism, and sojourned in European cultural centers as well. He enjoyed a national reputation but was also dedicated to the San Diego art community; he opened the San Diego Academy of Art in 1912, where he taught, and helped found the Contemporary Artists of San Diego in 1929. From

about 1921 to 1929, he had studios in both San Diego and either New York City or Connecticut.

Braun's high-keyed, airy painting of low hills, covered with the golden grasses of summer, shimmers with a diffuse atmospheric haze, quintessentially signaling the heat of the season. The painting is executed in a harmonious unity of warm reds, yellows, and oranges balanced by subtle greens and blues in the foreground hills, distant mountains, and sky. The mood overall is one of calm reverie in spite of the almost startling display of color. In a 1925 article in *International Studio*, Helen Comstock wrote: "Braun is not only a poet but an optimist. He calls attention to the enduring majesty and peace that exist in nature." The artist exhibited the painting at Cannell and Chaffin Gallery in 1924.

Clarence **HINKLE**

b. Auburn, California, 1880
d. Santa Barbara, California, 1960

Quiet Pose, c. 1918
Oil on canvas
36 x 30 inches

Class of Winter 1929

When he painted *Quiet Pose*, Clarence Hinkle had recently moved to Los Angeles from San Francisco; his studio was near the Los Angeles School of Art and Design, where he taught life classes. A year later, in June 1918, he exhibited for the first time in Los Angeles, in the California Art Club's *Spring Exhibition*.

Quiet Pose, one of two paintings he showed in that exhibition, depicts a young woman serenely reading with a small book open in her lap. The setting is a shady corner of a garden loosely rendered in blue, green, and white strokes of color, filled with dappled sunlight and infused with a sense of peace and repose. The orange umbrella poised on the young woman's shoulder not only helps to shade her face but also acts as an enlivening complement to the cool background.

Although the painting shows that Hinkle was well versed in Impressionism, he is better known for Expressionistic figural studies, landscapes, and still lifes that are modernist in their essence. Hinkle was a member of the Group of Eight, who exhibited sporadically throughout the 1920s in Los Angeles and was dedicated to creative experimentation and individual expression. It is a testament to GHS's importance in the art community that Hinkle let one of his popular figurative paintings go to the school.

Carlo **WOSTRY**

b. Trieste, Austria-Hungary, 1865
d. Trieste, Italy, 1943

Beethoven, c. 1905
Oil on canvas
59 x 59 inches

Class of Summer 1930

Beethoven, which hung in the school library for many years, remains one of the most popular acquisitions among GHS alumni. Two prior classes had coveted the painting but didn't have sufficient funds. The class of 1930 was successful, perhaps, because Wostry was about to return to his studio in his native Trieste to complete a mural commission for St. Andrew Church in Pasadena.

Art critic Arthur Millier devoted a paragraph to *Beethoven* in a 1928 article, observing that it depicted the young composer before he had gained international renown. "He was treading his way through a narrow street, his eyes cast down, as in contemplation. On his head was a gray nap-worn top hat. In his hand was a baggy umbrella. Protruding from a pocket of his top coat was the

manuscript of what is now, perhaps, one of his noted compositions." Behind him a woman leans out of a window without noticing the composer, signaling his anonymity, as he was merely on the threshold of greatness.

The GHS student newspaper, *The Lark*, remarked that the artist brought the painting when he arrived in the United States in 1926. Wostry was a history painter who sought accuracy in his work. The house pictured in the town of Hetzendorf, seven miles from Vienna, had once belonged to Beethoven; the Count Tunn family lent clothing once belonging to the composer to Wostry. The artist had expected to realize some four thousand dollars for the painting; due to the persistence and admiration of the GHS seniors, he let them have it for a mere four hundred dollars.

Dan Sayre **GROESBECK** | b. St. Helena, California, 1879
| d. Los Angeles, California, 1950

Loading the Barge, c. 1924
Oil on canvas
29 x 48 inches

Class of Winter 1931

Dan Sayre Groesbeck was a colorful individual with a rare talent for visualizing dramatic scenes and setting them down in works on paper, paintings, murals, and films. Groesbeck was a successful commercial artist and book illustrator in New York and Chicago during the golden years of American illustration, but it was his work as a concept artist on many films with Cecil B. DeMille, such as *The Ten Commandments*, that earned him fame. He also exhibited widely and was an internationally respected muralist, but after being "discovered" by DeMille in 1923, he devoted his talents to creating backdrops, sets, and promotional illustrations for the film industry. According to art historian Robert Henning in *Destined for Hollywood: The Art of Dan Sayre Groesbeck*, the artist was a pivotal figure in translating the great pictorial tradition from illustrated books to the new medium of film in the early twentieth century.

Groesbeck grew up in Pasadena and studied at the Throop Polytechnic University before attending California School of Design in San Francisco. He covered the Japanese war in Manchuria for the *London Graphic* from 1904 to 1905, and served during World War I in Russia with a Canadian regiment that was part of the "Cordon Sanitaire" containing the Bolshevik Revolution. He exhibited paintings related to these adventures in 1924, including Asian junks and fishing fleets, at the Biltmore Salon; this fact helps to date Gardena High School's *Loading the Barge*, a vibrant tour de force combining the techniques of Impressionism with the drama of the best illustration.

Benjamin Chambers **BROWN** | b. Marion, Arkansas, 1865
| d. Pasadena, California, 1942

Mt. Lowe in Winter (or *Opalescent Morning, Mt. Lowe, California* or *Snow on Mt. Lowe*), 1925
Oil on canvas
30 x 40 inches

Class of Summer 1932

Benjamin C. Brown, one of the earliest Impressionists to settle in Southern California, first won fame as a printmaker and painter of the Altadena poppy fields. He was also generous with his time for the GHS students, who visited him in his studio in Pasadena. On one visit he showed them his collection of etchings; on another he shared the sketches he had made in the High Sierra, which had dabs of paint along the margins as his color guide. He had used these to complete full-sized paintings back in his studio.

Mt. Lowe is located in the foothills above Pasadena. In a letter to Alberta Munro Whitely dated April 20, 1932, Brown said he considered *Mt. Lowe in Winter* one of his best "snow scenes" and had exhibited it at the National Academy

of Design in New York and the Los Angeles Museum. To capture the scene, he "tramped over trails while it was snowing, got wet and cold, and had to stay up there all night in a tent. I was no sooner in bed, than I got severe cramps in both legs—got up three times to rub them out, and finally gave it up and sat up all night in an arm chair smothered in quilts and blankets. So you see, Art has its troubles as well as its joys—but the trouble is hidden and the joy remains—and I hope I have caught some of the beauty of the joyous morning to pass on to others—until time dims the canvas."

Kathryn Woodman **LEIGHTON**

b. Plainfield, New Hampshire, 1875
d. Los Angeles, California, 1952

Chief Bullchild, c. 1928
Oil on canvas
44 x 36 inches

Class of Winter 1932

In 1926 the Great Northern Railroad hired Kathryn Leighton to paint twenty-two portraits of Blackfeet elders, which they used to promote Western tourism in a cross-country tour. At the time, the Blackfeet tribes suffered widespread poverty and deprivation on the reservation, and Leighton sought to record what was left of their vanishing culture. She began to focus on portraits of American Indians, and is said to have accomplished some seven hundred over the years.

The subject of Gardena High School's painting is most likely George Bull Child (b. 1893), son of Chief Bull Child. In 1932, the railroad hired members of the Blackfeet tribe to greet the railroad at its Glacier Park Hotel with ceremonial songs and dances. FDR and Eleanor Roosevelt visited the park in August and were greeted by Chief Bull Child, leading healer and ceremonialist of the Blackfeet, and others.

George Bull Child was a pictograph artist and noted weather dancer who copied the earlier work of tribal artists onto deerskin robes as a means of upholding and recording the traditions of his people. Reservation-born Plains Indians were being torn between two worlds—the traditions maintained by aging warriors and the encroaching modern age. Leighton captures George Bull Child's strength of character as well as the decorative details of his ceremonial headdress or war bonnet, made of eagle feathers, and his fringed buckskin tunic. The Blackfeet adopted Leighton into the tribe and gave her the name "Anna-Tar-Kee" or "Beautiful Woman in Spirit."

62

Max **WIECZOREK**

b. Breslau, Germany, 1863
d. Pasadena, California, 1955

Portrait of Ted Shawn, 1918
Pastel painting on paper
37 x 25 inches

Collection of GHS/LAUSD, Gift of the artist to GHS, 1933. © 2018 LAUSD Art & Artifact Collection/Archive.*

*Ownership subject to dispute by
Gardena High School Student Body.

Max Wieczorak immigrated to New York in 1893 and became head of the design department for stained-glass windows at Tiffany. After moving to Los Angeles in 1908, he embarked on a career as a pastel painter of portraits. Wieczorek was also the founder and president of the Foundation of Western Art; from 1933 to 1945, that Los Angeles nonprofit sought to exhibit a mix of architecture, landscape gardening, furniture, craft, painting, and sculpture. Everett C. Maxwell, the foundation's director, was a former curator of the Los Angeles Museum of History, Science, and Art.

Ted Shawn (1891–1972) was a pioneer of American modern dance. With Ruth St. Denis, he operated the Denishawn school and dance company in Los Angeles from 1915 to 1931; the school launched numerous dancers, including Martha Graham. Graham was a student and

teacher at the school for eight years before starting a career in New York. Shawn went on to found the first all-male dance company in Massachusetts; it evolved into the Jacob's Pillow Dance Company.

Wieczorek's portrait shows Shawn in his military uniform before leaving for active duty during World War I. On the left it reads *Ted Shawn MCMXVII* (Ted Shawn 1918), on the right *Anno Aetatis Suae XVII* (in the twenty-sixth year of his life). The portrait won the California Art Club's William Preston Harrison Prize in 1918. A similar portrait of Shawn by Wieczorek, from the same sitting, is in the collection of the National Portrait Gallery in Washington, D.C.

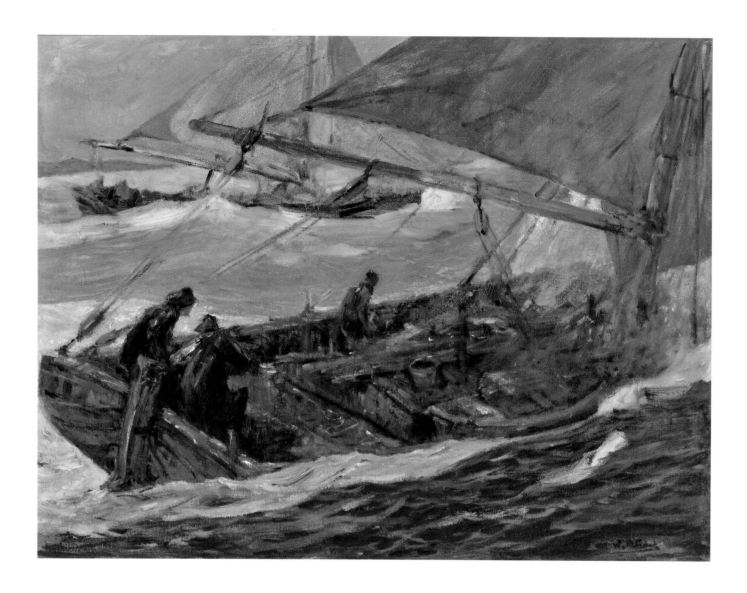

William Frederick **RITSCHEL**, N.A.

b. Nuremburg, Germany, 1864
d. Carmel, California, 1949

Making Port, 1917
Oil on canvas
30 x 40 inches

Class of Summer 1933

William Ritschel's love of the sea started in his youth; he spent several years in the Imperial German Navy before he entered the Academy of Fine Arts in Munich to study art. In 1911, Ritschel moved to Carmel, where he later built a great stone house high on the Carmel Highlands bluffs overlooking the Pacific Ocean. Ritschel had immigrated to New York in 1895, where he launched a very successful national career and was elected a member of both the Salmagundi Club and the National Academy of Design. His marines of nearby Point Lobos drew many artists to California in search of untrammeled nature.

Ritschel had a remarkable ability to convey the many moods of the sea, including dramatic ocean storms. In *Making Port*, two boats are tossed about on the sea, with the shore just visible beyond. Two sailors, wearing protective gear, sit in the stern of one of the boats, working the rudder. The action and intensity in the painting are expressed by the cacophony of small dabs of paint, as well as the layers of short, curved brushstrokes and splashes of white representing the unruly, blue-green waves. Numerous strong, opposing diagonals intensify the dynamic composition and add to the feeling of speed Ritschel achieves: the angle of the booms and orange sails juxtaposed to the sides of the boats and horizon line. The sails in *Making Port* are thinly painted with the canvas showing through, accentuating the power of the sea in man's struggle against nature.

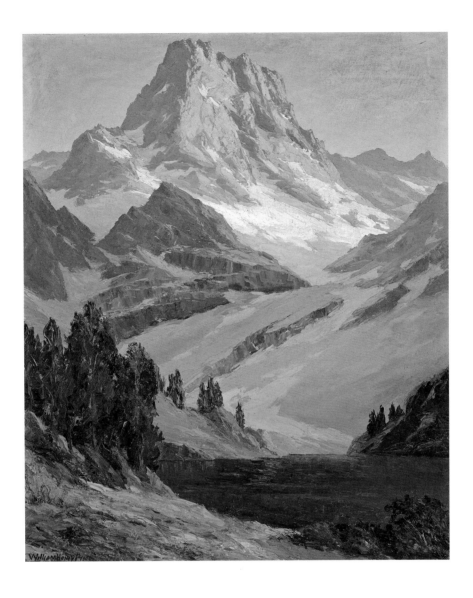

William Henry **PRICE** | b. Irwin, Pennsylvania, 1864 / d. Pasadena, California, 1940

Towering Peaks, Sierras (or *Towering Peaks*), 1933
Oil on canvas
39 x 33 inches

Class of Winter 1933

Artists, both professional and unschooled, proliferated in California during the 1920s, when regional economic prosperity fueled cultural development. William Henry Price moved to Laguna Beach in 1920 at the age of 56. Although he had little formal training, Price advanced quickly, joining numerous art clubs and associations in support of regional artists. He often used a small palette knife instead of a brush, suggesting that he may have closely studied the work of Anna Hills, who was prominent in the Laguna Beach art community. Price had first visited the city in 1910, and later moved there after retiring as manager of mining interests for the Anaconda Copper Company in Butte, Montana.

By 1933, one of the very worst years of the Depression, Price had gained some notoriety. However, the GHS seniors were only able to raise enough funds to purchase one painting that year. It was not until December that the Winter Class was finally able to acquire *Towering Peaks, Sierras*.

Price executed the painting almost entirely using a palette knife, introducing texture and bold color to capture the mass, atmosphere, and majesty of a peak in the Sierra rising above a lake of bright cobalt blue. The mountain casts a cold shadow across the foreground; the sun illuminates the glistening white snow and towering peak. The setting is most likely the Big Pine area on the eastern slope of the Sierra Nevada range.

The New Deal

At the onset of the Depression, the changing economics and culture of the art market left dealers unable to pay their bills or nurture up-and-coming artists. Emerging artists faced an uphill battle to gain recognition and sell their work. One after another, galleries closed. The demand for California plein-air painting all but collapsed, because the economic and psychological climate that supported it had radically changed. In 1933, just as artists' morale had sunk to a

31.
Teachers and staff in the GHS Library, c. 1939.
Collection California State University, Dominguez
Hills.

32.
Stanton Macdonald-Wright. *Topanga Canyon-Santa
Monica for Federal Art Project '37*, 1937. Pencil on
paper. 27 x 22 inches. Collection of GHS/LAUSD,
courtesy of the Fine Arts Collection, General Services
Administration. Macdonald-Wright was district
supervisor of the WPA/FAP for LA County at the time.

new low, President Franklin Delano Roosevelt announced the launch of the Public Works
of Art Program (PWAP), the first of several New Deal arts programs promoting the
production of works of art. (fig. 32)

 This year would turn out to be pivotal for art in Southern California. Recognition
by the federal government that art and artists were worthy of support helped encourage the
Southern California community to support the arts. The PWAP lasted seven months, from
December 1933 through June 1934. The program paid artists and craftspeople from $23.50
to $42.50 a week to create public works of art as well as easel paintings and crafts. As
Arthur Millier wrote, "By taking the simple attitude that artists want both to work and eat,
and that the public needs their contribution to civilization, Uncle Sam has started a real
art movement. Instead of a lot of gush about the 'sweet mystery' and uplifting influence
of art which well fed 'art lovers' have fed to starving artists in lieu of hard cash, Uncle Sam
proffered a modest but regular paycheck."[1] The enormous success of the PWAP led to
other New Deal arts initiatives, with some persisting into the early 1940s.

 However, there was a price to pay for federal government support of the arts.
Under the projects, art became officially committed to themes reflecting the American
Scene. In Southern California, this translated to subject matter that reflected the resources,
industries, and recreational activities of the area as well as historical eras of California.
New Deal murals and easel paintings projected an idyllic image of rural and urban life
during a period when the citizenry suffered severe hardships, the region was being rapidly
transformed, and (by 1932) unemployment stood at 28%. Promoting an upbeat vision
of the California Dream served the vested interests of both federal and local governments

67

seeking to expand their economic and political bases. Committees of the civic elite closely scrutinized most local murals, and censorship was fairly common. Controversies arose over murals and works of art that made social or modernist statements that did not comply with local standards of taste. This situation contributed to a rising split between the modernists and the conservative California Impressionist and Regionalist painters of the American Scene (who employed realistic styles in scenes of rural and small-town life) that would fully erupt in the late 1930s. The conservatives, and the clubs that supported them, such as the California Art Club, would begin to effectively impede the advent of modernism in the region.

Nevertheless, the 1930s marked the first time that Los Angeles' dual history as troubled citadel and sunny paradise became a subject for art. American Scene painters in Southern California asserted the value of everyday life and popular culture, ushering in a greater range of subject matter and points of view. Though many painters continued to celebrate the Southern California landscape, by about 1932, the cohesive view of California as paradise began to fall apart. California Scene watercolor painters like Millard Sheets, Phil Dike, Rex Brandt, and Loren Barton incorporated images of developing modern culture and leisure activities as well as rural culture. Modernist and eclectic approaches to art prevailed. Social Realists, such as Fletcher Martin, Philip Goldstein (later Guston), Reuben Kadish, and Paul Sample, reflected the poverty and cultural diversity of the region in their work. For a brief period in the early 1930s, social concerns were fairly common in murals and works of art by even the most conservative artists as a result of the influence of Mexican School painters visiting California—among them, David Alfaro Siqueiros, who invited artists to assist him with three murals in the Los Angeles area.

Although the 6:30 p.m. dinner at Gardena High School in 1934 still cost 50 cents, according to art critic Arthur Millier, "two hundred Gardenans have paid $1 each to swell the prize money raised by the senior classes."[2] The crowded exhibition included 137 pictures, which were hung on the walls of the library and one classroom. For the first time, Millier had a negative reaction to the show: "One hesitates to voice any criticism of so fine an enterprise. Nevertheless, at least half of the current showing could be thrown out without any artistic loss. The remainder could then be better seen. The crowded pictures would not fight each other so hard. It would be an interesting experiment if Gardena would submit, for one year anyway, to the mercies of an expert jury of selection, in forming the show."[3]

The criticism is ironic in light of the fact that it was Millier who had urged the school to forgo the jury system a few years earlier. However, if a jury had been introduced, as suggested by Millier, it might have served the students and the collection well. A jury of art professionals could have helped the students understand the major transformation of art, nationally and regionally, in the wake of the Depression. The 1934 *Purchase Prize Exhibit* included a handful of artists that were prominent during the Depression era, including Dean Cornwell, Val Costello, Lorser Feitelson, Emil Kosa Jr., Elsie Palmer Payne, Fletcher Martin, and Millard Sheets. The Winter Class purchased Charles L. A. Smith's *Monterey Pines*, a plein-air landscape, and the Summer Class bought Cornwell's *Weeping Over Jerusalem* (or *Jesus Wept*). Cornwell had completed murals for the rotunda of the Los Angeles Public Library and was receiving a lot of national publicity for them—both positive and negative.

The students would collect paintings by other artists whose work reflected themes of the American Scene, including Loren Barton, Robert Clunie, William Spencer Bagdatopoulos, Maynard Dixon, Joe Waáno-Gano, Cornelis Botke, Hugo Ballin, Francis de Erdely, and Christian von Schneidau. But landscapes by prominent artists of the plein-air generation continued to be popular student choices. This may have been a

33.
Charles Bensco, *If Ye Believe*, 1934. Oil on canvas,
50 x 40 inches. Collection of GHS/LAUSD.
Gift to GHS, 1934. © 2018 LAUSD Art & Artifact
Collection/Archive.*

reflection of the advice they were receiving and the works of art offered, but it was also due
to the established direction of the collection under Principal Whitely, as well as to his
ongoing influence.

The seniors' choices probably also had to do with the fact that the paintings in
the collection were part of the students' everyday environment. Incoming seventh graders
viewed the collection with amazement, selecting new favorites year after year until they
were thoroughly familiar with the paintings' subjects, artists, and techniques. By the
time students were seniors, they were endowed with what one observer called "clearness
of judgment and uncanny discrimination . . . in evaluating a painting."[4] Student Mary
Warshaw reminisced about her experience of living with the collection from seventh
through twelfth grades:

> Our library, a beautiful brick building with stained glass . . . housed part of
> the collection and I spent many hours looking at the work. From the library I
> remember Dean Cornwell's large painting *Weeping Over Jerusalem* and Maynard
> Dixon's *Men of [the] Red Earth*. Most of the paintings were housed in the
> auditorium where at 11 o'clock everyone met once a week. Those pieces have also
> been etched in my memory: a whole series of California coastlines, wildflowers,
> mountains, gray dawns, and eucalyptus swim through my mind as I remember
> the times I daydreamed in those frames.[5]

In 1934, four additional paintings and six works on paper entered the collection,
presented as gifts from the Public Works of Art Project of the Fourteenth Regional
District. The oil paintings were Edgar Payne's *The Sierra Trail*, Don Smith's *Cats at Play*,
William Frederick Foster's *Girl in Brown*, and Charles J. Bensco's *If Ye Believe*. (fig. 33)
While the directors of the PWAP in Southern California had arranged for murals to be
painted in many regional high schools, this was not the case in Gardena. It seems fitting
that the project decided to add paintings to the permanent collection instead. Directors
of the Fourteenth Regional District committee included art critic Arthur Millier, artist

69

*Ownership subject to dispute by
Gardena High School Student Body.

Gardena Art Association Banquet, 1935. Photo by
Churchill Gardiner Studios.

and lecturer Louis Danz, sculptor Merrill Gage, artist Millard Sheets, and dealer Dalzell
Hatfield. All were close friends and supporters of the GHS Art Collection project and were
charged with allocating all project artwork to eligible tax-supported public institutions.[6]
Unfortunately, there is no documentation of the names of the six works on paper donated
by the PWAP.

1935

In 1935, the Superintendent of Schools canceled the art exhibit, causing a cloud of
disappointment to hover over the school and the community. The continuance of the
program was in serious doubt due to financial difficulties (and other, unnamed problems)
that needed to be resolved with the approval of the Los Angeles school board. As a result,
in order to perpetuate the program, the Gardena Chamber of Commerce named a special
committee charged with maintaining the exhibit as an annual affair. The Gardena Art
Association became a permanent organization headed by Mrs. P. E. Hennis. (fig. 34)

Almost a month after the school board scrapped the exhibition, it was reinstated.
This led to a flurry of last-minute arrangements during Easter vacation. The eighth annual
Purchase Prize Exhibit included 114 paintings. Five hundred people attended the annual
dinner, and fifty artists were expected to be among them. Roscoe Shrader, president of the
California Art Club, a member of the progressive American Artists Congress, and head of
Otis Art Institute, was the toastmaster, and Allan Bennett, Chairman of the Art Committee
of the newly founded (in 1933) Los Angeles Art Association, was the principal speaker.
Otis Art Institute and the Los Angeles Art Association, situated next to each other in
Westlake Park, were both positive forces for modern art in the region. The list of invited
artists may have been more carefully engineered following Millier's complaints the
previous year. According to an ambiguous note in the *Gardena Valley News*, "The paintings
this year have been more carefully selected as to types, and therefore present a more
varied exhibit of particularly good work of each type."[7] This remark suggests an attempt to
balance conservative landscapes with more modernist approaches. There was to be only
one purchase this year.

The *Los Angeles Times* revealed the students' selection method, whereby the "choice of the painting to be bought is made by a series of votes of the class following long discussions as they sit and look at the canvases. The number is reduced to twenty and then to ten and then to five and so on until the prize winner alone remains."[8] According to alumnus Roy Pursche, art teacher Adele Lawrence "would give you the pros and cons of each picture, but it was up to us to make the final decision. As far as I know, there was no electioneering by anyone."[9] Of course, the students did not always agree on the prizewinners. The boys of the senior class this year preferred Duncan Gleason's *Head Winds* (or *Storm at Sea*), while the girls chose Theodore N. Lukits's still life with a Della Robbia Madonna. The boys won.[10]

1936

In 1936, the permanent collection comprised thirty-three paintings purchased by the students, the gift from Max Wieczorek, and the ten paintings and watercolors acquired through the Public Works of Art Project. This year, the Gardena Board of Education and the Works Progress Administration, another federal art program, donated four oil paintings and twenty-nine watercolors to the GHS collection, to be hung in classrooms.[11] Unfortunately, no existing documents name these works of art.

The students assembled the bulk of the 117 paintings for the annual exhibition, accompanied by Principal Whitely. One group went to Pasadena to collect works at the Vista del Arroyo Hotel Gallery, the Carl F. Smith Gallery, and the homes of Marion Wachtel and Jean Mannheim. The students' last stop was the California Art Club, at Vermont and Hollywood boulevards in Los Angeles, where they had lunch. Another group of students took the truck the following day to make pick-ups at Royars Art Center, Barker Brothers, the Biltmore Hotel, and Stendahl Art Galleries.[12] As was to be expected with inexperienced students doing all the work, some mishaps occurred along the way. Former student Pete Radisich reminisced that Whitely sent him to downtown Los Angeles to collect one of the 1934 prize winners in the school's old pickup truck. Although Radisich said he was driving at only 35 m.p.h., the painting flew out of the truck.[13]

The *Purchase Prize Exhibit* opened on April 14 with Frank Tenney Johnson, president of the California Art Club, as toastmaster. Forty artists were present for the spring preview dinner event. The students collected five hundred dollars for two paintings,

35.
A corner of the 1936 art exhibit. Courtesy of the City Clerk's Office, City of Gardena.

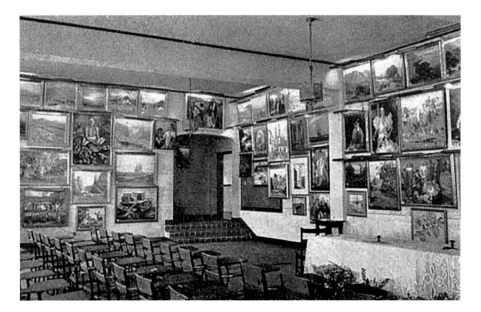

36.
Cover of the catalogue of the permanent collection, written by Lorenna Vanderlip Keliher in 1936. Courtesy of the City Clerk's Office, City of Gardena.

assisted by the Gardena Art Association, which donated the proceeds of the dinner toward the paintings. The annual exhibition, hung in the study hall and library, was on view from April 14 to 28. (fig. 35) Students purchased Walter Elmer Schofield's *Cornish Inn* (Summer Class 1936) and Robert Clunie's *River Dwellers* (Winter Class 1936).[14]

In 1936, Lorenna V. Keliher, a member of the English Department faculty, created a commemorative book of the permanent collection with biographies of the artists. (fig. 36) A "revised, improved volume" printed by the students, containing reproductions of all the paintings and a biography of each of the artists, was published in 1937.[15]

1937

The *Los Angeles Times* announced the opening of the tenth annual *Purchase Prize Exhibit* with an article and a reproduction of two works of art in the show, *Hay Wagon—Corona*, by Barse Miller and *Matilija Poppies*, by Nell Walker Warner. The article also mentioned that *The Cowboy*, by Frank Tenney Johnson, was a favorite. The exhibition of 114 paintings was said to have a wide range of styles.[16] Johnson, who was still president of the California Art Club, again served as toastmaster. A short list of artists who attended the dinner, published in the *Gardena Valley News*, included Roger Noble Burnham, Arthur F. Beaumont, Clyde Forsythe, Duncan Gleason, Theodore Lukits, and Evylena Nunn Miller.[17] The brevity of this

37.
Jean Mannheim. *Portrait of Mr. John Henry Whitely*, 1938. Oil on canvas, 44 x 34 inches. Collection of GHS/LAUSD. Gift of Gardena Art Association to GHS, 1938. © 2018 LAUSD Art & Artifact Collection/Archive.*

list might signal that the Los Angeles art community was no longer a strong supporter of the exhibit. More likely, however, the dinner had become less of an event for artists and more of a social event for Gardena Valley's clubs and civic organizations.

The *San Bernardino Daily Sun* lauded Gardena's practice of buying paintings from artists instead of seeking donations: "When the schools go in for art they waste no time talking about art and its high and holy mission for the uplifting of soul—you have all heard that line—they get down to business on a business basis. And what's more they don't ask the artists to give away paintings to further art appreciation. They buy them—and that is after all, the only way to further the real appreciation of art."[18] However, the Summer Class had raised only $250, and the Winter Class only $150. *Matilija Poppies*, by Nell Walker Warner and *Hay Wagon—Corona,* by Barse Miller—one of the artists submitting paintings for the first time this year—were the students' first choices, but the artists refused to part with them for the small sums the students could offer. The senior students' gifts this year were Frank Tenney Johnson's *The Cowboy* (or *Lengthening Shadows*) (Summer Class 1937) and H. Raymond Henry's *The Storm King* (Winter Class 1937).

1938

In 1938, Principal Whitely retired and was temporarily replaced by Dr. Raymond E. Pollich, who had been Assistant Superintendent of Elementary Education and would become principal of Venice High School following his brief tenure at GHS.[19]

More than 550 people attended the opening dinner of the eleventh *Purchase Prize Exhibit*. Mayor Wayne A. Bogart and Roscoe Sevier, president of the Gardena Art Association (now a group of 277 "citizen-members"), referred to the annual as "the city's 'most outstanding event'" and testified to the cultural value that the study of the pictures added to civic life. Faculty and friends presented Jean Mannheim's portrait of Principal Whitely to the collection, with Mannheim on hand to speak about it.[20] (fig. 37) He had unveiled the painting earlier to faculty members in a special reception held in his studio.[21] The other speaker, sculptor Roger Noble Burnham, had the role of wittily introducing the

73

artists as master of ceremonies. He divided the audience into four groups: those being educated, those doing the educating, those who have been educated, and the artists.[22] Burnham was a prominent Los Angeles artist, well known as the sculptor of USC's Tommy Trojan statue and for the "Burnham Salon" he held in his home, attended by artists and community members, including Principal Whitely.

During the run of the exhibit, Whitely introduced an annual evening event to promote the understanding and appreciation of art, including lessons in how to analyze and judge a painting's merits.[23] He had provided direction since the founding of the program in 1919 and was clearly unwilling to give up his influence. It probably contributed to the students' avoidance of modernist trends and continued interest in collecting California Impressionist painting long after its prominence in the art community had waned.

After the Shower, Cuernavaca (or *Cuernavaca*), by Alson Clark (Winter Class 1938) and *Along the Slope* (or *Moose in Cut Timberland*) by Carl Rungius (Summer Class 1938) were the seniors' purchases. The *Gardena Valley News* noted that this was the first year Clark had submitted a work to the exhibition and that *After the Shower* was the students' second choice. They had selected Charles Bensco's *Memory Stays My Hand*, but the artist was unwilling to accept the comparatively small sum allotted for the painting.[24] Bensco has been all but forgotten by the history of art except for the notoriety he gained as president of the Society for Sanity in Art, founded in Los Angeles in October 1939 to oppose all forms of modern art. Clark continues to receive critical acclaim for his plein-air Impressionist paintings.

In 1938, the GHS Art Collection, which had been acquired over the years at a cost of about eight thousand dollars, was appraised at thirty-five thousand dollars (an equivalency today of about $587,000.)[25] Ernest Dawson of Dawson Book Store in Los Angeles donated ancient illuminated medieval manuscripts, a copper engraving, and lithographs to the school this year. Dawson had previously made generous donations to George Washington and Los Angeles high schools.[26]

1939

Frank X. Goulet, previously at Bell High School, became principal of GHS in September 1939. Years later, Goulet, who was an amateur artist, noted that the *Purchase Prize Exhibit* served as a unifying force in Gardena. "When I first came to Gardena I found something new to my experience," he said, "a school centered community. Picking up the *Valley News*, I found never less than 12 to 20 items dealing with the high school."[27]

In 1939, Gardena High School assembled a traveling exhibition of works from the school's permanent collection, the start of an era during which the collection entered the public realm to a greater extent. The impetus was a request from Pedro Joseph de Lemos, Stanford University Museum Director and Curator, for a loan of the collection. De Lemos called it "one of the outstanding art projects of school and community in the United States." The exhibition at Stanford opened during commencement exercises in June and remained at the university gallery through the summer.[28]

In February 1940, twenty-four paintings from the collection were placed on view at the Friday Morning Club in Los Angeles. In November, a selection of twenty-five works traveled to Los Angeles City Hall at the invitation of the Municipal Art Commission.[29] *The Los Angeles Times'* February 2, 1941 "Exhibits" column listed another show at the Friday Morning Club of paintings from the "Gardena High School permanent collection," on view to March 31.[30] In 1942, sixteen paintings from the collection traveled to Fisher Gallery at USC, where they were displayed from about August 9 to 27. The paintings USC borrowed were by Ralph Davison Miller, Jack Wilkinson Smith, Edgar Payne, William Wendt, Franz

Bischoff, Carl Oscar Borg, Benjamin C. Brown, Dan S. Groesbeck, Carlo Wostry, Kathryn W. Leighton, William Ritschel, Robert Clunie, Don Smith, C. Thompson Pritchard, Carl Rungius, and Emil Kosa Jr.[31] The inclusion of the Smith painting, a gift of the Public Works of Art Project, shows that donated works of art were considered part of the school's permanent collection.

At the twelfth annual *Purchase Prize Exhibit*, Principal Goulet introduced retired Principal Whitely as a special guest. Goulet commended girls' Vice Principal La Veta Crump, who had assumed some of Whitely's former organizational duties, for making the exhibit a success. A separate room was set aside this year to show the sizable group of watercolors that had been sent to the exhibition—a sign of the times, since watercolor was the medium of choice for many Regionalist artists in Southern California throughout the 1930s and early 1940s. The dinner speakers were Ralph Holmes, president of the California Art Club, and May Gearhart, former Art Supervisor of the Los Angeles city schools. Gearhart was also at the center of a circle of Southland printmakers influenced by the Arts and Crafts Movement; her Pasadena home was its headquarters.

Gearhart stated, "This is an occasion to give us heart that we are going in the right direction." She went on to say that she believed in the contribution of art to democracy and to life "in these troubled times." She said that she had been asked many times about the GHS art exhibit while traveling on the East Coast the previous summer and about "that man Whitely," who could start such a thing in a school and keep it going. According to Gearhart, GHS was known throughout the nation.[32] Gearhart's sober message of democratic ideals and hope stood in stark contrast to a persistent thread of anti-modernism that began in 1939 with the founding of the Los Angeles branch of the Society for Sanity in Art. The original group had been founded three years earlier by Josephine Logan, a Chicago socialite, as a haven for traditional styles.

American Scene painting was falling out of critical favor, associated with a narrowness of scope and isolationism at a time when fascism was on the rise in Europe and there was an increasing threat of war. Although some California Scene painters retained their Regionalist style, new developments in American art were on the rise. European émigré artists escaping World War II were transforming the Los Angeles art scene with work that reflected international artistic movements. Conservative painters in Los Angeles—many of whose works were in the GHS collection—banded together in the 1940s to protest the encroachment of modernism in exhibitions, equating it with radical ideas and communism. They joined the Society for Sanity in Art and attempted to impede the growth of modernism by picketing exhibitions, giving radio interviews, and initiating letter-writing campaigns. In 1950, conservative Los Angeles artists would form an umbrella organization, the Coordinating Committee for Traditional Art. According to its president, Charles Bensco, the group aimed to "restor[e] American art back to American artists of American conceptions."[33] Many of the artists selected by the students at GHS—including Joe Duncan Gleason, Will Foster, Edgar Payne, William Ritschel, James Swinnerton, Armin Hansen, Leland Curtis, and Sam Hyde Harris—exhibited with this group.

The student body purchases this year were Clyde Eugene Scott's *Mirror of Summer* (Winter Class 1939) and Armin Hansen's *Before the Wind* (Summer Class 1939).

1940

The 1940 census showed the population of Gardena to be just under six thousand residents. As a result of the increased involvement of the community in the planning, organization, and implementation of the exhibit, numerous leaders of civic organizations made remarks at the annual dinner. This caused it to run until 10:00 p.m. in 1939, leaving

little time for weary guests to visit the *Purchase Prize Exhibit* in the study hall—the primary reason for the evening. In 1940, an attempt was made to limit remarks at the dinner, which drew a crowd of five hundred people. Yet there were many speeches, beginning with Principal Goulet's tribute to former Principal Whitely. Goulet also thanked his "right hand man" and advisor to the art exhibit, girls' Vice Principal La Veta Crump. Art critic Arthur Millier presented the artists in attendance. Ralph Holmes, president of the California Art Club, was the main speaker. Mayor Wayne A. Bogart, the twelfth person to be introduced (with many to follow), stated that "in [his] opinion, the requests from noted groups outside of the City of Gardena to borrow pictures from the local collection for exhibition in their galleries was the finest kind of publicity for the city."[34]

It seems that once the *Purchase Prize Exhibit* became a community event, the banquet was largely geared toward the civic groups rather than the school or the artists. Over the years, fewer and fewer artists made the trip to Gardena for the annual dinner. The ones who did attend probably enjoyed rubbing shoulders with the city elite or hoped to garner a future sale. Organizing the annual exhibitions within the civic realm would have other unforeseen consequences. During the late 1940s and early 1950s, the art on view would reflect little or no postwar angst or the philosophical introspection of the Cold War. The exhibitions featured no avant-garde modernist works or outright political expressions, and none of the artists would be associated with leftist causes. Perhaps this circumspect approach was to be expected at a high school. And to be fair, there were few exhibitions of avant-garde art in Southern California galleries and museums before 1945.

The students had enough funds to purchase three paintings this year, allowing for a change in the method of selection that was instituted in 1923. For many years, the graduated Winter Class had been called back to the school to vote on a painting that would be acknowledged retroactively as their class gift. From now on, the Summer Class graduating in June and the Winter Class graduating in January of the following year would vote together. As noted in the *Gardena Valley News*, "From this time on, then, the two classes still in school will be the purchasing groups, and thus each will have a picture for presentation at the graduation ceremonies." To streamline the process, based on comments from students, the faculty selected ten paintings they believed to be the favorites. They were required to be by California artists not already in the collection, necessitating the elimination of "some fifteen of the outstanding pictures from first consideration."[35] It is not known whether this was the first year the purchase prize was governed by this rule; beginning around 1943, it became the norm. Generally, although the students voted on their class purchases, they were not able to pay the artists until all the fundraising activities were completed.

The Winter Class of 1940 selected William Spencer Bagdatopoulos's *Drought* (or *Taos Indian*); the Summer Class of 1940 chose G. Thompson Pritchard's *Nearing Home* (or *Brothers to the Ox*). Both artists were prominent veterans of the film industry, reflecting the growing influence of Hollywood in Los Angeles. The Winter Class of 1941 selected Peter Nielsen's *Sierra Alta*.

Clearwater Junior High School, in Paramount, California, asked former Principal Whitely to act as master of ceremonies for their annual dinner and exhibition as a tribute to him and GHS for inspiring their own collecting tradition, then in its seventh year.[36]

William Frederick **FOSTER**, A.N.A. | b. Cincinnati, Ohio, 1883 / d. New York City, New York, 1953

Girl in Brown, c. 1930
Oil on canvas
51 x 36 inches

Collection of GHS/LAUSD, Gift to GHS, 1934. © 2018 LAUSD Art & Artifact Collection/Archive.*

*Ownership subject to dispute by Gardena High School Student Body.

In 1930, Will Foster was voted an Associate of the National Academy of Design in New York as recognition for his painting *Girl in Brown*. A prolific painter of portraits and nudes, Foster began his career during the Gilded Age in New York as an illustrator. He had studied with some of the greatest portrait and figure painters, Frank Duveneck, Robert Henri, and William Merritt Chase, learning to paint formal portraits of smartly dressed and coifed woman in the academic manner. Foster was on the jury of selection for the National Academy's winter exhibition in 1932; he moved to Los Angeles soon thereafter.

In *Girl in Brown*, Foster shows his subject in a three-quarter-length portrait format in profile. Although the artist's focus is on effectively interpreting various textural qualities, he also captures the subject's moody beauty and quiet poise. According to Foster's biographer, Phyllis Settecase Barton, the sitter was Foster's estranged wife, Audrey Marye. Dressed as she is in turn-of-the-century attire, and given that the couple had long been separated by 1930, questions arise as to the date of the painting's completion.

The *Gardena Valley News* reported on May 17, 1934, that *Girl in Brown* entered the GHS collection soon after it was included in an exhibition at the Los Angeles Museum of works by Southern California artists on the Public Works of Art Project. The Fourteenth Regional District committee of the PWAP presented it as a gift to the school, along with many other works of art.

Edgar Alwin **PAYNE**
b. Washburn, Missouri, 1883
d. Hollywood, California, 1947

Sierra Trail, c. 1932
Oil on canvas
40 x 50 inches

Collection of GHS/LAUSD, Gift to GHS, 1934. © 2018 LAUSD Art & Artifact Collection/Archive.*

*Ownership subject to dispute by
Gardena High School Student Body.

Edgar Payne lived in near-constant motion, traveling throughout Europe and the United States, and camping out in the High Sierra and other remote locales untouched by civilization.

Evelyn Payne Hatcher was along on the trip during which her father painted *Sierra Trail*. She recalled the arduous expedition in an interview at California State University, Dominguez Hills, in 1999: "It took a good amount of time to get across the Mojave Desert. We followed two ruts in the sand, the only path we had. It took three days just to get to the Owens Valley. I remember on occasion having to put sagebrush under the tires of our automobile so we wouldn't get stuck in the sand." To ascend into the mountains, they loaded their packs on horseback. The painting,

perhaps a sort of self-portrait, evokes the myth of the Western cowboy, with its adventure and daring.

Payne exhibited *Sierra Trail* at Gardena High School in the 1930 annual Purchase Prize Exhibit, but it was not selected as a class gift. In 1934, the regional directors of the Public Works of Art Project of the Fourteenth Regional District, charged with allocating all project artwork to eligible tax-supported public institutions, donated the painting to the school collection.

Donald Richard **SMITH** | b. Cambridge, Massachusetts, 1908
d. Torrance, California, 1999

Cats at Play, 1934
Oil on canvas
50 x 40 inches

**Collection of GHS/LAUSD, Gift to
GHS, 1934. Courtesy of the Fine
Arts Collection, General Services
Administration.**

Don R. Smith attended the Art Students League
in Los Angeles for six years, studying with the
modernist greats Stanton Macdonald-Wright,
Morgan Russell, and Lorser Feitelson. *Cats at
Play* is a brilliant example of the philosophy
and approach that arose at the League under
Macdonald-Wright's influence. Art historian Julia
Armstrong-Totten writes, in *A Seed of Modernism*,
that an East-West fusion style emerged at
the school, due in part to the many Japanese
Americans who studied there. It combined design
and motifs derived from Asian precedents with
Macdonald-Wright's high-keyed Synchromist
color theories.

Lorenna K. Poulson's description of the painting
in her 1936 catalogue of the GHS collection
illustrates the sophisticated approach to art

appreciation imparted to students at GHS.
"*Cats at Play* by Don R. Smith, is modernistic in
arrangement, decorative in design, and painted
in colors of vibrating intensity. The figures of
the girl and the cats dominate the picture, with
a background done in greens, richly varied,
contrasted with purple and black. The clouds are
infinitely remote with the sky showing luminosity."
On 17 May 1934, the *Gardena Valley News* reported
that *Cats at Play* entered the GHS collection
soon after it was included in a Public Works
of Art Project exhibition at the Los Angeles
Museum of works by Southern California artists.
The committee of the PWAP of the Fourteenth
Regional District presented it as a gift to the
school, along with numerous other works of art.

Dean **CORNWELL**

b. Louisville, Kentucky, 1892
d. New York City, New York, 1960

Weeping Over Jerusalem (or *Jesus Wept*), 1928
Oil on canvas
34 x 46 inches

Class of Summer 1934

The celebrated illustrator Dean Cornwell visited the Holy Land to research his contributions to *The Man of Galilee: Twelve Scenes from the Life of Christ*, published by Cosmopolitan Book Corporation in 1928. *Weeping Over Jerusalem* portrays Christ's withdrawal, recorded in Matthew 23:37–39, to a hill overlooking Jerusalem a few days before the Crucifixion. According to the book of biblical stories, previously serialized in *Good Housekeeping*, "Jesus looked below him into the valley and across at the temple. For weeks he had planned every detail of his entrance. And now, when it was working out according to the plan—at that strange moment—Jesus wept."

Weeping Over Jerusalem is richly colored and teeming with figures and detail. While exhibiting some of the exaggerated stereotypes and stock poses of Cornwell's illustrations, it is also luxuriously painted, juxtaposing flat, abstract design in the background with the expressive figures of Christ and the Pharisees on the hill.

Renowned in Los Angeles at the time, Cornwell had a contract with Cosmopolitan worth $1,350,000 in today's dollars. His first mural commission, completed in 1933 for the rotunda of the Los Angeles Library shortly before the GHS purchase, had generated considerable national publicity. GHS students had attempted to buy another painting from the series in 1930 but couldn't afford it. When they saw *Weeping Over Jerusalem* in the Biltmore galleries, they contacted Cornwell by telegram in New York to ask if he would accept $300 for the $1,200 painting, and he agreed.

Charles L. A. **SMITH** | b. Auburn, Michigan, 1871
d. Los Angeles, California, 1937

Monterey Pines, 1934
Oil on canvas
39 x 46 inches
Conservation funded by the W. M. Keck
Foundation

Class of Winter 1934

On April 26, 1934, the *Gardena Valley News* reported that the Winter Class had selected *Pyramids of the Desert* by Charles L.A. Smith as their purchase. However, at around that time, one of the prizewinners flew out of the GHS truck after a student picked it up in Los Angeles. That canvas must have been *Pyramids of the Desert*, and *Monterey Pines* must have been its replacement.

Monterey Pines shows a road leading through the pine and cypress forest of Pebble Beach down to the shoreline, where Samuel F.B. Morse had opened a golf course in 1925. The narrow road, dappled with sunlight, leads the eye of the viewer through an allée formed by the branches of a cypress tree. Sand traps and golfers are framed

in the distance, with the lavender and blue of the Pacific Ocean behind. A blue sky filled with buoyant clouds lightens the composition and is in contrast to a shadow-filled foreground, patterned with streaks of color but largely devoid of detail.

Smith settled in Los Angeles around 1918, having come from Chicago, where he had established a studio and exhibited at the Art Institute. He was largely self-taught but had studied in Boston with the prominent portraitist John Singer Sargent and with John Enneking, who was adept at Tonalism and Impressionism. Smith brings all that to bear in *Monterey Pines*, as well as an early modernist sensibility that was current in Los Angeles during the 1930s.

George Thompson **PRITCHARD**

b. Havelock, New Zealand, 1878
d. Reseda, California, 1962

Where East is East, c. 1935
Oil on canvas
30 x 36 inches

**Collection of GHS/LAUSD, Gift of the
Faculty to GHS, 1935. © 2018 LAUSD Art
& Artifact Collection/Archive.***

*Ownership subject to dispute by
Gardena High School Student Body.

Little is known about George Thompson
Pritchard's early years other than that his art
studies took him from Elam School of Art
in Auckland to the Academy of Fine Arts in
Melbourne, Australia. After spending three years
in San Francisco, he settled briefly in Los Angeles
around 1909 and exhibited at the Kanst Art
Gallery. He then left for Europe and studied at the
South Kensington School of the Royal College of
Art in London, at the Académie Julian in Paris,
and in Amsterdam. He lost his right arm in a
work-related accident in London and subsequently
learned to paint with his left.

Pritchard resettled in Los Angeles around 1934.
He showed thirty paintings at the Frances Webb
Galleries in 1935 that documented his world
travels, including Holland, Belgium, France, Great
Britain, the northeastern United States, and China.
It may be that *Where East is East* came out of that
exhibition, as the GHS faculty made a gift of the
painting to the school in that year.

Pritchard's *Where East is East* is spectacularly
colored with various shades of warm gold, with
combinations of cool blue creating depth and
atmosphere. His lively brushwork and dabs of
color further enliven the composition and give
a sense of movement appropriate to the busy
street scene in Shanghai, while showing he was
well versed in French Impressionism. The title of
Pritchard's colorful Asian street scene alludes to
the 1929 film starring Lon Chaney, one of the last
silent black-and-white films to be made.

Joe Duncan **GLEASON** | b. Watsonville, California, 1881
d. Glendale, California, 1959

Head Winds (or *Storm at Sea*), c. 1935
Oil on canvas
30 x 40 inches

Class of Summer 1935

After J. Duncan Gleason won the first purchase prize in the high school's eighth annual exhibit, a reporter for the *Gardena Valley News* wrote that Gleason "considered *Head Winds* to be his best ship painting. It is a strong and vigorous painting, with shades of brilliant blue dominating the background, of sailors on a ship fighting the terrific winds and waves." The view is from above and to the side of the ship, looking down on the bow—probably an impossible perspective unless you were hanging from the yardarm, highly unlikely in rough seas. The heightened angle allows the viewer to see the action in the ship and on the bowsprit. As the crew struggles to secure the sails and the ship pitches back and forth, water gushes from the deck; more waves loom in the distance. *Head Winds* presents us with one of the most dramatic moments a sailor can face, but we sense that all is under control and that these sailors will survive in the face of nature's awesome power.

A native Californian raised in Los Angeles, Gleason worked as an illustrator in New York for several years before returning to the Southland in 1914. An intrepid traveler and sailor, Gleason also worked for the Hollywood studios on films whose plots involved sailing and clipper ships, including Cecil B. DeMille's *The Yankee Clipper* (1927) and Warner Brothers' *Captain Blood* (1935).

Elanor Ruth Eaton Gump **COLBURN** | b. Dayton, Ohio, 1866
d. Laguna Beach, California, 1939

Gold—The New Era, c. 1934
Oil on canvas
60 x 96 inches

Collection of GHS/LAUSD, Gift to GHS, c. 1936. © 2018 LAUSD Art & Artifact Collection/Archive.*

*Ownership subject to dispute by
Gardena High School Student Body.

Elanor Colburn's *Gold—The New Era* celebrates the ascending importance of the aerospace industry to Southern California's economy beginning in the 1930s. Although the federal government introduced several social programs to thwart the ravages of the Great Depression, it was new commerce that really helped lift the economy. The new industry was spurred on tremendously by the Army Air Corps' mandate to rapidly upgrade its firepower in the face of Germany's domination of Europe and the looming threat of World War II. Economic studies have shown that the 1933 suspension of the gold standard also helped the country's recovery.

Colburn's small mural, most likely produced under the Public Works of Art Project, is structured as a three-part narrative. In the middle, a woman holding a baby looks left toward images of a gold mining camp—in other words, she looks to the past. A man holding a pickax gazes right, toward airplanes, clouds, and a metal truss structure emblematic of the new materials and technologies being used in the aircraft industry. He looks to the future—though he still has one foot in the past. Colburn further accentuates the division between the past and future by introducing a vertical gold line (referring to the gold era) and a vertical black line (referring to the metal used in airplane construction) to divide the canvas. Like gold prospectors drawn to northern California in search of riches, new pioneers were attracted to the Southland by the prospect of employment in the aerospace field. Colburn's *Gold—The New Era* is right on the money in capturing two of the main economic drivers that have shaped California.

STAN POCIECHA PORAY
1936

Stanislaus Pociecha **PORAY** | b. Krakow, Poland, 1888 | d. New York City, New York, 1948

Kuan Yin and Lama, 1936
Oil on canvas
48 x 40 inches

**Collection of GHS/LAUSD, Gift to
GHS, c. 1936. © 2018 LAUSD Art & Artifact
Collection/Archive.***

*Ownership subject to dispute by
Gardena High School Student Body.

Stan Pociecha Poray was raised in Poland; his father, Count Michael Poray, was a landscape painter. Stan studied at Krakow's Academy of Fine Arts and in Paris. In flight from the Russian Revolution, he immigrated to Los Angeles in 1921; there he designed and built a home whose interior was based on a Japanese temple. Poray collected objects from a range of cultures for use in his still lifes, but he was especially interested in Japanese, Chinese, and Tibetan culture.

The Thirteenth Dalai Lama had died in 1933. With increasing instability in Tibet caused by the absence of a Dalai Lama—the nation's spiritual and political leader—coupled with the threat of a Chinese takeover, the period before the identification of a new Dalai Lama was full of uncertainty. *Kuan Yin and Lama* features a statue of Kuan Yin, the Buddhist goddess of compassion; a Chinese vase; and a *jia*, or Chinese ritual vessel. The painting behind is Tibetan, one that Poray would have had in his collection. In the painting, Kuan Yin, "she who hears the cries of the people," makes the hand gesture called the Shuni mudra, which symbolizes patience and discipline. It is possible that Poray's sumptuous *Kuan Yin and Lama*, completed in 1936, symbolized his wish for the Tibetan people that the new Dalai Lama be discovered soon and that patience would prevail in the interim. In 1937, the Fourteenth Dalai Lama—the current spiritual leader of the Tibetan people—was found.

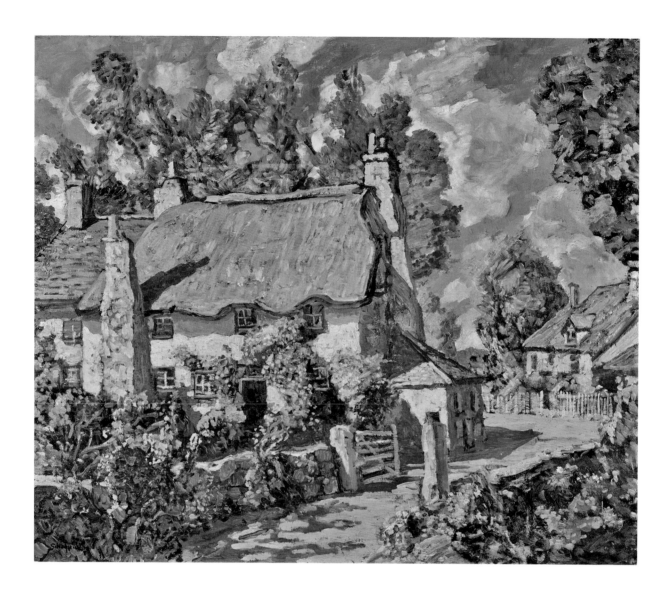

Walter Elmer **SCHOFIELD** | b. Philadelphia, Pennsylvania, 1866
| d. Cornwall, England, 1944

Cornish Inn, c. 1929
Oil on canvas
30 x 36 inches

Class of Summer 1936

A central figure in the broader development of American Impressionism, Elmer Schofield enjoyed a truly international reputation. According to a label on the back of *Cornish Inn*, Grand Central Art Galleries in New York exhibited the painting in December 1929. It depicts Ipswich Village, a coastal fishing village in Cornwall, a county in South West England. The wild moorlands, rocky coastline, clusters of cottages, and mild climate made Cornwall Schofield's primary painting location. He lived there half of the year from 1901 onward, first taking up residence in St. Ives. In *Cornish Inn* the Impressionist influence is evident in the construction of the picture plane through the buildup of masses of color infused with brilliant light.

Schofield's first two-year sojourn in California began in 1928 with a visit to his friend George Gardner Symons. They exhibited together at the Stendahl Galleries in March; critic Arthur Millier commented in the *Los Angeles Times* that "their reputation is very well-founded on a type of landscape painting, broad, solid, flashing with light, that is typically American." They exhibited together there again the following year, and attended the opening ceremony of the new Laguna Beach Art Association building in 1929. Schofield was in Los Angeles again from 1934 to 1936, and briefly in 1937, exhibiting and teaching landscape painting out of the Stendahl Galleries. One wonders if he was among the forty artists that attended the 1936 banquet and *Purchase Prize Exhibit* at GHS. The *Gardena Valley News* noted that Earl Stendahl was in attendance.

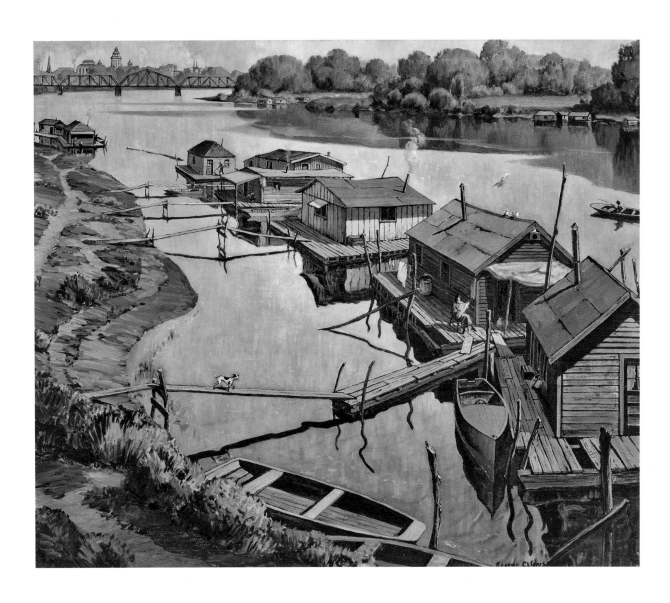

Robert **CLUNIE**

b. Eaglesham, Scotland, 1895
d. Bishop, California, 1984

River Dwellers, 1936
Oil on canvas
36 x 42 inches
Conservation funded by the Historical Collections
Council of California

Class of Winter 1936

Robert Clunie's view of river dwellers is a light-hearted portrayal of life on the Saginaw River in Michigan. Clunie grew up in Saginaw after moving to the United States from Scotland, but he relocated to Santa Paula in 1920 and lived there until 1945. His Saginaw paintings, made on return trips to Michigan, won several awards, including first prize in the 1937 Academy of Western Painters Exhibition.

River dwellers floated on rafts along the Saginaw riverbank, fastened to the shore. The practice had begun in the 1850s, when houseboats provided food during lumber drives. Descendants of the French-Canadian lumber drivers began building homes on the river in the late 1920s; during the Depression, colonies of river dwellers clustered near the bayous along Ojibway Island, next to the

Center Street Bridge, behind City Hall, and along the shores of the city's south side.

Photographs of the river houses taken during the 1930s reveal that Clunie's painting does not depict the river dwellers' extreme poverty. Instead, he represents the reflections on the gleaming river, the railroad bridge, and the city in the background, as well as the wooden boats and walkways to the houseboats, while creating a positive narrative of a leisurely life. A woman reads a newspaper in the morning sun, while her little dog prances toward her across a wooden plank. It is a classic Regionalist painting, showing the sunny side of the American dream, which was the main mode of representing national culture at the time.

Frank Tenney **JOHNSON** | b. Big Grove, Iowa, 1874
d. Los Angeles, California, 1939

The Cowboy (or *Lengthening Shadows*), c. 1936
Oil on canvas
28 x 36 inches

Class of Summer 1937

Frank Tenney Johnson was considered the foremost painter of the west in his day, known for his scenes of the Santa Fe Trail bathed in the romance of moonlight or set at twilight. He was born on a farm beside the Overland Trail near Council Bluffs, Iowa, at a time when covered wagons and stagecoaches were still heading west. He had formal training at the Art Students League under John Henry Twachtman and at the New York School of Art with Robert Henri and William Merritt Chase, but he first gained fame as an illustrator.

Johnson settled in Southern California in 1925, where his circle of friends included artists and Hollywood personalities. Johnson's paintings and Zane Grey's pulp novels retained their interest for the American public long past the days when cowboys roamed the range, due to Hollywood's adaptation of the Old West in film. *The Cowboy* conveys the story of the mythic west while exuding a sense of quiet solitude. GHS's painting shows a lone cowboy at twilight, that liminal interlude when the shadows start to spread over the land. He has turned, one hand holding the reins, the other on the horse's haunch, to look over the range with a confident and searching gaze. Though standing still, the horse appears to be moving its head, introducing subtle movement that implies they will soon be on their way—heading into the sunset, most likely. Johnson had not yet been elevated to the status of Academician when he signed *The Cowboy*, dating it to before April 1937.

H. Raymond **HENRY** | b. Woodson, Illinois, 1882
d. Costa Mesa, California, 1974

The Storm King, c. 1937
Oil on canvas
30 x 40 inches

Class of Winter 1937

H. Raymond Henry's *The Storm King* was used by the railroads to promote travel to the West. The Union Pacific and Southern Pacific railroads distributed oleograph posters (photogravures printed on oilcloth) of Henry's paintings to hotels and travel agencies throughout the country and abroad to encourage wanderlust and ticket sales. His paintings, some in an Art Deco style, also decorated the trains' dining and parlor cars. In startlingly vivid colors in an Impressionist style, and combining several of California's exotic landscape features, *The Storm King* depicts the wind blowing through trees on the edge of a desert sea below a snowcapped mountain range. It may depict the manmade Salton Sea, looking toward one of the surrounding mountain ranges, such as the San Jacinto Mountains in the Imperial Valley.

Henry worked as an illustrator in New York before moving to California in 1910. During the 1920s, he bought the El Adobe in San Juan Capistrano and exhibited his art out of it. In 1929 he became the art critic of the *Hollywood Citizen-News*. Like many other landscape painters in California, Henry combined environmentalism with antimodernist sentiment. In 1932, his work appeared in a pro-preservation exhibition at the central library sponsored by the Santa Monica Mountains Protective Association; in 1947, he won second prize in an exhibition of the San Francisco Society for Sanity in Art at the California Palace of the Legion of Honor.

Carl Clemens Moritz **RUNGIUS**

b. Berlin, Germany, 1869
d. New York City, New York, 1959

Along the Slope (or *Moose in Cut Timberland*),
c. 1938
Oil on canvas
30 x 45 inches

Class of Summer 1938

Carl Rungius immigrated to the United States in 1894, settling in New York. From 1936 to 1939, at the time of the GHS collection purchase, he lived in the Los Angeles area. He hunted, and used the animals he shot—bears, moose, caribou, goats, deer—in the plein-air paintings he made in the wilderness, capturing the light and color of the landscape. Rungius had often visited the Berlin Zoo, and even a glue factory, to study animals so that he could become familiar with their muscles, bone, tendon, and tissue. His expressive brushwork, patches of vibrant color, and emphasis on realistic portrayals of his animal subjects all contributed to his signature style. Rungius specialized in paintings of North American wildlife, particularly big game animals of the Rocky Mountains. Hunters and naturalists

favored his work and commissioned wildlife scenes from him, and the New York Zoological Society accepted him as a member; the City of New York commissioned him to paint dioramas for the Museum of Natural History.

In *Along the Slope*, a moose, standing at the edge of a hill between dead and fallen trees, looks back toward the viewer in the direction of the forest below. Two female moose on the slope above him are poised facing the other way, silhouetted against distant, snowy mountains. The scene is filled with a sense of anticipation as the moose show an instinctive alertness to their environment.

Alson Skinner **CLARK**

b. Chicago, Illinois, 1876
d. Pasadena, California, 1949

After the Shower, Cuernavaca (or *Cuernavaca*),
1923
Oil on canvas
36 x 40 inches

Class of Winter 1938

Alson Clark sent a painting to the *Purchase Prize Exhibit* for the first time in 1938. *After the Shower, Cuernavaca* had been the Grand Prize winner at the *Southwest Museum Annual Exhibition* in Los Angeles in 1923. Clark had completed the painting on an extended painting trip to Mexico with fellow artist Orrin White. They had traveled by boat to Manzanillo, then by slow stages inland to Mexico City, and then down to Cuernavaca, about forty miles farther south.

Like many of the other artists in the GHS collection, Clark worked internationally and drew upon numerous influences in the creation of an artistic vision that was wholly original. He had training with some of the brightest stars of the day—William Merritt Chase, James Abbott McNeill Whistler, and Alphonse Mucha. *After*

the Shower reflects the Impressionism of Chase except for the painting's organized system of layers or horizontal planes, which build dimension and draw the viewer into the landscape.

Clark's view of the sixteenth-century Cuernavaca Cathedral looks from afar, across the city's rooftops. Half the composition is a remarkable cloudy sky, while the whole lower fifth is a pattern of crisscrossing tile in complementary colors. It is probably no accident that in 1953 the GHS seniors bought Orrin White's painting of Cuernavaca, *Pilgrimage*, also made on that shared trip to Mexico.

Armin Carl **HANSEN** | b. San Francisco, California, 1886 / d. Monterey, California, 1957

Before the Wind (or *Crossing the Bank in a Gale*
or *Crossing the Banks*), c. 1912
Oil on canvas
29 x 36 inches

Class of Summer 1939

Art historian Scott Shields writes that Armin Hansen "aimed to capture the raw power and vitality of the Pacific and those who sailed it rather than the beauty of the ocean's light and color for its own sake." After studying with Arthur Mathews at San Francisco's Mark Hopkins Institute of Art from 1903 to 1906, Hansen went to Stuttgart to attend the Staatliche Akademie der Bildenden Künste. From 1908 to 1912, he was based in Nieuwpoort, Belgium, where he signed on as a crew member of a trawler, taking his paints with him. *Before the Wind*, completed in Belgium, features a small fishing vessel with two fishermen fastening the sails before the onslaught of a storm.

Hansen returned to the United States in 1912 to teach at the University of California, Berkeley,

and one year later moved to Monterey. Fishing was a strong industry there, and it was an ideal place to live and paint fishermen and dramatic seas. Hansen's lush, expressive paint application and subtle tonal shifts were a great match for the bold weather off the coast. He also taught private classes; many of the most progressive painters in the area, including C.S. Price and August Gay, studied with him. In March 1914 *Before the Wind* appeared at the Schussler Brothers' San Francisco galleries in an exhibition of Hansen's marines dating from his years spent in Belgium.

Clyde Eugene **SCOTT** | b. Bedford, Iowa, 1884
d. Los Angeles, 1959

Mirror of Summer, c. 1939
Oil on canvas
30 x 40 inches

Class of Winter 1939

According to art historian Debbie Solon, Clyde Scott's early training was in Boston; he counted among his friends Elbert Hubbard, the leader of the Boston Arts and Crafts community and founder of the Roycroft artisans' community. Scott's affinity with the Arts and Crafts aesthetic can be seen in his early Tonalist work done in San Francisco, with its "silhouetting of the cypress trees, an interest in pattern and contour, and strong outlines." In 1935, Scott began a new career as a special-effects painter for 20th Century Fox after twenty-five years in San Francisco, where he had worked in the advertising and commercial art sectors. He was President of the Painters and Sculptors Club of Los Angeles at the time the students purchased *Mirror of Summer*. Scott was also active in the Laguna Beach Art Association,

which went through an acrimonious confrontation between the "conservatives" and "moderns" in 1939; the modernists split off to form their own group, in a battle that was being replicated across the Southland.

One of Scott's most striking works of art, *Mirror of Summer* exhibits the emphasis on color and light typical of California Impressionism. The tonal harmony of color in the rocky cliff and its glassy mirror image echoes his subtle use of a gray-green in the foam rolling onto the shore. Scott made another painting of the same wall of rocks and beach called *Shimmering Sand, Laguna Beach*, helping to locate the scene.

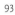

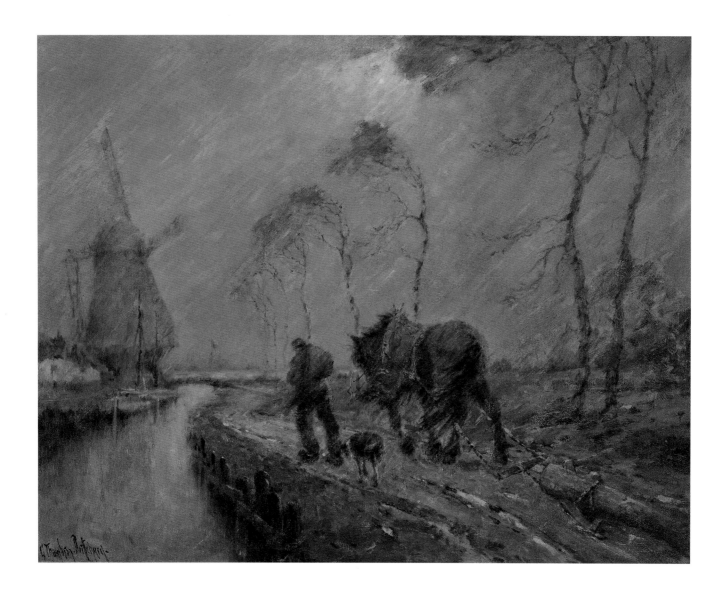

George Thompson **PRITCHARD**

b. Havelock, New Zealand, 1878
d. Reseda, California, 1962

Nearing Home (or *Brothers to the Ox*), c. 1914
Oil on canvas
34 x 44 inches

Class of Summer 1940

After a brief period in Los Angeles around 1909, G. Thompson Pritchard returned to Europe for further studies at the South Kensington School (of the Royal College of Art) in London, the Académie Julian in Paris, and in Amsterdam from 1911 to 1914. *Nearing Home* may have been painted during that period; the subdued colors and loose brushwork are characteristic of the Barbizon School (1830–1875), to which Pritchard was exposed as a protégé of Sir Alfred Edward East, a member of the Royal Academy.

In *Nearing Home*, a strong wind blows and rain beats down on a man with a large bundle on his back as he walks along a drainage ditch accompanied by his dog and a horse hauling a log. The broken windmill in the distance suggests the ravages of toiling against nature over time, as

well as the difficulties of creating and maintaining the dikes in the Netherlands. If *Nearing Home* was painted during Pritchard's studies in Amsterdam, it would have been fairly soon after he had lost his right arm in a working accident in London. The trauma of losing a limb, especially for a painter, would have been profound.

While *Nearing Home* expertly suggests the misery of fighting against nature to survive, it may also suggest the artist's personal battles in the face of long odds. The GHS Class of 1940 could probably relate to those difficulties, as they grew up during the worst of the Great Depression in an agricultural community with a similar set of problems.

William Spencer **BAGDATOPOULOS** | b. Zante, Greece, 1888
d. Cornwall, England, 1965

Drought (or *Taos Indian*), c. 1932
Pastel chalk on paper
53 x 35 inches

Class of Winter 1940

William Bagdatopoulos was an accomplished painter, printmaker, and set designer for stage and film, who very early on established a considerable reputation as an artist in England and beyond. Born to Greek and English parents on an island in Greece, Bagdatopoulos was brought up in the Netherlands and began studying at the Rotterdam Art Academy while still a child. After traveling extensively through Europe and Asia, he settled in London in 1908 and established himself as an artist there. He was elected a Fellow of the Royal Society of Arts the following year, at the age of twenty-one, and served in the British armed forces during World War I. In 1929, he moved to Los Angeles, taking up residence in Santa Barbara a couple of years later, while retaining a studio in London.

Bagdatopoulos is reported to have visited the Taos Pueblo Indians in 1928 and 1932. In *Drought* he uses direct sunlight and contrasting shadows to create heightened drama. He also focuses on the psychological drama of his subject, and the life force that animates him. *Los Angeles Times* art critic Arthur Millier summed up his work succinctly in a January 1932 review: "His forte is to transfer the life of his subject so suddenly to paper that it seems to quiver in its rebirth there." Bagdatopoulos's portraits are startlingly realistic. In February 1933, Millier remarked, "His sitters are so instantaneously present ... that one wonders if they are not too disturbingly real, as if they might walk out of their frames."

The Tools of Combat

The United States would enter World War II in December 1941. While the impact of the war on Gardena High School and its community was soon to become significant, the fourteenth annual Purchase Prize Exhibit was held as usual, in April, with five hundred people attending the opening dinner and reception. The show was now officially organized under the direction of La Veta Crump, girls'

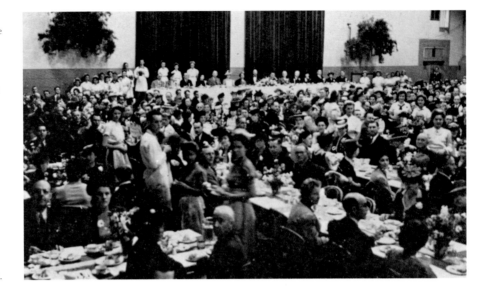

38.
Many Japanese-Americans were engaged in agriculture on the West Coast. I. Akuchi and Itoyo Minami, both Issei, working in a cauliflower field in Gardena, 1941. USC Libraries, Japanese American Relocation Digital Archive, 1941–1946. Photo by World Wide Photos, Los Angeles Bureau.

39.
Gardena High School annual banquet, *El Arador*, 1941.

Vice Principal and art adviser at GHS.[1] Former Principal John H. Whitely was the guest of honor, and artist James Swinnerton, the speaker. A former cartoonist in San Francisco and New York for Hearst newspapers, Swinnerton was currently painting backgrounds for Warner Bros. films, a leading form of employment for artists in Los Angeles. One hundred forty-three paintings were in the 1941 exhibition, which closed on May 7.

The Japanese community and students at the school were always actively involved in the art program, as well as other activities such as student council, clubs, honor societies, and athletics. This year, the Kobata Brothers donated more than four hundred gardenias for the occasion, presenting one to each woman at the dinner.[2] (fig. 39) In *School Arts*, a national educational publication, the former GHS librarian stated, "our Japanese students have presented the school with several canvases by famous modern Japanese artists and they plan to add to the collection every year."[3]

Arthur Millier again gave the show a rare negative review. He called the exhibition "a typical Gardena paint scramble," adding that "an overwhelming mass of mediocre work swamps the few better pictures in a close-packed, three-tier hanging. The school generally picks two of the better ones for keeps, but neither students nor community can possibly learn much about painting when each picture 'kills' its neighbor."[4] This problem would be solved when the school greatly reduced the size of the exhibitions due to wartime exigencies.

Many prominent artists of the previous generation, most now in their sixties—including Wendt, Puthuff, Mannheim, Hansen, and Johnson—still had paintings in the exhibition, most likely sent by a gallery. By this time, most California Impressionist artists had either died or withdrawn from public view, and some of the better-known modernists and American Scene painters did not regularly participate. Inevitably, there were artists in the show, including some who had been encouraged by the opportunity to paint and make a living under the Public Works of Art Project, whose work has not stood the test of time. Recognized artists who attended the 1941 dinner were few—Arthur Beaumont, Charles Bensco, Sam Hyde Harris, Emil Kosa Jr., Paul Lauritz, Peter Nielsen, and Nell Walker Warner. Most had or would soon have works in the collection.[5] For the most part, these were conservative artists, some of whom, like Bensco and Harris, considered all modernist experimentation to be "subversive propaganda." It is possible that the traditionalists viewed GHS as a sort of haven, but there is no sign that the school or students actively

97

entered into the conflict between the conservatives and moderns. As we will see, the school remained a neutral zone for the arts in Los Angeles despite the students' propensity to collect traditional art.

The students selected Leon Lundmark's *Symphony of Night* (Summer Class 1941) and Agnes Pelton's *Desert Royalty* (Winter Class 1942).

Desert Royalty was the first painting by a woman purchased by the students since 1932. Of the seventy-two works of art in the collection, the senior classes would collect only eight paintings by women, seven of them purchased after 1941.[6] The sudden interest in women artists reflects sociopolitical changes in American society that began during World War II. Women joined the workforce in record numbers, taking jobs vacated by men who had joined the armed services, thereby gaining confidence in their new skills. At Gardena High School, girls would assume a more active role in student government, experiment with traditionally male classes such as metal shop, and begin to assert themselves more forcefully in the selection of art for the collection.

1942

By the time of the 1942 exhibition, the media was issuing warnings about California's vulnerability to attack by foreign entities. Conceptions of "Americanness" became far more restrictive, reflecting heightened xenophobia and racism. Racist perceptions of the Japanese population led to the internment of Japanese Americans in camps in seven western states, from 1942 to 1945. Young Mexican men were stereotyped as juvenile delinquents and treated with hostility.

When the internment program began, much of the racist anger directed at Japanese Americans in Gardena could be traced to jealousy over economic competition in agriculture, but their alleged "foreignness" provided the necessary justification. The city council engaged in the same hysteria as the rest of the region in the 1940s, voting to intern Gardena's Japanese American citizens. "It was a grave and terrible injustice perpetrated on the Japanese in our midst," former Gardena Mayor Fletcher Bowron told radio broadcasters in 1956. Yet, he admitted, "those in whom we lost faith, never lost faith in us."[7] The internment of the Japanese had a profound impact on the community of Gardena and the high school, with its large Japanese and Japanese American population. Roy Pursche estimated that at least one-third of his class before the United States entered World War II were students of Japanese background, confirmed by an examination of the high school's yearbooks.[8] When the Japanese were evacuated in the spring and summer of 1942, school friends were separated, farm fields were abandoned, and homes and businesses were left behind.[9] In 1941, before the interment, Japanese businesses placed a third of the ads in the yearbook; in 1942, those ads had vanished from the pages of *El Arador*.

Much of the energy of the school and the community, formerly focused on the GHS arts program, was now marshaled in service to the war effort. GHS students contributed by taking part in the High School Victory Corps program established by the Federal Security Agency and Department of Education on September 25, 1942. As one authority wrote, "More than a patriotic or extracurricular service group, the High School Victory Corps program emphasized an entirely supplemental war-time education, complete with its own uniform, insignia, physical fitness regimen and command structure." In order to participate in the High School Victory Corps, students—both male and female—were required to enroll in a war-effort class (such as first aid, marksmanship, or navigation), pass a physical fitness inspection and volunteer in at least one extracurricular wartime activity. The program gave high school students a way to contribute to the defense of the country until time for their own induction into the military.[10]

Twenty Gardena High School departments prepared the special classes, which students took during their lunch break. Girls were the first to register for the classes, perhaps because it was the first time they were offered instruction in running a machine shop, blueprint reading, or handling a machine gun.[11] With so many young men off to war, opportunities opened up for young women. When Marjorie Page won the class presidency in March 1943, the *Los Angeles Times* ran an article with her photo.[12]

Southern Californians contributed to the war effort by working for the newly dominant force in American commerce, the military-industrial complex. Southern California artists who had worked together on Public Works of Art Project murals now joined together as camouflage painters, illustrators of defense posters and catalogues of wartime planes built by Douglas Aircraft, and bomb shelter designers. World War II provided both the final subject matter for American Scene painting in Southern California and the conditions that ultimately led to the end of its relevance as an artistic movement.

Despite world conditions and regional upheaval, the forty representatives of community organizations attending the annual art luncheon and planning meeting at GHS voted unanimously that the show must go on. However, the fifteenth annual *Purchase Prize Exhibit*, totaling eighty-five paintings, was far smaller than the previous year's exhibition. Former Principal Whitely was the guest of honor; no artist served as toastmaster this year. The principal speaker at the dinner, served in the school's gymnasium, was Dr. Rufus B. von KleinSmid, President of the University of Southern California.[13] He praised art that is "noble, pure, and strong, and not afraid to say that right is right, and truth is truth." According to the *Gardena Valley News*, he also said there had been a lack of artistic spirit among militaristic nations throughout history, citing Germany as an example of a nation without great literature or art. "Much fine music has come to us from Germany," he said, "but most of the musicians were not Germans, according to German standards, because they were Jews."[14] One wonders how the audience of five hundred people received this surprising message. Unknown by the general public at the time, Von KleinSmid was a co-founder of the Human Betterment Foundation, a private, Pasadena-based think tank that promoted eugenics and sterilization, from 1926 to 1942.

The students raised five hundred dollars for the two art purchases, Emil Kosa Jr.'s *Every Cloud Has Its Silver Lining* (Summer Class 1942) and Clyde Forsythe's *Conchita Valley* (Winter Class 1943). The funds, split between the two artists, were awarded in War Bonds, previously arranged with the artists' approval.

Roy Pursche recalled driving to Pasadena with three other students and art teacher Adele Lawrence to spend the day visiting artists. He is not sure how many other groups went to artists' studios, or why he was chosen. The number and complexion of student groups who went on these trips seemed to change from year to year; there are indications that academic achievers, artists, and student body officers were most often included. Adele Lawrence briefed the students ahead of time and instructed them in appropriate behavior. Pursche's group selected two paintings by each artist for the annual exhibit. One artist gave him a small painting made in the field as preparation for a full-scale work to be painted in the studio. At the time of the annual exhibit, Lawrence helped the seniors plan the layout of the show and hang the paintings, which also included works sent by artists throughout California. The art appreciation class she taught was mandatory for graduation; according to Pursche, she inspired many students to become artists and gave him the confidence to collect art later in life.

1943

The sixteenth annual *Purchase Prize Exhibit* was initially cancelled due to the "war emergency," and then reinstated, "streamlined for wartime efficiency." Limited to artists

40.
Students farming on a ten-acre tract at Gardena High School, 1942. Collection Simon K. Chiu.

whose work was not already represented in the school's gallery, the show comprised only twelve paintings. No opening dinner was held, due to rationing and food shortages. The list of invited artists included Conrad Buff, Nell Walker Warner, Sam Hyde Harris, Leland Curtis, Harvey Coleman, Mary Darter Coleman, Nicolai Fechin, Charles Bensco, George Brandriff, and Jessie Arms Botke.[15] Proceeds from sales of Gardena Art Association membership cards supported the purchase of the paintings. Two teas were given to which the public was invited. The public exhibition was open May 3–16, from 9:00 a.m. to 4:00 p.m. daily, including Sundays. La Veta Crump, girls' Vice Principal, and John J. Bruckshaw, President of the Gardena Art Association, sponsored the show. The two awards, for Jessie Arms Botke's *Cranes Under a Giant Fern* (Summer Class 1943) and Leland Curtis's *Afternoon Shadow* (Winter Class 1944), totaled five hundred dollars (paid either in cash or War Bonds, at the artists' discretion).[16] The late Leon Lundmark had left a painting to GHS, donated to the school this year by his widow as the prize for a student art contest. The winner's name was to be engraved on a metal plate along with the artist's name.[17]

GHS was not the only regional arts institution profoundly affected by the war during the spring of 1943. The Fine Arts Gallery of San Diego reopened in May after its building had been requisitioned as a Navy hospital. The Los Angeles Museum was showing *Wings Over the West Coast*, a photographic record of Army Air Force flyer training, and an exhibition on *Nutrition and Health*.

A perhaps inevitable outcome of the Japanese relocation in Gardena was the takeover of lands formerly farmed by the Japanese. In 1942, thirty GHS students took possession of a ten-acre farm that had been operated by Japanese tenant farmers until the previous spring, when they were evacuated. (fig. 40) The students organized as a chapter of the Future Farmers of America, earned school credit, and supplied wholesale and retail markets with produce. In three months, a produce stand on the school grounds sold

over one thousand crates of produce. Each student was assigned part of the acreage; after expenses were paid, the organization shared the returns.[18] By 1945, most of the farmland formerly cultivated by the Japanese was in new hands.[19] Yet some farmers saw their role purely as caretakers of their incarcerated neighbors' crops, pending their return.

1944

In January 1944, the first Gardena youth club for high school students opened, to "provide recreation for youthful residents and combat juvenile delinquency," a sign that crimes committed by youth had become a major issue in the community. Retired Petty Officer A. V. Ashbrook, recently back from the war, financially supported the endeavor. It was called the Mohican Club, named for the mascot of Gardena High School athletic teams.[20]

At the annual meeting of the Gardena Art Association, members decided that the seventeenth annual *Purchase Prize Exhibit* would proceed despite the ongoing "war time condition"—a resolution supported by GHS students, staff, and the PTA. The exhibition was limited to thirty juried paintings. A tea and reception would be held instead of a dinner, due to rationing restrictions, with six hundred dollars set aside for two purchases of art.[21] Fewer artists participated in the exhibitions during the war, because their energies were diverted to work for the government or defense contractors.

Of the thirty selections for the exhibit, which included well-known Western and Regionalist painters, only four were by women: Mary Everett, Marion Kavanagh Wachtel, Loren Barton, and Nell Walker Warner. The men included Russell Cowles, Ejnar Hansen, Maynard Dixon, Dan Lutz, Thomas Craig, Conrad Buff, Milford Zornes, Phil Dike, and Hernando Villa. Dixon's *Men of the Red Earth* (Summer Class 1944) and Einar Cortsen Petersen's *Gray Dawn* (Winter Class 1945) entered the permanent collection, bringing the total number of pieces to sixty-one.

1945

Newspapers published fewer articles on the annual exhibit during the war, a period when GHS and the city of Gardena were featured in the news for other reasons. The exhibit garnered a couple of notices each year, but with much less fanfare. However, Arthur Millier of the *Los Angeles Times* still found the purchase prize exhibitions notable. As he wrote, "The school pioneered the idea of forming a collection of representative American paintings by this method."[22] Thirty-two artists, most of whom had been invited the previous year, submitted paintings in April 1945. Until 1950, postwar exhibitions would be small and restricted to an artist list that did not vary much from year to year.

The art opening itself was also a more modest affair, with approximately one hundred attendees, in addition to visiting artists. The students still hosted various organizations, clubs, and groups during the run of the show, maintaining the tradition of serving the wider community while raising funds. According to the *Gardena Valley News*, former Principal Whitely retained an influence in the choice of paintings. He "met with the senior class as has been the tradition for many years, to analyze the paintings for the selection to be purchased and presented by the seniors to the school as a class gift." Studio talks by artists were an added feature this year, with artist Paul Lauritz giving the first lecture.[23] Sam Hyde Harris's *Desert Design* (Summer Class 1945) and Marion Kavanagh Wachtel's *Mt. Moran, Teton National Park* (Winter Class 1946) were the student selections.

Leon **LUNDMARK**

b. Stockholm, Sweden, 1872
d. Altadena, California, 1942

Symphony of Night, c. 1941
Oil on canvas
29 x 36 inches

Class of Summer 1941

Raised in a small village by the sea, Leon Lundmark studied art in his native Sweden at a technical school and at the Stockholm Fine Art Academy. As a youth he had apprenticed to a decorating firm that serviced the interiors of the city's palaces and grand homes. In 1906, Lundmark immigrated to Illinois, where in 1921 he began to exhibit frequently in the Art Institute of Chicago annuals and served locally as director of the Scandinavian-American Art Association. Lundmark was prolific and became well known for his seascapes and coastal paintings. He had a particularly successful run at the J.W. Young Art Gallery in Chicago, which resulted in several exhibitions and the 1924 publication of a monograph, *The Rise of Lundmark, Marine Painter*. Lundmark moved to California in 1937, settling in Altadena.

Artists paint nocturnes to express emotional and aesthetic insights; in *Symphony of Night*, touches of brilliant blue, turquoise, and purple are deftly integrated into the overall composition. According to Lorenna Poulson in the GHS collection catalogue, Lundmark said he painted the sea because "in it all the emotions of man are to be found in addition to incomparable color combinations." Lundmark completed the painting the year before he died and during some of World War II's darkest days. The United States would enter the war in December 1941; the Germans were bombing England and taking over most of Europe. The dark, unsettled state of the world is subtly conveyed in the stormy seas of *Symphony of Night*.

Peter **NIELSEN** | b. Denmark, 1873
d. Santa Ana, California, 1965

Sierra Alta, c. 1941
Oil on canvas
36 x 40 inches

Class of Winter 1941

Peter Nielsen made many bucolic paintings featuring the farms, ranches, coastal inlets, and rocky hills of San Luis Obispo County. A chain of nine craggy volcanic peaks that stretches from Morro Bay to San Luis Obispo—the Nine Sisters—made the area a favored location for landscape artists. The painting *Sierra Alta* is of a farm at the base of a hill, most likely Cerro Alto (high hill), one of the Sisters' tallest and most impressive peaks. Nielsen was a realist; typically employing a darkened palette, his paintings underscore a dedication to the integrity of form and an attention to crisp detail, and do not usually accentuate the sunlight-and-shadow paradigm integral to the California Impressionism aesthetic. However, *Sierra Alta* deviates from his general approach: it is painted loosely with a large brush loaded with paint, and is suffused with drama through Nielsen's adroit manipulation of shadows. It depicts a working farm complete with a plume of smoke rising from a farmhouse chimney, barns, rows of crops, and grazing cattle, a subject that would have been familiar to Gardena High School students.

Nielsen immigrated to the United States in 1887; settling in Chicago, he attended night classes at the Art Institute of Chicago. He moved to Los Angeles in 1925 and executed murals in the Adamson House in Malibu and the Fiesta Room at the Biltmore Hotel in Los Angeles. He also assisted on murals for the Congress Hotel in Chicago.

Emil Jean **KOSA**, Jr.

b. Paris, France, 1903
d. Los Angeles, California, 1968

Every Cloud Has Its Silver Lining, c. 1942
Oil on canvas
30 x 36 inches

Class of Summer 1942

Emil Kosa, Jr.'s *Every Cloud Has Its Silver Lining* shares with the work of Edward Hopper the importance of light as a dramatic element. However, Hopper's Depression-era paintings of barns began as homages to a passing way of life; farms were being abandoned across the country, symbols of the wretchedness of the period. The saying "Every cloud has its silver lining," meant as encouragement to one beset by difficulty and unable to see a way forward, originated in seventeenth-century England with the poetry of John Milton. The message would have been especially welcome in a year bridging the Depression and World War II.

Kosa's painting, with its upbeat message, is of a working farm. Two farmers lead a horse out of a barn; brilliant golden sun glances off the roof of an adjacent outbuilding and highlights the flowing fields of grass and haystacks. The sky is filled with billowing, light-filled clouds. Kosa softened the edges in his paintings, imparting a dreamy, wistful quality. The painting hovers between art and illustration, as did much of the art of Southern California during the era, when there was plentiful work for artists in the film and animation industries. Nationally prominent for his watercolors, Kosa first turned to oil painting only around 1941. He also had a successful thirty-five-year career at Twentieth Century Fox as a set painter and special-effects artist, and won an Oscar in 1964 for his work on *Cleopatra*.

Agnes Lawrence **PELTON** | b. Stuttgart, Germany, 1881
d. Cathedral City, California, 1961

Desert Royalty, 1940
Oil on canvas
26 x 36 inches

Class of Winter 1942

Raised in the state of New York, Agnes Pelton studied with Arthur Wesley Dow and Hamilton Easter Field, exhibited in the landmark Armory Show in 1913, and developed a series of meditative, symbolist works known as her Imaginative paintings. By 1926 she had embarked on a new direction in her art—a fusion of the spiritual and the abstract—now seen as her signature work. Later, in 1938, she became a geographically distant member of the Transcendental Painting Group based in Taos, New Mexico, with Emil Bisttram and Raymond Johnson.

In 1932, Pelton moved to Cathedral City in the desert near Palm Springs. There, she painted both spiritual abstracts and desert landscapes; the desert paintings were largely an effort to support herself. *Desert Royalty*, a blooming smoke tree with the San Gorgonio Mountains behind it, is drenched with the light so prominent in Pelton's work. The small tree, with its leafless ash gray branches and bright indigo blooms, was her favorite desert subject. She completed this work at a time when her health was increasingly frail and she was seeking a more poetic approach, or as she put it, "realism in 'free verse.'" She showed the desert paintings at Stendahl Gallery in 1940; *Los Angeles Times* critic Arthur Millier described them: "Smoke trees and mud hills fairly burn with sunlight in these, some of the best desert renderings being made hereabout."

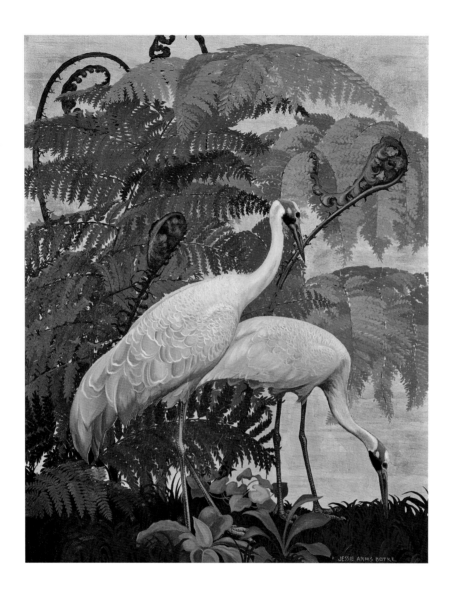

Jessie Arms **BOTKE**

b. Chicago, Illinois, 1883
d. Santa Paula, California, 1971

Cranes Under a Giant Fern, c. 1943
Oil and gold leaf on canvas
40 x 32 inches

Class of Summer 1943

Jessie Arms Botke was celebrated for her stylized depictions of exotic birds in lush gardens with backgrounds of 22-karat gold leaf. Botke had studied with and worked for Albert Herter, son of the founder of the leading decorating firm in the United States during the late nineteenth century. Herter Brothers created luxurious, cosmopolitan environments now recognized within the context of the international Arts and Crafts design movement.

Through her work for Herter Looms preparing tapestry cartoons, Botke discovered that birds, inspired by Japanese screens (*byōbu*) of the Edo period (1615–1868), were her forte. Such screens, featuring birds in spare garden settings with gold leaf backgrounds, were an important feature in the sacred settings of Shinto and Buddhist temples.

Later, screens featuring cranes were often used during the births of high-ranking members of the aristocracy.

Botke and her husband, Cornelis, were living in Santa Paula at the time of the 1943 *Purchase Prize Exhibit*. The painting may have come from a show at the Biltmore Art Gallery in Los Angeles, where the couple exhibited together at around this time. In 1954, they completed a 6½ by 26-foot mural of birds for the Oaks Hotel in Ojai, California (now in The Irvine Museum Collection at UC Irvine), that has echoes of the GHS painting. Ironically, the Japanese community was absent from the high school and city of Gardena at the time of this selection, as they had been sent to relocation camps in 1942 after America's entrance into World War II.

Victor Clyde **FORSYTHE** | b. Orange, California, 1885
d. Pasadena, California, 1962

Conchita Valley, 1935
Oil on canvas
30 x 42 inches

Class of Winter 1943

Early settlers called the Coachella Valley *Conchilla* or *Conchita*, diminutive forms of the Spanish word for seashell. Clyde Forsythe grew up exploring the valley, a desert region in Southern California that comprises numerous resort communities such as Palm Springs and Cathedral City. After attending the Los Angeles School of Art and Design, Forsythe moved to New York. There he had a successful career as an illustrator and cartoonist, mentored the young Norman Rockwell, and created propaganda posters during World War I before returning to California in 1920. The large Alhambra studio he shared with Frank Tenney Johnson was a gathering place for a large circle of desert painters and former illustrators, including Maynard Dixon, Charles Russell, Dean Cornwell, and James Swinnerton. Forsythe also befriended

some of the giants of the film industry, including Walt Disney, Gary Cooper, and Will Rogers.

Forsythe painted the Western frontier, focusing on the vestiges of its abandoned towns and mining camps: by 1935, the Old West had passed mostly into the realm of myth, sustained by Hollywood movies. While Forsythe often included desert prospectors in his paintings, *Conchita Valley* is a pure landscape with no sign of any human presence. The artist paints a quiet, beckoning vision of the desert rather than its inhospitable side, using calming blue-greens and gold. Perhaps it is early morning before the sun has started to really blaze or the dust kicks up. The edges of this desert are soft, round, and vibrate gently in the heat.

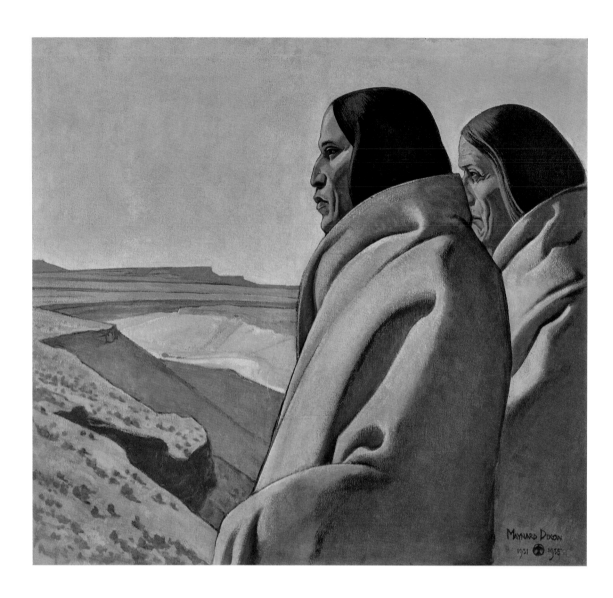

Maynard **DIXON** | b. Fresno, California, 1875
| d. Tucson, Arizona, 1946

Men of the Red Earth, 1931–1932
Oil on canvas
36 x 41 inches

Class of Summer 1944

Maynard Dixon was a member of the informal Garvanza circle of artists at the turn of the twentieth century. Situated on a plateau in the valley of the Arroyo Seco, Garvanza drew numerous painters as well as Charles Lummis, founder of the California Landmarks Club. Dixon was a close friend of Lummis, who in 1900 gave the artist a letter of introduction to the Pueblo Indians, starting him on his long career as a painter of the American West and its inhabitants. At the time, Dixon was an illustrator, and would have a spell in New York working for numerous publications until about 1912.

By the 1920s, Dixon had begun developing a stark, rhythmic approach to painting the desert, exposing the architectural forms and Cubist angles of the landscape. The pared-back aesthetic worked well in rendering the harsh Southwestern desert and its indomitable denizens. Dixon and the photographer Dorothea Lange, who he had married in 1920, traveled throughout the arid lands seeking inspiration for their art.

Men of the Red Earth is an example of Dixon's mature work. The iconic image of Native Americans looking out over a vast expanse of desert has been simplified to its barest elements. He juxtaposes flat, two-dimensional striations of color in the distant landscape with the tangible, three-dimensional forms of the two men. He emphasizes stoicism and solemn dignity in the men, while in the land he underscores the ordered, abstract structure underlying our perceived reality, endowing the whole with a sense of the eternal.

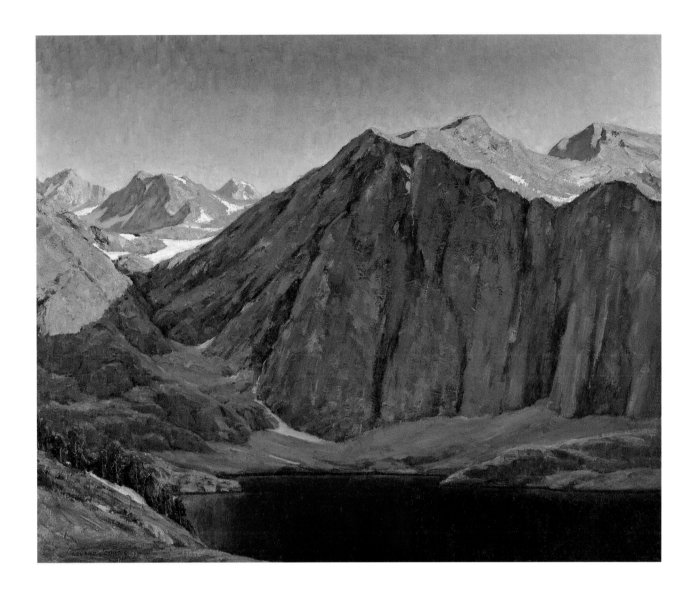

Leland S. **CURTIS** | b. Denver, Colorado, 1897
d. Carson City, Nevada, 1989

Afternoon Shadow, c. 1944
Oil on canvas
40 x 48 inches

Class of Winter 1944

Leland Curtis moved to Los Angeles in 1914 as a teenager; there he took his only art lessons from Rob Wagner, a teacher at Manual Arts High School. After working as a bank clerk and serving in World War I, he established himself as a commercial artist. His love of the outdoors resulted in his first painting trips to the Sierra Nevada, in 1919. He started to join and exhibit with regional art clubs in the 1920s. Through a chance encounter in 1938, he became the official artist for U.S. Antarctic expeditions in 1939–1940, 1955–1956, and 1957. The 1957 trip was the first U.S. expedition to reach the South Pole. Highly regarded, Curtis's Antarctic paintings helped him develop a substantial reputation.

The massive shadow of the mountain dominates *Afternoon Shadow*. Cool blues and subtle greens deaden the mountain's reflection on the lake, creating a greater feeling for the depth and purity of the lake. It also emphasizes the mountain's massiveness and colossal scale.

Traveling in the High Sierra was by foot, horse, or mule. Adventuresome artists like Curtis would pack their painting supplies in by mule and paint on site—the only way to pick up on the nuances of light and shadow, changing moment by moment.

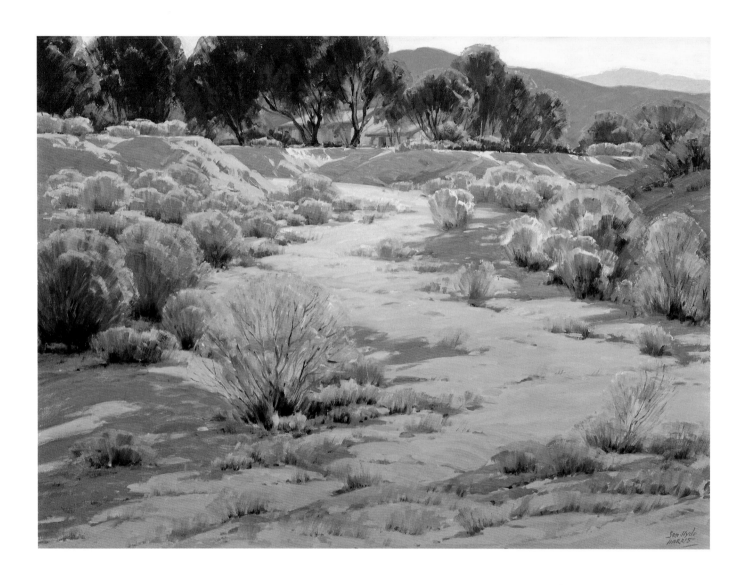

Sam Hyde **HARRIS**

b. Brentford, England, 1889
d. Alhambra, California, 1977

Desert Design, c. 1945
Oil on canvas
30 x 40 inches

Class of Summer 1945

The first things one notices about *Desert Design* are the painting's composition and unusual point of view. Harris designed the painting with a strong vertical tilt and a wide, meandering path that draws one into the scene (set in the Cathedral City area, near Palm Springs). Seemingly mimicking the devices of the film industry, it causes the viewer to visually pan to the house on the hill. Although the lower four-fifths of the painting comprise a panoply of dazzling golds, Harris managed to create a balanced composition. Through the introduction of complementary colors and the narrative interest of the house, the upper fifth provides the necessary counterweight.

The painting recalls the work of California School painters such as the much younger but highly influential Millard Sheets. These watercolor painters dominated the Los Angeles art scene of the 1930s and early 1940s, and developed a loose, direct style that drew from (and contributed to) the stylistic repertoire of illustrators and artists in the film industry. In *Desert Design*, this is most visible in the way the trees and bushes are rendered in a cartoony, fan-like brush stroke that enlivens the whole.

Harris taught at Chouinard Art Institute in 1935, where many of the California School artists were centered. A successful commercial artist for over seventy years, he had formal training at the Art Students League and Cannon Art School in Los Angeles, but learned much of his craft from painting with Hanson Puthuff, Jean Mannheim, Edgar Payne, and James Swinnerton in the field.

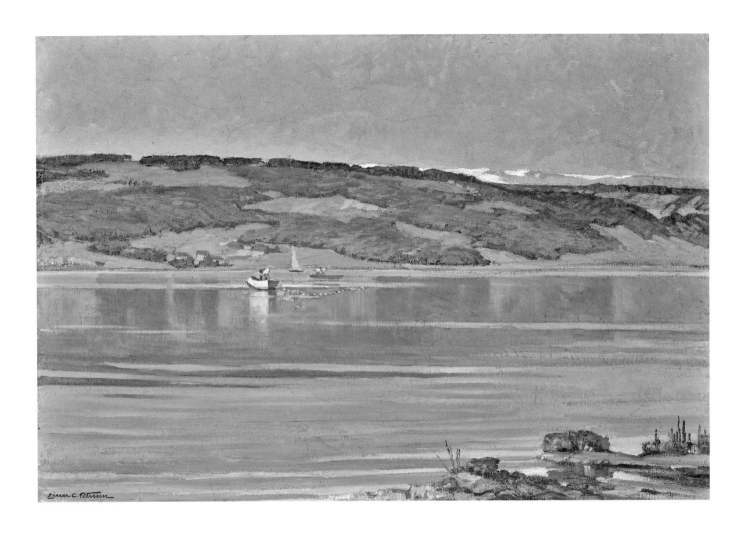

Einar Cortsen **PETERSEN** | b. Ebeltoft, Jutland, Denmark, 1885
d. Los Angeles, California, 1986

Gray Dawn (or *Seine Fishermen*), c. 1945
Oil on canvas
31 x 45 inches

Class of Winter 1945

At the turn of the twentieth century, Denmark gave artists financial support in the form of travel bursaries. Following a seven-year apprenticeship in his native city, Einar Petersen studied in an art school in Zurich, and then in the museums of France, Italy, and Germany. Petersen's specialty was mural painting; he was versatile and prolific, completing many works in Europe and then in the United States after immigrating in 1912. He settled in Los Angeles in 1915; his first commission there was for the Beaux Arts–style New Rosslyn Hotel, depicting the history of Los Angeles. From 1915 to 1945, he painted murals for some twenty buildings in downtown alone, many in the Art Deco style.

Petersen was also a landscape painter, and proficient in the Impressionist style. In *Gray Dawn*, daubs of pink, blue, and purple cover the hills rising above a small village, suggesting blossoming vegetation, and are mirrored in variegated stripes in the calm, glassy water. A snowcapped mountain range arises in the distance, while the foreground shows a bit of shore, painted vibrantly and loosely. Fishermen work from small boats near the far shoreline, casting their nets by hand. This method is known as Danish seining, as the technique has its origins in Denmark.

Although its title is *Gray Dawn*, Petersen's remembrance of his homeland is anything but gray: it is a carefully organized composition arranged in a subdued palette of many colors. Perhaps the real "gray dawn" was the German occupation of the country that had begun in 1940.

Advancing American Art

In 1945, San Francisco was chosen as the site of the founding
conference of the United Nations, accompanied by an official
art exhibition at the California Palace of the Legion of Honor.
Contemporary American Painting "proclaimed abstraction the
language best suited to the international attitude and cosmopolitan
vision of the postwar age" and recognized the interdependency
of all nations in a new world culture.[1] For decades, Los Angeles,

like San Francisco, had lagged behind artistic developments in Europe and New York. During the 1930s, as we've seen, the climate for modernism was nationally unfavorable. The 1940s in Los Angeles were even more inhospitable to new trends in art.

With the formal end of World War II on August 14, 1945, Southern California entered an era marked by social transformation, rapid population growth, economic prosperity, and increased diversity due to wartime and postwar migration, and the staffing needs of the film and aerospace industries. Los Angeles cultivated a self-image as the paragon of American suburbia and the good life. Yet, while some GHS students may have enjoyed the affluence and confidence in American values of the postwar era, others were negatively affected by the legacy of the war.

After returning from World War II internment camps, a large Japanese American community consisting of first- and second-generation Americans—the Issei and Nissei— began to resettle in Gardena. Real estate developers' ads in the Japanese American newspaper, *Rafu Shimpo*, drew many of the second-generation settlers of the 1950s and 1960s. According to Bruce Kaji, a former Gardena city treasurer, "Gardena was the only community in the Los Angeles area where developers sought to sell homes specifically to the Nisei . . . whereas the Nisei did not feel welcome anywhere else."[2] After the war, the family of Eiko Kamiya (later Moriyama) (Summer Class 1961) moved to Gardena, where her father became a real estate agent who sold homes to other Japanese Americans. Recalling that the area "was still fairly rural," she said that her family "owned a large parcel of land with two houses on it and had a strawberry farm, too."[3] Paul Tsukahara, a Gardena city councilman in 1989, recalled signs refusing service to Japanese. A dentist and World War II veteran, he moved to Gardena in 1953 because its large Japanese population allowed him to work in his profession.[4]

Nonetheless, some residents were concerned that not enough was being done locally to support Japanese Americans. Prior to their return, in April 1945, two hundred residents of Gardena assembled in the auditorium at GHS to hear a debate sponsored by the Citizens Emergency Corps on the subject: "Resolved: That we should welcome American citizens of Japanese ancestry and Japanese Americans who have been allowed to return to their Pacific Coast homes."[5]

Another legacy of the war was a plaque at the high school that honored thirty-two GHS students who had "made the supreme sacrifice." Many had enrolled in the Navy while still in high school and never returned to finish their schooling.

1946

"Gardena was really very much a working-class community, but the high school was the center of the community's cultural life, and it was held in high esteem. Everybody came to our programs," recalled alumna Mary Grove Warshaw.[6]

The nineteenth annual *Purchase Prize Exhibit* was the first peacetime exhibition in five years. C. Irl Kennedy, president of the Gardena Art Association and a member of the inaugural 1919 class at the high school, presided over the reinstated banquet dinner. Lt. Commander Arthur Beaumont, a naval artist, spoke on the subject "Art Missions with the Navy," about the rigors of an artist's life on board ship.[7] The *Los Angeles Times* noted that five hundred students staged the dinner and exhibition, which consisted of thirty-four paintings: thirteen from Carmel, four from Santa Barbara, and the rest from Los Angeles. The students purchased Beaumont's *Task Force* (or *Destroyer Task Force*) (Summer Class 1946) and Cherokee artist Joe Waáno-Gano's *Ceremonial Night* (or *Indian Nocturne, Ceremonial Night*) (Winter Class 1947).

Notably, after the show closed at Gardena High School, it traveled to Dana Junior High School in San Pedro, sponsored by the Art Patrons of San Pedro.

41.
(detail) Art banquet, *El Arador*, 1953.

"Youth Interprets the News," broadcast on KMPC-AM, featured GHS students speaking on changes to the school curriculum and on "the occupation of Japan and the results of the Pearl Harbor investigation."[8] Also in the news, Lowell Wagner, a 1941 GHS graduate and first-string wingback of the New York Yankees, was in town to play against the Los Angeles Dons.[9]

1947

Censorship, advanced modernism, and communism were hot topics of discussion in Los Angeles at the time of the twentieth annual *Purchase Prize Exhibit*, and the controversy would continue during the next few years. The Hollywood Ten—directors, writers, and actors who refused to cooperate with the anti-communist hearings of the House Un-American Activities Committee—were cited and jailed for contempt of Congress and blacklisted by the film industry. These ruthless actions instilled a climate of fear within the Los Angeles art community that would endure into the 1950s.

Several months earlier, in response to public outrage, the U.S. State Department had been forced to pull *Advancing American Art*, an international traveling exhibition of avant-garde art organized to promote artistic freedom. The public, unaccustomed to modernism, believed that the show promulgated a communist agenda. It included works by Romare Bearden, Arthur Dove, John Marin, Ben Shahn, Georgia O'Keeffe, and Jacob Lawrence. Few of the paintings were Abstract Expressionist, but most were identifiably "modern" rather than representational and didactic.[10] In the *Los Angeles Times*, Millier defended the exhibition as "typical of the art movements which parallel the philosophical and scientific developments of our era." He added, "If the showing of vital art is inhibited, this familiarity, which comes from frequent seeing, cannot develop and art stagnates."[11]

Closer to home, two weeks after the close of the annual exhibit, the Los Angeles Museum ignited a similar controversy. Edward Withers, retiring director of the California Art Club, lambasted the museum's *Eighth Annual Exhibition* for favoring "radical art" and "subversive propaganda." The issue arose when the exhibition, which in the past had regularly included some 150 works of art, was reduced to only fifty mainly modernist paintings, despite the more than 675 works submitted for jurying.[12] Regional artists had been feeling shortchanged since 1945, when the museum stopped hosting annual exhibitions of local art groups, including the California Art Club. While disturbing to traditionalists, these changes reflected a new sensibility sweeping through the Southern California art world.

Coincidentally, the principal speaker at the art banquet this year was James F. Breasted Jr., Director of the Los Angeles Museum, who would soon take the heat for the museum. He urged the gathering at Gardena High School to become familiar with more advanced forms of art: "You say you know what you like, but I say you like what you know. . . . There are emotions created in this age of nuclear fission, which cannot be expressed by conventional art forms." He classified artists into four groups: those who express "what you and I believe, only better than we could; those who disagree with us; those who don't know what we believe and don't care; and the experimenters and innovators."[13] It was clear which group he rated most highly.

Breasted also posed the question, "What are we doing for the artist today?" He reminded his listeners that it was the role of the museum to show work by living artists and to encourage the public to support them.[14] "Meetings like this," he said, "are giving art back to the people."[15] He was in favor of hosting exhibitions that contributed to art scholarship and introduced important new developments in art, rather than shows of regional artists working in traditional styles.

More than 520 people attended the annual banquet held in the school gym, evidence that community support was still strong. Principal Goulet announced that the

success of the event was due to 873 activities performed by 750 community members, faculty, and students. As in previous years, the purchase prizes for $250 and $300 came from the class treasury, the sale of Art Association memberships, and proceeds from banquet ticket sales.

The forty-one paintings displayed in the study hall included work by several prominent American Scene artists, such as Phil Dike, Loren Barton, Jean Goodwin Ames, Phil Paradise, Conrad Buff, Louise Everett Nimmo, Elsie Palmer Payne, Francis de Erdely, and James Patrick. The *Los Angeles Times's* photo of Barton's *Day's End* showed the painting surrounded by girls in the senior class who supported the purchase of this work. Although landscapes predominated in the exhibition, the Summer 1947 students selected Barton's mild social commentary of women in a migrant encampment; the Winter 1948 students chose Cornelis Botke's *Spring Plowing* (or *Spring Planting*, or *In the San Gabriel Valley*). According to alumnus Rassie Harper (Winter Class 1948), students saw the painting as a paean to the school's logo, which showed a farmer plowing, with the motto "Plowing Ground for the Future."[16]

Gardena had been slowly losing its agricultural focus, a change that accelerated after World War II. People moved in droves to Los Angeles to work in the defense industry. Suburbs, stores, roads, and freeways gobbled up agricultural land. However, according to alumnus Roy Pursche, the high school still owned twenty acres and continued its 4/4 Plan in agriculture, which permitted students to take classes at GHS for four hours and work on farmland for the other four—including bailing hay or cultivating the fields on his own family's thousand-acre farm. Pursche recalled that the coaches at the school hauled the students' produce to market in Los Angeles every night and sold it for them. "Now, I don't have to tell you," he said, "back during those hard days, if you had a couple of bucks in your back pocket, you didn't have any trouble getting a date."[17]

1948

Many of the artists who had exhibited in 1947 were invited back the following year, despite James F. Breasted Jr.'s appeal for a more expansive view of art. This is both an indication that the students were taking a curatorial approach—seeking to broaden the collection's holdings of work by specific artists—and that steps were taken to screen out artists with subject matter considered too modernist or controversial. In an era when art was highly politicized, Principal Goulet's explanation, "This way we can really tell the senior class that they won't go wrong choosing any of the paintings on display," suggests that a concerned art committee may have been exerting pressure. This year, the principal speaker at the banquet dinner was Judge Daniel Beecher, a member of the California Art Club and Chairman of the Citizens' Committee for Art of the Los Angeles Municipal Art Commission, a conservative and elitist civic organization. The fact that his viewpoint was diametrically opposed to Breasted's suggests that GHS encouraged open dialogue. Whether conscious or not, there was a pattern to the choice of principal speaker, alternating between those opposed to and supportive of postwar modernist experimentation.

Judge Beecher's topic was "Art and the Community." He reviewed the history of American art, showing how it gradually freed itself from blind imitation of European schools to assume a degree of importance in its own right. He went on to say, "Gardena's art collection has been a great influence in the development of art in this area. I know of no place around where a person can go and find so many fine paintings. This is one community that has done an outstanding piece of work so far as fostering fine arts is concerned."[18] Judge Beecher's implication was that a truly American art was distinguished by its freedom from modernistic strains deriving from European art, an idea popular

during the 1930s. But by the late 1940s, progressive commentators believed that modern American art, despite exhibiting modernist qualities derived from European art, exemplified the freedom of expression enjoyed by artists in a democracy while demonstrating America's artistic coming of age.

Artists in the show who were cited by the *Gardena Valley News* reviewer as more modernistic (and thus the recipients of considerable public attention) included Francis de Erdely, Alfredo Ramos Martinez, Edward Withers, Conrad Buff, James Patrick, and Douglass Parshall. The students selected Hugo Ballin's Regionalist genre scene *Saving a Life* (Winter Class 1949) and Parshall's *Portrait of a Young Girl* (Summer Class 1948), a painting of a child holding a stuffed elephant—which raises questions about the artist's possible political motive, since the animal is the Republican Party emblem and 1948 was a presidential election year.

1949

In 1949, Principal Goulet affirmed the educational goals of the annual exhibit, noting that "art exhibitions at the school are open to the public and in addition are used by student classes for a study of contemporary art."[19] During the two weeks of the exhibit, former Principal Whitely, visiting artists, and the art faculty held open forums and presented critical analyses of the paintings.

The art faculty at the school had always been key to the success of the program in art appreciation. Alumna Mary Warshaw, who graduated in 1949, recalled, "We had teas and talks in the library surrounded by the permanent collection, with viewing of the current candidate paintings in the study hall transformed for the occasion into a gallery." The students also continued to visit galleries in small groups, as Warshaw recalled: "My group of five became world connoisseurs for a day in downtown Los Angeles, visiting galleries—ones in the elegant Biltmore Hotel come to mind—and grandly having lunch with our sponsor, Mrs. Lorenna K. Poulson."[20] Poulson was an English teacher at the school and author, in 1936, of the first history of the collection. Her stewardship of the students and the art collection over many years was essential to the program's success. She chaired committees responsible for the banquet and annual exhibit; later, she was president of the Gardena Art Association.

GHS invited entries from forty-two artists. Submissions came from Dalzell Hatfield Galleries at the Ambassador Hotel, Cowie Galleries at the Biltmore Hotel, and the Laguna Beach Art Association. Every faculty member and some seven hundred students were assigned to work on one or more of thirty-three committees, from "Alumni" to "Waitresses."[21] The banquet drew 550 attendees.

From the thirty-nine submitted paintings, the students selected Francis de Erdely's *Return of the Prodigal* (Winter Class 1950) and Edward Withers's *Show Girl* (Summer Class 1949). De Erdely's painting incorporated abstract elements as well as figurative Expressionism and an existentialist sensibility. Withers, who had been at the center of the Los Angeles Museum controversy two years before, found a sympathetic audience among the students, who were probably thrilled to have a suggestive image of the artist's famous model, Carol Janis, in the collection.[22] The students' selections reflect the ongoing battle between the "conservatives" and "moderns" in Los Angeles and across the country.

Lorser Feitelson, the principal speaker at this year's annual, represented the moderns. Feitelson was a nationally known abstract painter, member of the faculty at the Art Center in Los Angeles, and supporter of the Los Angeles Art Association. In the 1930s, Feitelson and his partner, Helen Lundeberg, introduced Post-Surrealism— which employed traditional painting techniques to explore subconscious imagery—

to Los Angeles; in recent years, the couple had adopted an abstract style that came to be known as Abstract Classicism or Hard Edge painting. Feitelson said that the GHS collection was "tremendously important" because "hanging crowdedly on your walls, you have the history of art in California—the solid foundations of our California culture."[23]

According to the *Los Angeles Times*, the Gardena Art Association was "seeking a gallery building for the school for more advantageous display."[24] A true gallery space in which to display the art would better serve the growing permanent collection, which now consisted of fifty-nine oil paintings purchased by the students, supplemented by thirty oils acquired as gifts, eighteen watercolors, five etchings, two lithographs, and three pastels. The association's announcement was the first glimmering of what would become the goal of everyone who cared deeply about the collection—to preserve its legacy by creating a permanent repository in the community.

Arthur Edwaine **BEAUMONT** (born Arthur Edwin Crabbe)

b. Norwich, Norfolk, England, 1890
d. Laguna Hills, California, 1978

Task Force (or *Destroyer Task Force*), c. 1945
Oil on canvas
30 x 40 inches

Class of Summer 1946

Arthur Beaumont was commissioned as a lieutenant in the U.S. Naval Reserve in 1933, partly on the strength of his 1932 portrait of Admiral William Leahy. By the time he left the service a little over a year later, he had painted a number of important battleships, primarily in watercolor, as well as portraits of other officers. Beaumont's goal, according to art historian Janet Blake, "was to make even a battleship artistic while, at the same time, maintaining a strict fidelity to accuracy in the rendering of the subject." He set up a studio in Long Beach, where he kept track of the ships coming and going in the harbor.

When the United States entered World War II, Beaumont illustrated ships and battle scenes for various outlets, including *National Geographic*, by request of the War Department. His efforts also included raising funds for war relief and for the construction of the heavy cruiser USS *Los Angeles*. After the war, he took trips on the *Los Angeles*, USS *Iowa*, and USS *Midway*. At Gardena High School's nineteenth annual art banquet, Beaumont was the guest speaker. During an amusing speech full of anecdotes, he graphically recalled the difficulties of making art while on a ship that was going at full speed and engaged with the enemy.

Task Force (or *Destroyer Task Force*) is a tribute to the prowess of the United States Navy and to the critical role it played in World War II.

Marion Kavanagh **WACHTEL** (born Kavanaugh)

b. Milwaukee, Wisconsin, 1876
d. Pasadena, California, 1954

Mt. Moran, Teton National Park, c. 1946
Oil on canvas
30 x 40 inches

Class of Winter 1946

Marion Kavanagh Wachtel established a solid reputation as a watercolorist. Her delicate, poetic interpretations of the landscape, in a tonal palette of blues, expressed her emotional engagement with nature. They epitomized what art historian Harvey Jones called "the twilight and reverie" that found an audience among devotees of the Arts and Crafts Movement. As time went on, Wachtel's watercolors became brighter in color and more literal in interpretation. She took up oil painting in the early 1930s, working both *en plein air* and in the studio.

Mt. Moran is named for Thomas Moran, the American landscape painter, and rises some six thousand feet above Jackson Lake, in Jackson Hole, Wyoming. Wachtel has depicted the mountain, which today still has several active

glaciers, in what looks like full summer. Wachtel studied with William Merritt Chase in New York and at the Art Institute of Chicago, where she later taught for several years, before traveling to San Francisco to study with William Keith. She moved to Los Angeles in 1904, newly married to Elmer Wachtel. The couple painted together, often interpreting the same scenes each in their own way. They traveled in an automobile specially equipped for painting to remote places throughout California, the American Southwest, and Mexico. Wachtel was the only woman member of the prestigious Ten Painters Club of California, established in 1919. She turned to oil painting after a period of grieving following Elmer's untimely death on a 1929 trip to Mexico.

Loren Roberta **BARTON** | b. Oxford, Massachusetts, 1893
d. Claremont, California, 1975

Day's End, c. 1947
Oil on canvas
36 x 40 inches

Class of Summer 1947

Loren Barton's image of two women in a migrant camp at the end of a day's work is a commentary on the difficult social and economic times wrought by the Great Depression. The painting may allude to the federal *bracero* ("manual laborer") program that invited Mexican temporary workers into the United States to fill a labor shortage in agriculture from 1942 to 1964. The program promised decent living conditions in labor camps and a small wage, as well as protection from discrimination.

More specifically, the painting refers to the plight of women who joined the agricultural labor force with their families, living in tents and makeshift homes. The face of the young woman on the left shows quiet resignation. She wears a bright red wrap and holds a sleeping baby; her wedding ring indicates her married status. The exhausted woman next to

her closes her eyes while resting her head on her hand. Barton has simplified the realistic detail in the light-filled painting, using well-defined outlines, bright colors, and a background full of implied movement to help convey her story.

John Steinbeck's *The Grapes of Wrath*, the powerful novel of farm workers struggling for survival in California, would have been well known to the GHS students. Moreover, because Gardena was an agricultural community, the painting would have been especially meaningful for students at the school, who traditionally began working in the fields when they were children and often continued to do so throughout their high school years.

Joseph Theodore **WAÁNO-GANO** (born Joseph Theodore Noonan)

b. Salt Lake City, Utah, 1906
d. Los Angeles, California, 1982

Ceremonial Night (or *Indian Nocturne, Ceremonial Night*), 1947
Oil on canvas
40 x 30 inches

Class of Winter 1947

Joe Waáno-Gano spent over ten years exploring natural lighting effects while painting on location under the full moon. According to Gregory Schaff in *St. James Guide to Native North American Artists*, Waáno-Gano's goal was "to produce the exact strangeness and unreal colors of a moonlit night."

Ceremonial Night shows two warriors who have emerged from the dark and are waiting for their moment to come out of hiding. The artist pays particular attention to the figures' ceremonial dress, such as the ethereal, silvery features of the headdresses. The shapes of the men's tensed muscles are echoed in the rocks, and a rock at the upper left suggests a looming figure, perhaps referring to powerful life forces in nature. The otherworldly light of the moon seems to cast the warriors themselves in the role of spirits.

Waáno-Gano made some of the original sketches for *Ceremonial Night* as early as 1936, but finished the painting soon after World War II. He had served in the United States Air Force and was no doubt aware, and proud, of the many contributions Native Americans had made in the war effort. Through his art and other activities, Waáno-Gano promoted Native American culture until his death.

Ceremonial Night may refer to the Ghost Dance, a ceremonial circle dance that was believed to reunite the living with the spirits of the dead, thereby supporting an end to white colonial domination of the Native Americans. The ceremony is recognized in part for leading to the atrocities of another war, the Wounded Knee massacre in 1890.

Douglass Ewell **PARSHALL** | b. New York City, New York, 1899 | d. Santa Barbara, California, 1990

122

Portrait of a Young Girl, c. 1948
Oil on canvas
29 x 22 inches

Class of Summer 1948

In *Portrait of a Young Girl*, an unusually aware and self-conscious child looks over her shoulder in an appraising glance—acknowledging, confronting, and returning the viewer's gaze—as if annoyed by the distraction. Given the girl's uncomfortable position, with her head twisted to look behind her, we can assume that this was not a subject posing for her portrait for a prolonged period of time. It is an imagined child caught in a particular act, that of playing with a toy elephant.

In the summer of 1948, the country was on the cusp of a presidential election that was thought to be child's play—an election easily won for Thomas E. Dewey, the Republican Governor of New York. The confident look on the girl's face, as well as the fact that she is playing with the symbol of the Republican Party, may sum up Parshall's personal thoughts about the election. Instead, against all predictions, the incumbent Democrat, President Harry S. Truman, won reelection in a stunning upset for the Republicans.

Parshall had moved to Santa Barbara with his family in 1917 and established a studio there. He traveled widely during the 1920s, and in 1933 was appointed District Supervisor of the New Deal's Federal Art Project. In 1952, he became the first President of the Santa Barbara Art Association. He continued to travel throughout his life and taught portraiture at the Santa Barbara Art Institute in the 1960s and 1970s.

Cornelis J. **BOTKE**

b. Leeuwarden, Friesland, Netherlands, 1887
d. Santa Paula, California, 1954

Spring Plowing (or *Spring Planting* or *In the San Gabriel Valley*), c. 1948
Oil on canvas
32 x 40 inches

Class of Winter 1948

Over the course of his lifetime, Cornelis Botke created a significant body of art that won numerous awards and earned the artist critical acclaim. Raised in an orphanage, Botke studied at the School of Applied Art in Haarlem in the Netherlands. He graduated in 1905, immigrated to Wisconsin in 1906, and moved to Chicago a year later, enrolling in evening classes at the School of the Art Institute of Chicago. In 1914, while working as an architectural draftsman, he met a fellow painter named Jessie Arms. They married a few months later, living first in Carmel before moving to Los Angeles, where they exhibited regularly at the Stendahl Galleries. In 1929, they relocated to a ten-acre ranch in Wheeler Canyon, Santa Paula. The Botkes traveled extensively in the 1930s. During World War II, and despite their duties as air-raid wardens in the canyon, they continued to

paint and exhibit. As an artistic team, they created numerous murals together.

The students selected *Spring Plowing* just as the last of the Gardena Valley farmland was being converted into suburban bedroom communities. According to alumnus Rassie Harper, his class purchased the painting because Gardena High School had started as an agricultural school in a lush agrarian valley and because the school's logo featured a farmer plowing the fields. Clearly, Cornelis Botke kept pace somewhat with changes in the arts: *Spring Plowing* is a classic California Regionalist interpretation of the landscape.

Edward Oscar **WITHERS** | b. Wellington, New Zealand, 1896
d. Los Angeles, California, 1964

Show Girl, c. 1947
Oil on canvas
40 x 34 inches

Class of Summer 1949

As a young man, Ted Withers left his native New Zealand to serve in World War I. After the war he trained at numerous art schools, including the Royal Academy in London and the Académie Julian in Paris. Arriving in Los Angeles in 1924, he worked for MGM and Universal studios for about twenty-five years while exhibiting portraits and landscapes.

Withers was in the news twice in 1947, when he was President of the California Art Club. He led a protest on the steps of the Los Angeles County Museum that received national coverage in *LIFE* magazine. The artists protested being left out of the annual *Artists of Los Angeles and Vicinity*, calling the exhibition—which comprised only modern and contemporary paintings—"radical" and "subversive."

At about the same time, Withers painted *Show Girl*, a surprising work to find in a high school art collection. It features the artist's favorite model, Carol Janis, who had recently been in the news for slashing and burning a nude painting of herself that had won Withers the gold medal in the Painters and Sculptors Club exhibition. In *Show Girl*, the focus is on the folds of the dress and the risqué exposure of the model's leg. Withers takes great care in rendering the darks and lights within the fabric, thereby establishing the tactile sense of the dress and the model's flesh. With *Show Girl*, Withers revealed the undeniable virtuosity and training that he had picked up in Europe. Soon thereafter, in 1950, he achieved fame as a pin-up artist.

Hugo **BALLIN**, N.A. | b. New York City, New York, 1879
d. Santa Monica, California, 1956

Saving a Life, c. 1949
Oil on canvas
36 x 42 inches

Class of Winter 1949

At the time of the GHS purchase, Hugo Ballin was seventy years old and teaching classes out of his studio home. Ballin had enjoyed a long, nationally distinguished career as a painter, set designer, novelist, filmmaker, and muralist. His numerous murals included works for the executive chamber of the State Capitol in Madison, Wisconsin, and, in Los Angeles, for the Temple B'nai B'rith, the *Times* building, and Griffith Park Observatory. When Ballin passed away at the age of seventy-six after a brief illness, the *New York Times* ran an obituary. Among the prestigious national awards mentioned there, such as the President's Medal of the Architectural League of New York, was "the Gardena Purchase Prize."

According to Ballin's biographer, Caroline Luce, the most important years of study he undertook were those in the 1890s with the portraitist Wyatt Eaton, an alumnus of the National Academy of Design in New York and L'École des Beaux-Arts in Paris. Eaton promoted a reverence for tradition, craftsmanship, and beauty, inspiring an American Renaissance movement that had a lasting impact on the young painter. Ballin's superior academic training and tremendous skill are on display in *Saving a Life*, which may originally have been a study for one of his murals. Recalling both a baptism and a pietà—an image often found in Christian art, depicting the Virgin Mary cradling the body of Jesus—it shows a veiled woman attending to a nude young man arising out of turbulent waters.

The Writing on the Wall

Almost every year, the *Gardena Valley News*, in its generous reporting of the *Purchase Prize Exhibit*, announced that the exhibit was rated "one of the school's best." The fact that students and visitors judged every year's exhibit to be an improvement on previous shows demonstrates a high degree of pride in and commitment to the art collection. In 1950, Principal Goulet attributed the paintings' high quality "to the greater selectivity exercised on the part of the art committee."[1]

The composition of this committee is unknown, but it most likely included leaders of the business community and the public school system, along with artists and arts professionals. The first such committee, formed in 1928, was composed of one artist (William Wendt), the Superintendent of Los Angeles City Schools, a member of the Los Angeles School Board, former and current art critics of the *Los Angeles Times*, and a member of Gardena's Wednesday Progressive Club.

This year, the high school invited twelve new artists to exhibit, some of them based in East Coast cities, adding a greater diversity of subject matter and stylistic approaches. An unnamed Beverly Hills gallery—most likely the Frank Perl Gallery, which exhibited sophisticated European and American modernism and figurative Expressionism, and served the Hollywood crowd—sent several paintings, including works by Joe Jones, Frederic Taubes, and Peter Hurd. The inclusion of these works reflected Principal Goulet's aim of exposing the students to the variety of figurative art from the Depression era, which was still nationally popular with collectors.[2]

Somewhat incongruously, the artist speaker at the dinner this year, plein-air painter Sam Hyde Harris, took aim at abstract and nonobjective painting. At a large exhibit he had viewed recently, he said, the three rooms full of abstracts would have made nice batik prints or patterns for wallpaper. "There should be a place for conservative paintings, too, and then let the public decide," he declared, causing most of the artists present to applaud.[3]

The paintings the students selected were Loren Barton's *The Circus* (or *Behind the Scenes, The Horse Tent*) (Summer Class 1950) and William Frederick Foster's *Girl with a Vase* (Winter Class 1951).

Senior Janet Perdew (later Halstead-Sinclair) and four of her friends supported the purchase of the Barton, a lively and loosely rendered American Scene painting of a circus. "We started a blitz on all our classmates to convince them that was the painting we should have," Halstead-Sinclair said. "California plein-air work was too old fashioned and we wanted something that looked more modern, more of the times."[4]

1951

The banquet at the twenty-fourth annual *Purchase Prize Exhibit* honored two retiring faculty members: La Veta Crump, girls' Vice Principal since 1927, and Reginald Moore, head of the drafting department. Crump had made significant contributions to the development of the art collection over the years and was largely responsible for the longevity of the program. She helped organize the banquet and annual exhibit, assuming several of Principal Whitely's functions when he retired. Moore, hired in 1928 and called "Reggy" by the students, was extremely popular. As instructor of mechanical drafting for many years and chairman of the Industrial Arts Department, he worked with the art students.[5] Alumnus Rassie Harper, who became a practicing artist, recalled that Moore, who taught foreshortened perspective, "wouldn't let me touch a ruler, just a charcoal pencil." This training, as well as daily musings on the paintings in the collection, developed Harper's exceptional draftsmanship and understanding of art. "A lot of times during recess or something," Harper said, "I would go stand and just look at those paintings. I liked to see the reflection of trees on the water. . . . It was a whole education for me." He called his interaction with the paintings "a silent teaching." Harper did not realize the powerful effect the paintings had made on him until he saw them again fifty years later, when he was asked to participate in a July 2000 episode of Huell Howser's *California Gold* television program about the GHS art collection.[6]

The price of a dinner ticket increased to two dollars this year, with an additional charge of one dollar for membership in the Gardena Art Association. Members of the

42.
Purchase Prize Exhibit in Crump Memorial Hall, *El Arador*, 1954.

43.

Edward Reep, *Quiescence*, c. 1952. Class Gift Summer 1951. The painting disappeared in the 1950s.

association were now listed as Art Patrons in the catalogue. The higher cost of the dinner was not an impediment for the 540 patrons and guests who attended, many of them, apparently, former alumni who wanted to honor the retirees. Dr. Alexander Stoddard, Superintendent of Los Angeles City Schools, described the art collection and annual festival as "one of the most unique affairs in the country of which the entire school system is very proud."[7]

The variety of fundraising events for the class gifts and annual dinner constituted what came to be known as the Art Festival. The Summer Class's choice of painting was formally announced at the Parents' Tea held in the study hall toward the end of the run of the show.[8] Christian von Schneidau's *Clown Says Grace* (Summer Class 1951) and Ruby Usher's *Twelve O'Clock* (Winter Class 1952) (fig. 45) were the class gifts. *Twelve O'Clock* was one of three paintings that perished in a fire at the school in 1975.

1952

By the early 1950s, streetcars were being replaced by freeways, resulting in a sprawling urban environment with isolated pockets of humanity. Less than fifteen miles south of downtown Los Angeles, with a population of about fifteen thousand, Gardena "was considered the boonies," recalled Rosemary Best (Class of 1952). "We were farm kids. Most of us were not encouraged to go to college. But we had this art collection that we lived with every day."[9]

The students bravely ventured into modernism this year, selecting work by two abstract figurative painters new to the exhibit: Edward Reep's *Quiescence* (fig. 43) and Guy Maccoy's *Composition 1951* (fig. 44). (Sadly, both paintings disappeared from the school sometime in the 1950s.) The art of the 1950s had an evocative quality all its own and was a synthesis of the many art influences gaining prominence in Los Angeles, including figurative abstraction, Cubism, Surrealism, and Hard Edge painting. The *Gardena Valley News* ran the headline "Moderns Selected by Seniors." Anne Olney-Finnegan (Summer Class 1952) later recalled:

> Among the paintings exhibited for the classes of summer and winter 1952 was *Quiescence*, an abstract design in greens and blues of the old, shut down Pacific Ocean Park in Santa Monica by Ed Reep. It stood out among the realistic paintings of landscapes, flowers, portraits, etc. And, probably because it was "daring," my class of S[ummer] '52 was leaning towards selecting it when we were suddenly called to a meeting in which a very old Mr. Whitely returned

44.
Guy Maccoy, *Composition 1951*, 1951.
Class Gift Winter 1951. The painting
disappeared in the 1950s.

from his retirement to warn us against purchasing such an unworthy painting.
Instead, he urged us to select another one, a large and very traditional still life
with flowers. Of course we ignored him and bought the Reep painting. Reep
was so impressed with us, he visited Mrs. Lawrence's art class and demonstrated
his painting techniques."[10]

Perhaps it is not surprising that the seniors ignored Principal Whitely. The
1950s saw the emergence of "cool," which can best be described as a mixture of seeming
indifference and effortlessness. Young people in Southern California broke away from the
influence of their parents and authority figures, in search of transformative experiences
like hot-rodding and surfing (though Gidget would not become a pop culture icon until the
release of the eponymous film in 1959). Some high schoolers experimented with drugs;
GHS students arrested for smoking marijuana were in the news in the later 1950s.

The twenty-fifth annual *Purchase Prize Exhibit* was the center of a two-week art
festival celebrating the silver anniversary of the exhibition. Dinner reservations for the
opening banquet could be made by telephone for the first time. The principal speaker was
Dr. Jean Theodore Delacour, the new director of the Los Angeles Museum, an authority
on ornithology and aviculture. Special tables were set up for community groups that had
made the exhibition possible over the years, including the Wednesday Progressive Club,
Kiwanis Club, Lions Club, Zam Zam Club, Gardena Junior Women's Club, and PTA, and
Mayor Adams Bolton and the Gardena City Council. (fig. 46)

The exhibition of forty-one paintings was displayed in the library, now called
Crump Hall; the permanent collection of 120 paintings was on view in the auditorium,
library, and halls of the school. Many of the special events in conjunction with the
exhibition were planned to involve students and faculty from other schools. Student

45.
Ruby Usher, *Twelve O'Clock*, c. 1951. Class Gift
Winter 1952. Destroyed in a campus fire in 1975.

councils from fifteen high schools were invited to hold their quarterly meeting at GHS. A tea with talks by the art faculty welcomed the Girls' Leagues from seven regional high schools; faculty members from ten nearby high schools attended a separate tea. Studio talks open to the public featured Arthur Beaumont, the marine painter whose work was purchased for the collection in 1946, and Paul Lauritz, President of the Los Angeles Municipal Art Commission and the California Art Club.[11]

1953

The loss of momentum that would lead to the abandonment of the annual exhibition and a lack of interest in the future of the collection began in 1953 with the deaths of Principal Frank X. Goulet and former Principal John H. Whitely. Principal Goulet died unexpectedly on March 25, three weeks before the opening of the art exhibit, stunning the faculty and nearly causing the banquet to be canceled. He had planned to retire in June, and the banquet was conceived as a tribute to his years of service. Whitely died in December, a couple of weeks after the students presented a play to raise funds for their Winter Class purchase.

On the day of his death, Principal Goulet was being treated for a low-grade virus infection. Nevertheless, he attended a faculty meeting to present plans for the new high school building that would open in 1956, about twenty blocks south of the current location. At the meeting, according to the *Gardena Valley News*, "his remarks took a philosophical turn and he discussed at some length the trend for decentralization, predicting that the life of the community would center upon the new school and that great things lay ahead for education." He died later that night either from a hemorrhage caused by severe coughing or a heart attack.[12] Attilio G. Parisi joined the school as Interim Principal while plans for the new building were developed.

In consultation with the mayor and other community leaders, the faculty executive committee decided to go ahead with the banquet and exhibition. Lorenna Poulson, the first faculty member to be elected president of the Gardena Art Association, announced that Paul Lauritz would be the principal speaker at the banquet, discussing modern art trends.

The exhibition included many familiar names, such as Rex Brandt, Conrad Buff, Leland Curtis, Ejnar Hansen, Orrin White, Edgar Payne, and Hermann Struck. Ralph Davison Miller's widow presented her husband's painting *Singing Trees* to the permanent

collection. The students selected White's *Pilgrimage* (Summer Class 1953) and Martin Mondrus's *The Tribute* (Winter Class 1954), reflecting the growing artistic pluralism of the region.

1954

The writing was on the wall when GHS named a committee to discuss the pros and cons of continuing the traditional art banquet during the twenty-seventh annual *Purchase Prize Exhibit*. The issue that prompted this discussion was overcrowding at the school. Principal Parisi rather weakly laid out the problem as follows:

> 1. The faculty members, although in full accord with the program's importance, do not have the time to help stage the banquet due to double sessions at the school, which occupies their full attention.
> 2. The students are disrupted in their classes and lacked seats for classes, which were used at the cafeteria for the banquet.
> 3. Most of the faculty members, who are association members, don't have an opportunity to see the exhibits because they are busy helping stage the banquet in various ways.[13]

In fairness to Principal Parisi, the 1954 school yearbook reveals that six grades were crammed into a campus designed to hold far fewer pupils. By July 1953, the city population had expanded to nearly eighteen thousand residents, a 20% increase from 1950. Junior high and high school students were again attending half-days in two shifts.

A seven-member committee, made up of three faculty and four members of the Gardena Art Association, was charged with studying the problem and making a full recommendation. Suggestions included an alternate plan for the annual opening celebration. On April 28, the opening program was held in the auditorium. It began with a flag salute led by Eiichi Kamiya, student body president, and dedicated to the two school principals who had piloted the program through the years. The evening's principal speaker, Rex Brandt, a prominent California Scene painter of the 1930s and early 1940s, gave a watercolor demonstration and showed a brief film of one of his classes in which Principal Goulet appeared. Refreshments followed and then the exhibition of thirty-five paintings was unveiled to the public. In 1951, Brandt, who donated the demonstration painting to the school, had been at the center of one of the biggest art controversies of the 1950s, when ultraconservative members of the public and the art communities ludicrously judged his watercolor of a sailboat to be a pro-communist gesture (because a detail on the sail of the boat was thought to be the hammer-and-sickle symbol).[14]

Principal Parisi also took a practical approach to the selection of paintings this year. Rather than inviting specific artists to participate, a faculty committee assisted by four students made the initial selection from the stockrooms of the Cowie Galleries (in the Biltmore Hotel) and Dalzell Hatfield Galleries (in the Ambassador Hotel), both in downtown Los Angeles. The senior students selected Robert Watson's *The Palace* (Summer Class 1954), a painting that eventually disappeared, and Ruth Osgood's *Act One* (Winter Class 1955) as class gifts.

This year a *Los Angeles Times* article revealed that "community interest in the purchase prize exhibit includes many school representatives and private citizens seeking to buy pictures for their own enjoyment." For years, the GHS exhibition paintings had been sold to other schools; now, interested collectors could also purchase the paintings.[15]

The *Times* also devoted articles to the construction of the new high school building. In November, excavation had started for the footings of the first two classroom

46.
Art banquet, *El Arador*, 1953.

buildings, one to contain the paintings, the other "to house the business and arts unit."
The five-million-dollar high school, at 182nd Street and Normandie Avenue, was expected
to be completed by February 1956. It would be the second senior high school built by
the Los Angeles city school system with funds voted in a 1952 bond election. The school's
capacity was projected to be a minimum of two thousand students. Along with a full
complement of general and specialized high school classrooms, there would be a fully
equipped industrial arts facility with wood, auto, metal, electric, and print shops, a
drafting room, and a photography section. With a seeming nod to the past, the plans
also included a vocational agricultural unit of about ten acres, containing a classroom,
lath house (to raise seedlings), livestock barns, animal pasture, and exercise barns.[16]

1955
Anticipating the changes that were to come, at the initial meeting of the Gardena
Art Association this year, retiring President S. O. Barnes suggested reorganizing the
association into a permanent organization with bylaws, dues, and possible incorporation.
A small committee of longtime supporters of the permanent collection, comprising
Barnes, Lorenna Poulson, Roscoe Sevier, and Stephen Owen, explored the idea. Soon

47.
Emil Kosa, Jr., *Portrait of Mr. Frank Goulet*,
1955. Oil on canvas, 38 x 32 inches. Collection
of Gardena High School, Class Gift Summer
1956.

thereafter, the GAA voted to form a permanent organization. Principal officers were to be GHS alumni or faculty members. Annual dues were set at one dollar. The ten-member board of directors would consist of the GAA officers, the GHS principal, and four at-large members. A permanent alumni association was also instituted, in Principal Parisi's words, "so alumni may keep closer contact with the school and help build a stronger and more meaningful program of instruction." Janet Perdew Halstead-Sinclair, who joined the group in 1955, said the alumni kept a close watch on the collection beginning that year. Alumni continue to pay close attention to the current status of the art collection, updated in the monthly *Mohican* newsletter.

The organization also decided to make the *Purchase Prize Exhibit* the centerpiece of the high school's fiftieth-anniversary celebration, with its theme "Fifty Golden Years of Progress."[17] In addition to the twenty-eighth annual exhibit, festivities associated with Golden Anniversary Week included a pageant depicting events in the history of the school, featuring four costumed performances of tableaux, skits, and dances; open house exhibits at the school; and numerous teas—all of which were preceded by a parade through the streets of Gardena. In an effort to look to the future as well as the past, the Masonic Lodge organized and underwrote a field trip to the site of the new high school. An exhibit of archival ephemera and objects related to the history of the school was on view in the gymnasium.

The opening celebration for the annual exhibit was an afternoon tea held in the library to honor art patrons, former faculty, principals of local schools, service club members, and others. The 1955 Summer Class students selected Robert Watson's *Remains*, and the 1956 Winter Class chose Richard Haines's *Fogbound*. Perhaps symbolically, *Fogbound* would be the last gift to the school purchased by the student body of Gardena High School.

1956

In 1955, Emil Kosa Jr. accepted Gardena Art Association's invitation to paint a portrait of former Principal Frank X. Goulet. (fig. 47) The funds for the painting came from association members, friends of the late principal, and faculty members, but the portrait was considered the gift of the Summer Class of 1956. The GAA presented the completed portrait at a tea in March; over one hundred guests attended, and Kosa and Lorenna Poulson gave brief talks.

There were no notices in the *Los Angeles Times* or *Gardena Valley News* about the permanent art collection. Instead, the news was about the renaming of the former high school as Robert E. Peary Junior High, and the opening of the new Gardena High School campus at 1301 West 182nd Street. The *Los Angeles Times* published a photo of the new five-million-dollar school; the caption reported that the seventy classrooms, spread over thirty-six acres, would accommodate 3,200 students.

At the end of the 1956 school year, Dr. John Abbott, the new Principal of Gardena High School, announced the end of the long tradition of student donations of paintings, much to the disappointment of the graduating class. The Winter Class of 1957, the first to graduate from the new campus, did not contribute to the collection. The art education program at Gardena High School had finally run its course.

Loren Roberta **BARTON** | b. Oxford, Massachusetts, 1893
d. Claremont, California, 1975

The Circus, Behind the Scenes (or *Behind the Scenes, The Horse Tent*), c. 1947
Oil on canvas
28 x 38 inches

Class of Summer 1950

Circuses and clowns were popular as subject matter during the Depression era, when artists turned to making realistic portrayals of American leisure activities and other aspects of the native experience. Scores of circuses came through Los Angeles every year. Some set up big-top tents at Washington Boulevard and Hill Street, like Clyde Beatty's Wild Animal Show & Circus, and Ringling Bros and Barnum & Bailey Circus. In 1947 Loren Barton painted a series of works focusing on the circus, which she exhibited at the Dalzell Hatfield Galleries at the Ambassador Hotel; the show included GHS's painting, then called *Behind the Scenes, The Horse Tent*.

Barton taught watercolor painting at Chouinard Art Institute, where artists trained to work in the film industry, and in particular for Walt Disney

Studios. She could capture a scene quickly as well as tell a good story, and was adept at watercolor, for which she won many prizes. *The Circus,* executed in oil, resembles Barton's watercolors for its painterly immediacy—one of the hallmarks of the watercolor style popularized in Southern California beginning around 1930. Her lively depiction of the ringmaster and clown trudging past a colorful, light-filled horse tent shows that she was a master of characterization and the depiction of action and movement.

Francis **De ERDELY** (born Ferenc de Erdelyi) | b. Budapest, Hungary, 1904 | d. Los Angeles, California, 1959

Return of the Prodigal, c. 1950
Oil on canvas
40 x 30 inches

Class of Winter 1950

Francis de Erdely was renowned in Europe and the United States for his powerful figure paintings and drawings reflecting human struggle, as well as for his teaching abilities. He had studied in some of the finest academies in Europe and had traveled the world after receiving early notice for his royal portrait of the Queen of Spain. Due to his strongly antiwar, anti-Nazi paintings, he was forced to flee Europe in 1939. He arrived in Southern California in 1944, carrying the torch of European Expressionism and Existentialism in a darkly emotive brand of figuration. At the time of the students' purchase of *Return of the Prodigal*, de Erdely was a professor at the University of Southern California, where he taught academic painting and drawing from 1945 until his death in 1959.

Many artists over the centuries, from Albrecht Dürer to Giorgio de Chirico, have depicted the return of the prodigal son. In the Gospel of Luke (15:11–32), Christ relates a parable in which a son requests his inheritance and leaves home, only to fritter away his wealth. After many years, he returns in sickness and poverty and the father accepts him back into the fold. De Erdely's brilliant interpretation of the story is wholly new, not only because of the artist's tightly woven figurative expressionism, but because the painting focuses entirely on a close-up view of father and son at the moment of their reunion. The image is compelling in its drama and depth of feeling.

Christian **VON SCHNEIDAU** | b. Smoland, Sweden, 1893
d. Orange, California, 1976

Clown Says Grace, 1951
Oil on canvas
30 x 42 inches
Conservation partially funded by GHS Alumni
Classes 1950 to 1953

Class of Summer 1951

The clown genre is full of examples epitomizing narrative eloquence on one hand and bad taste on the other. Christian von Schneidau's *Clown Says Grace* is a clown painting of a higher order, embodying a contradiction of another sort. The clown, looking heavenward before eating a meager dinner, is modeled after Emmett Kelly as "Weary Willie," a tragic clown figure in tattered clothes. Based on the tramps and hobos of the Depression, Weary Willie was created by Kelly in 1932. He became nationally famous for his role as the sad clown, which he played in the Ringling Bros. and Barnum & Bailey Circus from 1942 to 1956.

Kelly was in Los Angeles in October 1950, not long before the students purchased the painting. *Los Angeles Times* social columnist Hedda Hopper

asked him about Weary Willie's special appeal. "Audiences laugh at him, but they feel sorry for him," said Kelly. "But there's something beyond that. It has to do with the line drawn between comedy and tragedy. It's so fine I don't know where one leaves off and the other begins."

Clown Says Grace is humorous yet poignant. The clown's reserved, introspective demeanor during a private moment of prayer invites us to delve into his soul, allowing for open-ended musing that would have been especially appealing to young viewers.

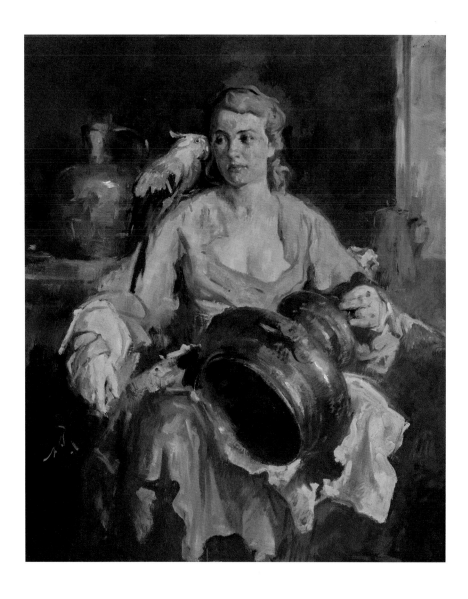

William Frederick **FOSTER**, A.N.A. | b. Cincinnati, Ohio, 1883
d. New York City, New York, 1953

Girl with a Vase, c. 1951
Oil on canvas
48 x 40 inches

Class of Winter 1951

William Frederick Foster, a gifted draftsman and prolific painter of portraits, figure studies, and nudes, studied with three of the great twentieth-century American figure painters: Frank Duveneck, Robert Henri, and William Merritt Chase. Foster started his career during the Gilded Age in New York, as an illustrator for the *Saturday Evening Post, Cosmopolitan*, and *LIFE* magazines from 1903 to 1931. He won the National Academy of Design's Thomas B. Clark Prize for his painting *The Music Room* in 1926; in 1930 he was voted an Associate member of the academy for *Girl in Brown*, also in the GHS collection.

Foster moved to Los Angeles in 1932, following a nearly fatal motorcycle accident. His late figure studies are of seated women holding objects in their arms or laps, as is seen in *Girl with a Vase*.

He largely used red, yellow, and brown pigments, indistinct settings, and loose brushwork in the style of Henri. Here, although the painting is clearly a celebration of paint and technical ability, Foster has also captured the essence of his subject. *Girl with a Vase* has a dazzling array of attributes—the allure of the female figure, the gleaming brass vessel, the voluminous drapery of her dress, the wistful expression on her face.

According to Eugena Ordonez, who conserved *Girl with a Vase*, the vivid cockatoo on the girl's shoulder, based on a porcelain prototype much used by Foster, was a later addition.

Orrin Augustine **WHITE** | b. Hanover, Illinois, 1883
d. Pasadena, California, 1969

Pilgrimage, 1923
Oil on canvas
25 x 30 inches

Class of Summer 1953

Orrin White settled in Pasadena in 1912 with little artistic education, but made a quick ascent through the ranks of Southern California painters. He befriended fellow artist Alson Clark around 1921, and painted often with him and John Frost in the desert near Palm Springs, in the High Sierra, and in the San Gabriel foothills above Pasadena. The others were much more sophisticated painters than White, so he most likely learned much of his craft from them.

In 1923, White and Clark made an extended painting excursion to Mexico. In 1938, Clark sent his painting *After the Shower, Cuernavaca* from that trip to the *Purchase Prize Exhibit*, and the Winter Class purchased it for the collection. It is probably no coincidence that White sent *The Pilgrimage*, also made on that Mexican sojourn, to the students for the 1953 exhibit.

Pilgrimage is an atmospheric, close-up study of what appears to be the sixteenth-century monastery of La Asunción, the heart of the Cuernavaca Cathedral complex. White uses prodigious amounts of scumbling—a method of lightly brushing dry paint over a previous layer of color—to enhance the illusion of an aged edifice surrounded by storm clouds. The artist was interested in the culture of the Mexican people as well, and this work most likely shows the faithful in a procession to the cathedral during Holy Week, a period of religious observance around Easter Sunday. White exhibited the series of paintings he made on the trip at the Stendahl Galleries in 1924.

Martin P. **MONDRUS** | b. Los Angeles, California, 1925

The Tribute, c. 1954
Oil on canvas
26 x 36 inches
Conservation funded by the
W. M. Keck Foundation

Class of Winter 1954

Martin Mondrus served in the United States Merchant Marine toward the end of World War II and received his Masters in Fine Art at Claremont Graduate School in 1955. The influence of Millard Sheets and Phil Dike, who taught there at the time, can be seen in the reductive, decorative flattening of the space in *The Tribute*, as well as the warm colors and archetypal rendering of the figures.

According to Mondrus, in an interview on 11 March 2018, he traveled to Mexico often in the 1950s and remembers attending several bullfights. The architectural elements in *The Tribute* are drawn from common features of Mexican bullfighting rings of the period. The sombreros read as halos and the gold background is reminiscent of Russian icons.

Mondrus doesn't discount the influence that Operation Wetback—a joint United States/ Mexico program to deport Mexicans in the United States illegally, instituted in 1954—may have had on him when he painted *The Tribute*. Mondrus was a member of the Anti-Defamation League, which fights for minority rights and against racial injustice, discrimination, bigotry, bullying, and hate crimes. He says *The Tribute* acknowledges Mexicans for their contribution to the vibrancy of life in Southern California.

Robert **WATSON**
b. Martinez, California, 1923
d. Poway, California, 2004

Remains, 1954
Oil on canvas
20 x 30 inches
Conservation funded by the
W. M. Keck Foundation

Class of Summer 1955

Robert Watson painted *Remains* soon after his cover for the second edition of Ray Bradbury's *The Martian Chronicles* went to press in 1953. Like Bradbury's book, Watson's Surrealist paintings from the 1950s were commercially successful; however, they were not as critically well respected. As Arthur Millier pointed out in the *Los Angeles Times* in January 1956, "For the third successive year an exhibition of paintings of ruins, sea and sky by Robert Watson, Berkeley artist, appears headed for a sellout."

The problem was that the artist's work was seen as derivative of others', such as Leonid and Eugene Berman, who had left Russia in 1917 and immigrated to New York and Los Angeles, respectively. They also drew upon the Surrealist dreamscapes Yves Tanguy had developed in the 1920s. Nevertheless, Watson's painting, with its undeniable pop appeal, would have stood out in the *Purchase Prize Exhibit*. And with his work on the cover of a book everyone was reading, his prestige would have been high.

Remains is typical of Watson's work of the 1950s: expressive of loneliness and human isolation. A raking light suggests the passage of time, as does the decaying architecture. Enigmatic and mysterious, the painting offers up a series of questions: The tiny people appear to be waiting, but waiting for what? Perhaps they have been left behind, as suggested by the title. But by whom? Watson's work represents the point in the development of American science fiction/fantasy literature when it begins to be visually represented by art with Surrealist underpinnings.

141

Ruth L. **OSGOOD** (Salyer)

b. Los Angeles, California, 1920
d. Laguna Beach, California, 2003

Act One, c. 1955
Oil on canvas
24 x 36 inches

Class of Winter 1955

Like a theatrical production, bullfighting has three distinct acts. Act One (*tercio de varas*) starts right after the bull enters the ring, when the matador observes the bull's particular characteristics and how it charges as it approaches the cape. It's the most festive time of the bullfight, before the picadors weaken the bull and blood starts to flow. Utilizing the lessons of Cubism, in *Act One* Osgood fractures space into multiple planes, focusing on the mass of the bull as it moves past the poised matador.

During World War II, Osgood served as a U.S. Army nurse in the European theater. Like many male veterans returning from the war, she elected to attend college on the G.I. Bill. She went to the Chouinard Art Institute in Los Angeles, at the time one of the most progressive art schools in

Southern California. *Act One* is a relatively early work, completed soon after her student years, perhaps embodying her own opening act in another male-dominated arena—the arts.

In 1954, a GHS selection committee visited the Cowie Galleries in the Biltmore Hotel and selected paintings out of the storeroom, including *Act One*, for the small *Purchase Prize Exhibit* that year. Osgood later was an effective arts administrator in Laguna Beach, as President of the School of Art and Design (now Laguna College of Art and Design) from 1961 to 1974, and of the Laguna Beach Art Association (now Laguna Art Museum) in 1964–1965.

Richard Carver **HAINES**
b. Marion, Iowa, 1906
d. Los Angeles, California, 1984

Fogbound, c. 1956
Oil on canvas
24 x 20 inches

Class of Winter 1956

Richard Haines's poetic and magical work reveals a strong sense of abstract design, color, and line. In *Fogbound*—the last painting that GHS students voted on and gifted to the collection—line divides and contains a myriad of painterly textures and colors in the blue spectrum. The reflection caught in the wet, slick surface of the pier is tactile, imparting a sense of the viscosity of water—and of paint. What appears to be a paint can sitting on the pier adds to the mystery. Haines also experiments with the simultaneity of abstraction and figuration; fog erases the horizon line, thereby flattening the picture plane, while the pier structure emphasizes depth.

Haines studied at the Minneapolis School of Art and the Ecole des Beaux Arts in France. He was a commercial artist and then a muralist during the Depression under the Treasury Section of

Painting and Sculpture in the Midwest. He moved to Los Angeles in 1941 and taught at Chouinard Art Institute from 1945 to 1952 and as head of the Otis Art Institute painting department from 1952 to 1974, during a crucial period in the development of postwar art in Los Angeles.

Although Haines never abandoned figuration in his work, his reductive approach, attention to the sensuality of the painting's surface, and flattening of the picture plane indicate an interest in asserting the direct presence of the canvas over any reference to its subject matter. If Haines had pushed his abstraction further, it might have ended up looking not unlike Richard Diebenkorn's Ocean Park Series.

Aftermath

In a 1958 interview with the *Los Angeles Times*, Lloyd W. Waller, principal of Mira Costa High School in Manhattan Beach, said that an inspiration for his school's annual class gifts was the tradition begun by Gardena High School. He noted that "senior classes there began collecting art way back in 1919. But they had to stop in 1956—no picture hanging room left."[1] This assessment was accurate: there was no room for the paintings at the new campus. But that was by design.

Rather than planning the new auditorium around the collection, the architect of the new high school designed a small gallery that accommodates only fifteen to twenty paintings. (fig. 48) Although it is not clear why this decision was made, it was indicative of the contemporaneous school administration's lack of interest in the collection.[2]

When the new high school was built, the faculty was divided between Gardena High School and Robert E. Peary Junior High and, after much discussion and some infighting, so was the art collection, with the annual class gifts designated for the new high school campus and the other donated works going to the junior high. While negotiations were in progress, these plans were nearly upended when the Los Angeles Unified School District threatened to take possession of the paintings and move them to its downtown offices. When Gardena Alumni Association President Frank Barton learned about this plan, one of the people he contacted was alumnus and California State Senator Ralph C. Dills, who asked Governor Edmund "Pat" Brown Sr. to intervene. As a result of their combined efforts, the LAUSD retracted its decision.

Until the late 1960s, paintings hung in the auditorium, classrooms, and administrative offices of both campuses. At Gardena High School, most works were stored in the vault-like cement storeroom built into the small gallery. Although it was furnished with racks for the storage of paintings, air conditioning—required to maintain proper humidity and climate control—was never installed. From time to time, until about 1960, the gallery featured a selection of works from the permanent collection. But this space was also used for classes and for other purposes, such as exhibiting students' art.

After GHS stopped collecting and exhibiting the collection, the Gardena Art Association evolved into a succession of other organizations with similar priorities. The Gardena Valley Art Association mounted its first art exhibition in 1961. An ad in the *Los Angeles Times* in 1966 announced the association's *Fifth Annual Exhibit*: one hundred paintings by forty leading artists of the community. It was held July 11–22 in the lobby of Great Western Savings, at 2501 West Rosecrans Avenue in Gardena.[3] Two years later—with the cooperation of John J. Hunt, then principal of Gardena High School—Jack Hoel, vice president and branch manager of the bank's Gardena office, arranged for an exhibition in the lobby of thirty-three of the paintings from the GHS collection, "in order to continue cultivating interest in the cultural wealth of our community."[4]

From 1973 to 1991, Phila L. McDaniel, an art instructor at Gardena High School, assumed the role of art chairperson and curator of the permanent collection. During this period, regional plein-air painting began to be viewed as historically important as well as commercially viable, and these works rapidly increased in value. In the 1970s, a reassessment of American Scene and California Impressionist painting placed them within the long tradition of realism in American art and coincided with renewed interest in figurative styles in general. Aware of the increased value of the GHSAC, McDaniel recommended withdrawing the art from classrooms and the gallery and placing it in more secure locations on campus, such as administrative offices and the principal's conference room. And that's where a small selection of paintings remained until 1998.

In March 1975, Scripps College faculty organized an exhibition and educational program using the GHS collection, funded by a $30,312 grant from the National Endowment for the Humanities. Classes throughout the region in the Mentally Gifted Minors Program were supposed to incorporate the Gardena High School Art Gallery in their curricula.[5] Around this time, Gardena art students began painting murals on the walls of the buildings, which beautified the campus, reduced the potential for graffiti, and were seen as an extension of the artistic legacy of the school. African American artist Alonzo Davis, a substitute teacher who addressed social justice in his work, had suggested the project to the students.[6] Also this year, some of Phila McDaniel's former art students

48.
Gardena High School art gallery, built in 1955 (2015 photograph).

returned to exhibit their work in the school gallery. An unfortunate event was the 1975 school fire mentioned earlier in this essay; a student disgruntled about his grades who wanted to eradicate his records ignited it in the counseling office. Three paintings were lost: *The Blue Hill*, by Dana Bartlett (Summer Class 1929), *Desert in Bloom*, by F. Grayson Sayre (Summer Class 1931), and *Twelve O'Clock*, by Ruby Usher (Winter 1952).

Concerned about proper maintenance of the collection, McDaniel established the community-based nonprofit Friends of the Gardena Collection. She opened an account at Sumitomo Bank in Gardena for donations to an art restoration fund.[7] A change in the school's administration eventually forced her to close the bank account and move the remaining funds to the longstanding student body account. In a Friends of the Gardena Collection newsletter sent to alumni and distributed at several class reunions, McDaniel reported on the progress of collection maintenance. She also attempted to reestablish the tradition of senior class purchases of contemporary art as class gifts; between 1980 and 1984, four classes voted to donate paintings to the school. In 1986, a selection of nineteen paintings traveled to the Hoffman Gallery of the Ventura County Historical Museum in San Buenaventura, California. In 1989, for the second consecutive year, McDaniel was one of ten finalists for the annual Bravo Awards for excellence in teaching the arts. She also organized showings of the collection on campus for the 1991 and 1993 class reunions.

After the 1993 exhibit, four alumnae—Janet Coverly Stapp (Summer Class 1952), Rosemary Parrish Best (Winter Class 1952), Sandra Gough Haas (Winter Class 1953), and Janet Perdew Halstead-Sinclair (Summer Class 1950)—were concerned that no administrator, alumnus, or community leader was in charge of maintaining and restoring the paintings. To raise funds, the women made copies of the 1952 edition of Lorenna K. Poulson and Everett L. Eaton's book, *Art Collection*, which spanned the years 1919–1952, and sold them for fifteen dollars apiece. They opened a trust account and continued selling the books until 2004. Proceeds from the sales were sufficient to pay for the restoration of several paintings.[8] This was one of the first concerted alumni efforts in many years to protect the paintings; it led to the formation of GHS Art Collection, Inc. The reemergence of the art collection catalogue helped bring the collection back into the light.

By 1993, the collection had long been out of public view. Largely relegated to storage, the paintings were in serious need of restoration when Dr. Robert C. Detweiler, President of California State University Dominguez Hills, learned of the collection's existence. In January 1999, with his support, University Art Gallery Director Kathy Zimmerer-McKelvie conserved and exhibited thirty-one paintings.[9] *Painted Light: California Impressionist Paintings from the Gardena High School/Los Angeles Unified School District Collection* and its associated publication and educational component were underwritten by a generous grant of three hundred thousand dollars to the university from the W. M. Keck Foundation. Guest curator Jean Stern, executive director of The Irvine Museum, to which the exhibition traveled after CSU Dominguez Hills, pronounced the paintings "representative of one of the most remarkable and distinctive schools of regional American art." The fifty-four-page publication accompanying the exhibition contained a biography of each of the thirty-one artists. Thus, after a period of dormancy, the collection began a second life.

As in the days when the Gardena Art Association supported the annual exhibit and purchases, the effort to restore the paintings and organize *Painted Light* created widespread interest in the community. This effort was an enormous undertaking. The paintings were scattered throughout two campuses, some were lost, and cataloguing the collection was difficult because little documentation existed. The project brought together numerous individuals and groups, including alumnae Rosemary Best, Sandra Haas, and Frances Kaji; Ann Sutton of the Gardena Art Association; Gardena High School staff,

including Principal Michael Perez; Torrance Unified School District; Los Angeles Unified School District; the City of Carson Fine Arts and Historical Commission; and The Irvine Museum.[10] Huell Howser, host of the TV program *California Gold*, shown on California PBS stations, filmed an episode of his human-interest series at The Irvine Museum. At the close of the exhibition, CSU Dominguez Hills presented the Gardena High School student body with a check for ten thousand dollars, representing half of the proceeds from the sale of the catalogue. The funds supported the installation of a vault door for the storeroom and another round of painting restoration. Soon thereafter, a small group of works traveled to the Gene Autry Western History Museum in Los Angeles; fifteen of the paintings remained on long-term loan to the museum. In 2015, the Autry showed nine of the paintings in a small exhibition, and Gardena High School students were bused to the museum to see it. This was the first time since 1999 that GHS students had even heard about the collection.

According to notes on the history of the collection written by McDaniel, as early as 1949, the City of Gardena and the Gardena Art Association had hoped to build a cultural center that would house the GHS art collection. One reason the Gardena Valley Cultural Arts Organization was founded in the 1980s was to make that dream come true. A plan to build a museum on the old farm property on campus was almost successful. However, because the land was officially owned by Los Angeles, Gardena could not support the plan. Instead, low-income housing is being built on the property. One complex, completed in 2016, houses cafeteria workers, bus drivers, and special education assistants—the lowest-paid employees in the school system.

In 2004, Gardena High School celebrated its Golden Jubilee. The centerpiece of the festivities was an exhibition at the school of forty paintings from the GHS collection, organized by Janet Perdew Halstead-Sinclair and her son, James Halstead (Class of 1975). The public response was enthusiastic, and Halstead created a narrated DVD of the collection that raised several thousand dollars to support painting conservation.

In 2007, the LAUSD Arts Education Branch Archivist visited Gardena High School and Peary Middle School to appraise and photograph the collection. The archivist affixed two labels to each painting, attempting to establish LAUSD's ownership of the collection. The upshot was a series of meetings of the LAUSD and its Arts Education Branch with Gardena High School and the Gardena Alumni Group. Alumni Group chairman Wayne Johnson (Class of 1966) maintained that the collection consisted of gifts from each class to Gardena High School and not to the LAUSD. Halstead-Sinclair produced a 1965 memo from the LAUSD Superintendent stating that the Art Collection belonged to the GHS Associated Student Body—evidence that led the LAUSD attorney to concur and to affirm that the high school principal properly served as trustee of the collection. However, the LAUSD Student Body Finance Section considers paintings in the collection that were donated to the school to be LAUSD property. This issue remains a point of contention, because donors of artworks had clearly intended them to be part of the GHS art collection.

In May 2009, on the advice of Bill Johnston, retired superintendent of LAUSD, Eiko Kamiya Moriyama (Summer Class 1961) sought out Halstead-Sinclair. The women proposed the formation of a nonprofit committee to preserve, protect, and exhibit the art collection and ensure its legacy in the community. In 2010, the State of California granted nonprofit status to the GHS Art Collection, Inc., composed primarily of Gardena High School alumni. The directors are Bruce Dalrymple (Summer Class 1961), Janet Perdew Halstead-Sinclair (Summer Class 1950), Craig K. Ihara (Summer Class 1961), Carol Kofahl (Class of 1970), Pamela Nokes Rockwell (Summer Class 1961), Simon K. Chiu, Justin E. D. Daily, Keith Colestock, and Bea Walker. Eiko Kamiya Moriyama (Summer Class 1961)

and Jane Tadakuma Tokubo (Class of 1973) retired in 2017. It is the directors' hope that the collection can once again play a role in the education of current and future generations of students in the South Bay and beyond. In 2015, the nonprofit started a fundraising campaign to conserve the paintings and to underwrite an exhibition and publication featuring the collection, in anticipation of its hundredth anniversary in 2019. The goal of the Hundredth Anniversary Project is to document Gardena High School Art Collection's extraordinary story of community collaboration and to preserve and protect the collection for future generations. Since January 2015, the directors have hosted an annual alumni fundraising event with a selection of the paintings on view at the Gardena High School and guest speakers. They have included Jean Stern, then executive director of The Irvine Museum (2015); Susan M. Anderson, Hundredth Anniversary Project curator and publication author (2016); and Eugena Ordonez, art conservator for the project (2017). In February 2016, the nonprofit funded the first art insurance policy, providing full-value coverage for the art collection. Conservation of the collection began in April 2016. Over a period of two years, conservator Ordonez cleaned or restored some thirty paintings—work that was funded by donations to the GHS Art Collection, Inc. In March 2017, the directors contracted with art book designer Garland Kirkpatrick to design the publication and secured a contract with the Pasadena Museum of California Art to organize and host a two-venue traveling show of the hundredth-anniversary exhibition. Although the museum subsequently closed, the organization of the exhibition and tour continued under the direction of the GHS Art Collection, Inc. The directors also relocated GHSAC paintings from the high school storage closet to a professional climate-controlled art storage facility. In addition, the nonprofit organization underwrote and coordinated photography, editing, design, printing, and distribution of the hundredth–anniversary publication.

The long-term goal of the nonprofit organization—to provide in perpetuity for the care and exhibition of the collection for educational purposes—may possibly involve a partnership with a well-established art and educational institution in the Southland. The GHS Art Collection, Inc. board hopes that the Hundredth Anniversary Project will help achieve this ultimate goal.

148

49.
GHS graduates, *El Arador*, 1952.

Solutions in High School Art Collections

During the run of the 1931 *Purchase Prize Exhibit, Los Angeles Times* art critic Arthur Millier wrote an extended piece about the Gardena High School art collection that included a discussion of its influence on other schools. Middle schools, high schools, and colleges in greater Los Angeles had begun to collect based on the GHS example. In 1935, the *San Bernardino Daily Sun* announced that Glendale High School and Junior College and San Bernardino Junior College

had established collections as a result of the "shining example set by Gardena high school."[1] In 1936, according to an article in the *Press-Telegram* of Long Beach, "Gardena's collection . . . has become so famous that schools all over the Southland are studying the project with the idea of adopting a similar program. More than a dozen schools have made their start toward such a permanent exhibit within the past year."[2]

Los Angeles Unified School District has identified numerous schools that have or had California Impressionist or plein-air paintings, including Washington, Franklin, Marshall, Manual Arts, Los Angeles, South Gate, Alhambra, and Canoga Park high schools. Middle schools that had or have plein-air paintings include Burroughs, Cochran (formerly Mt. Vernon), Dana, Dodson, Hollenbeck, Irving, Bancroft, Le Conte, and Berendo.[3] Today, many of these works of art are part of the LAUSD Art and Artifact Collection; several paintings are on view in the district office.

The Gardena High School *Purchase Prize Exhibit* was a model program. It was locally initiated and partially funded with community money; it created something of value to the entire community, and it provided useful training for young people who thereby became more integrated into the life of their community. The program far outlasted any of the other regional high school art-collecting efforts. Many Los Angeles schools started art collections modeled after Gardena's but without launching a purchase prize exhibition, which was an enormous undertaking and required widespread community involvement to succeed. Few other schools would attempt to organize, or could sustain, an annual exhibition.

However, we know that Bellflower Middle/High School, Paramount High School, Clearwater High School, and Beverly Hills High School formed art collections and instituted annual purchase prize exhibitions modeled after Gardena's—Bellflower and Paramount in 1933, Clearwater in 1935, and Beverly Hills in 1936. Beverly Hills High School's exhibition was also a three-week affair with a purchase prize of three hundred dollars supporting the students' selection. The PTA and civic groups were involved, and the Beverly Hills Board of Education provided lighting equipment. Like the GHS program, the exhibition opened with a dinner, whose proceeds funded the purchase of a painting.[4] At Paramount High School, which held its sixteenth annual exhibition of paintings in 1949, tenth-grade students bought one oil painting and one watercolor for the permanent collection every year.[5] Mira Costa High School in Manhattan Beach held its second annual purchase prize event in May 1950.

Gardena High School was an early adopter of the community-based art festival model, which spread throughout the region beginning in 1950 with Los Angeles' *All City Outdoor Art Show.* Other community-oriented entities held exhibitions throughout Southern California, including the Long Beach and Palos Verdes Arts Associations and Compton, site of the Mid-Cities' annual.[6] As a result, the Gardena High School exhibition, which had been one of the primary venues for exhibiting regional art in the 1920s and 1930s, lost much of its impact. By the early 1950s, California Impressionist and American Scene painting were critically regarded as anachronisms. As Arthur Millier wrote, "There was no return to the ascendancy of comfortable landscape painting. The American Scene, replete with gas stations, coal mines, and soft-drink signs stemmed from the depression art projects[,] gradually giving way to two other types of painting—the superrealistic and the abstract."[7] Soon, Abstract Expressionism and other more avant-garde styles would predominate. Remarks made by alumni suggest that Gardena High School students were willing to take up the challenge, but as we have seen, larger forces were at work and the program ended in 1956. Meanwhile, other high school art collections managed to sustain their relevance to their communities.

50.
(detail) Robert Irwin, *Ibizi 56,* 1956.
Oil on canvas, 26 x 48 inches.
Ruth Stoever Fleming Collection of
Southern California Art, Newport Harbor
High School.

Springville High School Art Collection

The longest-lived high school art collection in the United States is the Springville High School art collection in rural Springville, Utah. The school's annual *Spring Salon* was the inspiration for Gardena High School's exhibitions, as acknowledged by Olive Hensel Leonard, a former GHS librarian who wrote about the collection's formation in 1941.[8] In 1930, the Springville High School principal visited the Gardena High School *Purchase Prize Exhibit*, probably to renew his contact with the California plein-air painting community. Unsurprisingly, Springville relied heavily on nationally respected California artists to send paintings for the *Spring Salon*. There are many similarities in the development of the two collections, as well as some key differences. For example, Springville students did not choose the prize paintings; an Art Board that included visiting artists—most likely, some from Los Angeles—made the final selections.

In 1905, when Springville High School opened, it established a public art gallery known as the Art Institute of Springville in the school auditorium. Seven years later, when a new high school building was completed, the permanent collection was split between the old campus (now a junior high) and the new campus, and displayed in the classrooms, halls, and auditorium of both schools. In April 1921, the high school founded the *Spring Salon* exhibitions of work by Utah artists, and the students started to visit artists' studios. The 1923 salon was the first to include out-of-state artists, many of whom were from the West Coast. In 1925, the school legally relinquished the art collection, and a separate nonprofit entity, the Springville High School Art Association, assumed the care and ownership of the collection.

In 1929, Macbeth Gallery in New York and Robert C. Vose Gallery in Boston sent American Impressionist and Tonalist paintings to the newly named *National Spring Salon*. While this annual exhibition quickly gained national attention and was said to inspire other high schools across the country to collect, Gardena's art education program appears to have received equal national attention and to have had as much national impact as Utah's collection. By the turn of the century, the powerful advertising machine of Los Angeles' civic boosters had established many connections at national publications. Arthur Millier, a staunch supporter of Gardena High School's program, was a correspondent for *Art Digest* and other national magazines published in New York. However, the annual salons in Springville drew more visitors than Gardena's exhibitions, since there were few other art venues in Utah. In 1932, the town had a population of only 3,748, with five hundred students in the high school. The $3,500 cost of the annual exhibit was almost entirely paid for by the students. The program also had the support of the Church of Jesus Christ of Latter-day Saints (the Mormon Church), and in 1935, a city tax was levied to help defray the Art Institute's expenses.

In 1937, with matching funds provided by citizen groups, the City of Springville, and the Church of Jesus Christ of Latter-day Saints, the WPA constructed a new art center with classrooms for the arts and a new art gallery. Its name was changed in 1962 to Springville High School Museum of Art. In the fall of 1967, Springville High School moved to a new campus. According to Springville Museum historian Vern G. Swanson, the move caused the museum to suddenly lose "its bearings, workforce and half its *raisonne d'etre*." Direction of the museum, renamed the Springville Museum of Art, was now in the hands of a professional staff. In 1975, a new crisis arose when the Nebo School District Board proposed selling the building and its collection, even though the district had relinquished control over the collection years earlier. After negotiations, it was decided that the City of Springville and the Springville Museum of Art Association would jointly assume operation of the museum.

Over the years, and under the direction of museum professionals, the collection has been refined through deaccessions and gifts of art from generous donors.[9] Springville

High School still donates a work of contemporary art to the museum through the *Annual Spring Salon*. In addition, a network of community-based programs continues to knit the museum and community together, making the museum a city cultural hub as well as a major source of arts education for the state of Utah.

Greater Latrobe Senior High School Art Collection

Another outstanding high school art collection with many similarities to the GHSAC is the Greater Latrobe Senior High School collection in western Pennsylvania, founded in 1936. Over two hundred works of Southwestern Pennsylvania art are on view in the hallways of the high school, and the collection is growing every year. During the Great Depression, teachers at the high school arranged for a special traveling exhibition at the school, drawn from the annual exhibition of the Associated Artists of Pittsburgh. In 1938, the student council founded the Latrobe One Hundred Friends of Art, an organization with annual dues of one dollar, which continues to support the art collection. Membership now far exceeds the original one hundred "friends."

The GLSD Art Conservation Trust, founded in 1991, oversees the art collection and raises funds for its conservation and maintenance, and for special projects. A broad-based volunteer committee composed of community leaders, school district administrators, and staff and faculty representatives, the trust has raised funds for special projects that include catalogues of the collection and construction of the Center for Student Creativity at the senior high school. In 2001, the trust raised nearly two million dollars for the center, which also houses a community center for classes, performances, and social gatherings. Funding came from the school district, foundations, corporations, and numerous individual gifts. The trust also holds an Art Gala each year at the high school while the works under consideration for the collection are on exhibit.[10] This ongoing partnership between the school and the community has enabled the art collection to grow and be preserved for future generations. The paintings line the hallways of the school, where the students can see them every day; alumni make special visits every year.

Albuquerque High School Art Collection

Less is known about the development of Albuquerque High School's art collection, formed from 1926 to 1958, and from 1977 to 1982. However, the collection clearly profited early on from generous donations and inspired purchases of art from artists in the Albuquerque area. In later years, the support of well-known artists only tangentially connected to the school—such as members of the Taos art colony—was equally significant. Many former students who had become prominent regional artists also either sold or donated art to the collection. As described in the catalogue, "The combination of an artistically oriented staff and faculty and such illustrious works of art gracing the halls, the library, and the offices of the school helped created a milieu where there was a remarkable consciousness of art."[11] Rather than serving to encourage art appreciation, the collection seems to have been primarily a catalyst for the formation of budding artists.

In 1974, the high school moved from its old brick building to a new location where, for security reasons, the paintings were kept in administrative offices and rarely seen by the public. Soon, alumni efforts brought new donations to the collection, spurred in part by the high school's preparations for a celebration of its centennial (1879–1979) honoring "an entire generation of the school's graduates [that] had come to maturity as artists."[12] By 1982, a growing number of alumni and friends of the collection decided that the valuable collection "should be kept under more appropriate conditions of security, light, climate and temperature control than were possible at Albuquerque High School."[13] Now part of the permanent collection of the Albuquerque Museum, the Albuquerque High School Collection is a memorial to those who built and preserved it, and a permanent tribute to the students of Albuquerque High School.

51.
Robert Irwin, *Ibizi 56*, 1956.
Oil on canvas, 26 x 48 inches.
Ruth Stoever Fleming Collection of
Southern California Art, Newport Harbor
High School.

Newport Harbor High School Art Collection

Closer to home, the Ruth Stoever Fleming Collection of Southern California Art is on permanent exhibit in the school library at Newport Harbor High School after nearly being lost to history. The collection started in 1935, when Principal Sidney Davidson urged the senior class to visit galleries in Los Angeles and choose a painting as a gift to the school. Although there is no documentation to prove this, the Orange County high school must have been inspired by the example of Gardena High School. However, the Newport Harbor approach differed in that the students neither raised the funds for the paintings nor selected them.

Principal Davidson hired Ruth Stoever (later Fleming) as the school librarian in 1938. Seven years later, she suggested organizing an annual open-call exhibition with funds from the Newport Beach Chamber of Commerce supporting a purchase prize of three hundred dollars for a painting of a Southern California subject. She assembled a jury consisting of an art critic, an artist, a high school art teacher, a ceramist, and a civic leader. The exhibit was on view for four days, open to the public at a tea served by the PTA. By 1948, the juried selection began to diverge from straightforward regional landscapes to encompass the variety of contemporary styles emerging in Southern California. The exhibitions, which Stoever organized singlehandedly at first, soon expanded and were shifted to successively larger spaces on campus. In the 1950s, she selected three jurors— a professional artist, an art school instructor, and a museum professional—to insure the high quality of the art. By the late 1950s, when Gardena High School's art program had been dissolved, the Newport Harbor exhibition had become a huge undertaking, with a group of community art aficionados helping to organize the show. In 1960, when Ruth Fleming retired, community members formed the school's Art Advisory Committee. By 1962, the *Newport Harbor Art Exhibit* had acquired a full calendar of events and was recognized throughout the western United States. The annual exhibit ended in 1966, when the principal deemed contemporary art, with its abstracts and nudes, unsuitable for a high school art collection. The cost had also become prohibitive due to the size of the

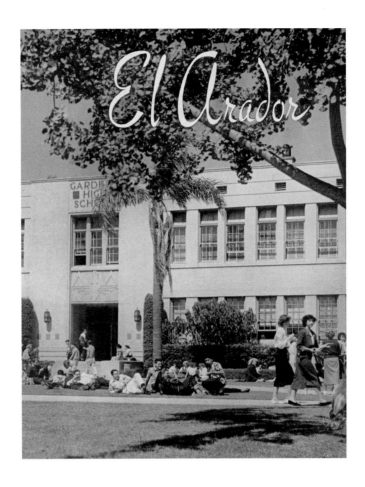

52.
GHS campus, *El Arador*, 1952.

undertaking: as many as eight hundred paintings were submitted for jurying, making the selection process a near-impossible task. The district dispersed the art among the four Newport-Mesa high schools. Eventually, the paintings were moved to administrative offices and even private homes.

John McGinnis joined Newport Harbor High as librarian in 1983. He formed a committee to track down, restore, and return the fifty-seven paintings to the high school library. Because the art had risen in value, it was necessary to install surveillance cameras and to secure the paintings to the wall. McGinnis succinctly described the collection in a 2013 interview: "The chief value of this collection, as opposed to most other high school collections from the Depression era, is that it contains an evolving representation of the art scene in California, and the United States for that matter, from the 20s to the 60s. It contains everything from plein air to abstract expressionism to pop art. It contains oils, watercolors and collage." [14] This is an example of what might have happened at Gardena High School if the students had been allowed to collect art after 1955.

Conclusions

For the Los Angeles plein-air artists of the turn of the twentieth century, the California landscape was a sacred terrain that embodied their deep engagement with nature and the environmentalism of the Arts and Crafts Movement. For the working-class farming community of Gardena, with its vital connection to the land, plein-air landscape was a natural fit. For the California Impressionists' dealers, patrons, and writers, paintings of the

land represented the harnessing of an image for consumption. Or, as historian William Hackman put it, "As with so much else concerning the history of Los Angeles, speculation in land and real estate was the engine that propelled the art world."[1]

Gardena High School served as a neutral space in which the ongoing debates about art and civic identity in Los Angeles played out. However, even at the high school, the organization of the annual *Purchase Prize Exhibits* within the civic realm had its consequences. Although the students demonstrated independent thinking, making increasingly adventuresome choices through the decades, the collection as a whole reflects the influence of Principal Whitely and the California Art Club, both of which supported traditional California Impressionist landscape painting. Their preference reflected the origins of the collection in 1919, when the Arts and Crafts Movement, with its attitude of oneness with nature and reverence for the land, was still regionally relevant, and California plein-air painters were the entrenched establishment. As time went on, and artists became embroiled in the struggle between "conservatives" and "modernists," this emphasis became an impediment to the acceptance of vital forms of modernist art.

An examination of exhibition checklists of the late 1920s and early 1930s shows that Gardena High School's annual exhibits included a variety of stylistic approaches, including Expressionism and Post-Impressionism. However, the students consistently gravitated toward clarity of form, choosing a Carl Oscar Borg rather than a Charles Reiffel, or a Jean Mannheim rather than a Donna Schuster. They also very rarely selected the work of a woman artist, though women accounted for at least a third of the paintings submitted to each annual.

The students purchased their first figurative painting in 1924, John Hubbard Rich's *The Brass Bowl*, which reflected Robert Henri's Ashcan School of realism and Gardena's Hispanic strain of history, culture, and ethnicity. Joe Waáno-Gano's *Ceremonial Night* (or *Indian Nocturne, Ceremonial Night*) is the only painting by an artist of color in the collection; no works by Japanese American artists were collected by the students even though a small Japanese artistic population was aligned with the modernist Los Angeles Art Students League at the time.

Only in 1930 did the Gardena High School students begin to choose art that diverged from traditional plein-air landscape. The first genre painting in the collection was Dan Sayre Groesbeck's *Loading the Barge* (1931); the first work by a woman was Kathryn Leighton's portrait *Chief Bullchild* (1932). Throughout the 1930s and 1940s, the students continued to select landscapes, sporadically alternating them with American Scene paintings, beginning with the purchase of Robert Clunie's *River Dwellers* in 1936. For many years, rather than seeking a variety of stylistic approaches, the students were primarily concerned with avoiding the repetition of subject matter. This made for a strong and coherent collection of landscape and genre paintings reflecting aspects of the American West. Beginning in the late 1930s, the school exposed the students and the community to both sides of the aesthetic debate at the annual dinner, with speakers alternating from year to year between "conservatives" and "modernists." However, the annual exhibitions still primarily invited submissions of traditional rather than modern art. Even though Lorser Feitelson, an internationally known abstract painter, spoke at the annual dinner in 1949, he rarely participated in the annual exhibits and never won a purchase prize from the students. This situation began to change around 1950, when artists in Los Angeles began to experiment with numerous artistic approaches, including figurative abstraction, Cubism, Surrealism, and Hard Edge abstraction. That year, the students selected their first and only figurative abstraction, *Return of the Prodigal*, by Francis de Erdely. By 1954, they were selecting paintings that reflected the new artistic pluralism of Los Angeles. The collecting program ended in 1956, just as Abstract Expressionism, geometric abstraction,

53.
Van de Kamp's Bakery. One of numerous businesses in Gardena exhibiting art as a result of the prominence of the GHS annual exhibit, 1953. (United Press Photo)

157

assemblage—and, a few years later, Finish Fetish—became the dominant modernist styles. The Ferus Gallery, which opened the following year, would put Southern California's avant-garde art on the map.

Tracing the history of Gardena High School's community-based art education program reveals that a broader public than was previously known—one that was ethnically diverse and driven by educational rather than economic values—participated in the development of regional art. The GHS art education program always served an ethnically diverse student body. All seniors at the high school were required to take the art appreciation class, vote on the class gift, and participate in the planning for the annual dinner and exhibition. They also acted as hosts at the spring functions, annual dinners, afternoon teas, and other special events. Designed to help students practice their social skills and become integrated into the larger community, these events were organized by regional clubs and civic groups. These aspects of the art program all contributed to the students' active interest in art and the development of their collaborative, teamwork, and social skills, as well as their ability to get along with people from different backgrounds.

During the formative years of the art collection, its leadership was almost entirely white and middle-class, as can be seen in the photograph of the Gardena Art Association, taken at the annual dinner in 1935. (fig. 39) Rare extant lists of the association membership confirm that at least a handful of Japanese businesses in town were members of the association and supporters of the art collection in the 1930s, including Asahi Garage and Kurato Dry Goods Co. Other instances of Japanese community involvement included visits by Japanese Clubs across Los Angeles to the annual *Purchase Prize Exhibits*. In 1941, as mentioned earlier, the Kobata Brothers donated flowers for the annual dinner, and Japanese families presented the school with works of art to add to the collection.[2] A photograph of the annual banquet held that year shows that the audience was far more integrated than it had been earlier. The Spanish-American Institute, a local orphanage and boarding school teaching vocational skills to Hispanic students, was also an early and longstanding supporter of the association.

An examination of GHS yearbooks shows that it was only from around 1952 that Japanese American, Chinese, and Latino students began to consistently hold student body offices. A study completed in 1938 found that Japanese American students were "usually represented on the student council and in the class offices, occasionally reaching the honored position of class president." The study also found that the majority of students at GHS had friends among the other ethnic groups that made up the student body. According to Eiko Kamiya Moriyama (Class of 1961), the absence of racial tensions at the high school contributed to the strong sense of community in Gardena and its culture of acceptance. She said, "The one thing I often recalled at class reunions with my friends was, Weren't we lucky that our parents chose Gardena? Weren't we lucky we got to go to school together? Sit next to each other? Live together? Yet we were all of different ethnic backgrounds. But it was never an issue."[3] The 1960s were a watershed in Japanese American civic leadership. In 1960, Bruce Kaji—one of the first Japanese Americans to hold a public office in the United States—was elected city treasurer; six years later, Ken Nakaoka became the first Nisei to sit on the city council. Beginning in the late 1960s, the city's economic growth depended in large part on the familial and transnational connections of its leading Japanese American citizens, who operated as cultural brokers between Japanese corporations like Toyota, Seiko, Mazda, and Hitachi, and the town.[4]

Gardena native and former Mayor Edmond J. Russ grew up on a ranch. He remembered that Latino, Japanese, and Anglo farm laborers always worked well together. "When blacks began moving to Gardena in the 1960s, the harmony continued," he said. "There has never been friction among the city's ethnic groups, even during the turbulent

1960s civil rights movement." However, because African Americans moved to the community decades after the others, it took longer for them to rise to leadership positions in local government and in community services, such as the police force.[5]

Lorenzo Ybarra, whose family has lived in the Gardena area since the turn of the twentieth century, recalled that Gardena High School teachers in the 1950s didn't think Mexican Americans were qualified to pursue academic careers. Like the sons and daughters of other farming families, he was advised to take vocational courses. But after Ybarra earned business degrees at USC and Harvard, he was elected Gardena's City Treasurer, becoming the city's first elected Latino official in 1988. "Gardena serves as one of our best examples of how people can live together," Ybarra said.[6]

From 1919 to 1956, Gardena High School had an important role as interpreter, patron, and advocate of Southern California art, and its influence extended to other communities throughout the Southland and beyond. The longstanding relationship between the high school and the civic arena that resulted from the *Purchase Prize Exhibit* and its associated programming established a grassroots advocacy for visual art and endowed the community with a strong sense of identity. (fig. 53) For decades, the high school collection of California regional art provided a unique cultural and civic benefit for Gardena residents as well as for the art and education communities of Los Angeles.

Reminiscing about his part in the development of the Gardena High School Art Collection, Hanson Puthuff wrote:

> It was a great satisfaction to me that the young students should have appreciated my work. One episode stands out in my memory particularly. I was building a home in La Cañada in 1948 and had a load of bricks delivered by a young Mexican-American. He saw my name on the mailbox and asked my wife, Louise, if he might meet me. It seems that he had attended Gardena High School and had studied my painting in the art class there. After a visit, he said, 'Now I'm going back to tell my friends that I shook the hand of Hanson Puthuff.' How could I have a finer tribute![7]

The history of the Gardena High School Art Collection enriches our understanding of Southern California's social and cultural history and identity. It is to be hoped that the collection will continue to be available for students and community members, and appreciated as a remarkable chapter in the history of regional art and education.

Endnotes

54.
GHS campus, *El Arador*, 1952.

Preface

1. http://artgallery.yale.edu/about-mission.
2. Author's interview with Rosie Martinez, Principal, Gardena High School, 15 March 2016.
3. Maria Rosario Jackson, senior advisor to the Arts & Culture Program at The Kresge Foundation, asked these questions to identify more subtle characteristics in "How Creative Placemaking Plays a Role in the Creative Economy," *Artbound*, KCET-TV, 13 March 2015. https://www.kcet.org/shows/artbound/how-creative-placemaking-plays-a-role-in-the-creative-economy.
4. *Gardena Strategic Plan*, 2016–2021 (8 March 2016): 18. http://www.cityofgardena.org/wp-content/uploads/2016/10/StrategicPlanCombined-FINAL.pdf.
5. 2017 *Otis Report on the Creative Economy of the Los Angeles Region*, May 2017, 13. Prepared for Otis College of Art and Design by the Institute for Applied Economics, Los Angeles County Economic Development Corporation. https://www.otis.edu/sites/default/files/2017-LA-Region-Creative-Economy-Report-FINAL-WEB.pdf.
6. Lorenna Vanderlip Keliher, "History of the Art Exhibit," *Gardena High School Art Collection* (Gardena, California: Gardena High School, 1937); essay reproduced in *Painted Light: California Impressionist Paintings from the Gardena High School Los Angeles Unified School District Collection* (Carson, California: University Art Gallery, California State University, Dominguez Hills, 1999): 13.

Silent Teachers

1. Arthur Millier, "Art and Artists," *Los Angeles Times* (29 May 1927): 24.
2. "Ideas in Brief: Practical Ideas Selected and Condensed from Articles in State and Specialized Education Journals," *The Clearing House* 14, no. 1 (September 1939): 35.
3. Keliher, *Painted Light*: 13.
4. Nancy Moure, *Painting and Sculpture in Los Angeles, 1900–1945* (Los Angeles: Los Angeles County Museum of Art, 1980): 10–11.

5. The artists, all plein-air painters, were R. Clarkson Colman, Maurice Braun, Benjamin C. Brown, Edgar Payne, Guy Rose, Hanson Puthuff, Jack Wilkinson Smith, Elmer Wachtel, Marion Kavanaugh Wachtel, and William Wendt, eight of whose works the students would collect over the years. The gallery was at 826 South Hill Street. The Ten Painters Club was founded by Jane D. Lee, a curator in Los Angeles. See "Alice Gentle at Art Colony," *Los Angeles Times* (7 June 1933): A16.
6. The list of Arroyo artists whose work they bought included Franz Bischoff, Benjamin Chambers Brown, Alson Clark, Clyde Forsythe, Joe Duncan Gleason, Armin Hansen, Frank Tenney Johnson, William Lees Judson, William Henry Price, and Marion Kavanagh Wachtel.
7. The regional popularity of the craftsman aesthetic is largely attributed to George Wharton James and Charles Fletcher Lummis. James, who had been associate editor of Gustav Stickley's *The Craftsman*, published a short-lived magazine, the *Arroyo Craftsman*, in Los Angeles in 1909. A leading figure in the Southern California art community, he established the Arroyo Guild of craftspeople and painters. Lummis, editor of *Land of Sunshine* magazine, was also a voice for the craftsman aesthetic; he especially embraced the revival of interest in the Mission period. Lummis built his home in the Arroyo and founded the Southwest Museum there in 1914. The Arroyo Arts and Crafts community included several schools established to spread the ideals of the movement and to educate new designers and craftspeople, among them, the School of Design and Handicraft, founded by Ernest A. Batchelder, and the School of Fine Arts, founded in Pasadena by William Lees Judson, the first dean of the USC Art Department. Numerous writers, architects, and craftspeople were associated with the movement, many of them well known, including Charles Sumner Greene and Henry Mather Greene. Many clubs devoted to the study, making, and exhibition of Arts and Crafts objects flourished from about

1905 to 1930 in Southern California.

8. Richard Guy Wilson, "Divine Excellence: The Arts and Crafts Life in California," in *The Arts and Crafts Movement in California: Living the Good Life* (Oakland, California: The Oakland Museum, 1993): 16–17.

Engagement with Nature

1. Robert W. Winter, "The Arroyo Culture," in *California Design 1910* (Salt Lake City: Gibbs Smith, 1980): 14. Anyone seeking to understand the legacy of the Arts and Crafts Movement in Southern California usually begins by referring to the *California Design 1910* exhibition presented in 1974 at the Pasadena Art Museum. The exhibition and its catalogue provide a vivid account of a pivotal chapter in the development of art and culture in Southern California. Also, see Constance W. Glenn, *In Praise of Nature: The Landscapes of William Wendt* (Long Beach, California: University Art Museum, California State University, Long Beach, 1989). Glenn places Wendt firmly in the context of the Arts and Crafts Movement.

2. Wilson, "Divine Excellence," 21.

3. Katherine Plake Hough, *American Arts and Crafts from the Collection of Alexandra and Sidney Sheldon* (Palm Springs, California: Palm Springs Desert Museum, 1993): 63.

4. George Wharton James, "Hanson Puthuff and His Work: A Study and an Appreciation," *Arroyo Craftsman* 1 (October 1909): 33, 34.

5. Jean Stern, "Masters of Light," *Masters of Light: Plein-Air Painting in California, 1890–1930* (Irvine, California: The Irvine Museum, 2002): 22.

6. Bram Dijkstra, "The High Cost of Parasols: Images of Women in Impressionist Art," *California Light, 1900–1930* (Laguna Beach, California: Laguna Art Museum, 1990): 43.

7. William H. Gerdts, "The Land of Sunshine," *Masters of Light: Plein-Air Painting in California, 1890–1930* (Irvine, California: The Irvine Museum, 2002): 38.

8. Sarah Schrank, "Introduction," *Art and the City: Civic Imagination and Cultural Authority in Los Angeles* (Philadelphia: University of Pennsylvania Press, 2009): 4.

Cultivation

1. "Lay Corner in Gardena: Event Marking the Building of the New High School Is Celebrated, Masons Assist," *Los Angeles Times* (17 December 1906): II8. The school was founded as Jewell Union High School in 1904; its name was soon changed to Gardena Union High School, and eventually to Gardena High School.

2. William H. Knight, "General Rosecrans," *Los Angeles Times* (8 August 1897): 8.

3. "Elaborate Programme. Commencement Exercises at Gardena Union High School Promise to be Most Interesting," *Los Angeles Times* (13 June 1908): II12.

4. The first principal of the school was Mark R. Jacobs. He supervised the building of the school and was transferred to the science department of Los Angeles High School after serving at Gardena for six years. See "School Principal Plans to Retire," *Los Angeles Times* (13 May 1946): II2.

5. Agnes Emelie Peterson, "Reminiscences," in Lorenna K. Poulson, Art Collection, 1952 edition, 137.

6. "Busy Hive, Homeseekers Locate in Gardena," *Los Angeles Times* (21 August 1910): VI6.

7. Ross H. Gast, "Early Strawberry Deal Under Way in Gardena Valley," *Los Angeles Times* (15 April 1923): IX2. While five thousand acres of berries were cultivated in 1916, production declined in subsequent years.

8. Peterson, "Reminiscences," 137.

9. J.B. Lilliard, "Remarkable Agricultural High School," *The Journal of Education* 80, no. 18 (November, 19, 1914) 488–489.

10. "Distinctive School Makes Real Farmers," *Los Angeles Times* (29 August 1909): VI8.

11. "Unique Schooling in Agriculture. Gardena High to Be Actually Metamorphosed," *Los Angeles Times* (7 August 1909): III1.

12 "President Lilliard Receives High Tribute as Leader in Agricultural Education," *The Pony Express* (8 January 1930): 6.

13. Amos Gager Throop founded Throop Polytechnic Institute in 1891 as Throop University. The name was changed to Throop Polytechnic Institute (1893–1912) and then to Throop College of Technology (1913–1919). The school became Caltech (California Institute of Technology) on February 10, 1920.

14. James A.B. Scherer, "The Throop Idea," *Arroyo Craftsman*, September 20, 1909, 30; and *California Design 1910* (Salt Lake City: Gibbs Smith, 1980), 23; and *Good Life* (Oakland, California: The Oakland Museum, 1993), 170.

15. Otto Salomon, *The Teacher's Handbook of Slöjd* (London: George Philip and Son, 1891): 2.

16. Lorenna K. Poulson, "Miss La Veta Crump," *Art Collection*, 1952 edition, 132. Crump also taught basketry, reed, and metal art (she was also a silversmith).

17. "Gardena's Art Exhibit," *El Arador*, 1933, 17.

18. James A.B. Scherer, "The Throop Idea," *Arroyo Craftsman*, September 20, 1909, 30; and *California Design 1910*, 23; and *Good Life*, 170.

19. Antony Anderson, "Art and Artists," *Los Angeles Times* (22 November 1914): III6.

20. "City Boys and Girls Make Good Farmers," *Pacific Rural Press* 92, no. 19 (4 November 1916).

21. Ibid.

22. "Shoulders Onerous Task," *Los Angeles Times* (7 July, 1917): II3.

23. "City Boys and Girls Make Good Farmers."

24. Laura Schumm, "America's Patriotic Victory Gardens," *History* (29 May 2014). http://www.history.com/news/hungry-history/americas-patriotic-victory-gardens.

25. "Schools Will Teach Farming: Board Plans for Extension," *Los Angeles Times* (13 July 1917): II3.

26. I am indebted to GHS Art Collection, Inc., board member Keith Colestock, who was instrumental in tracking down

and verifying the information in John H. Whitely's biography. Principal Whitely was a native of Greenfield, Indiana. His father's occupation was listed as "farm hand." Whitely studied at the State Normal School and Purdue University, and graduated from the University of Indiana—where he played baseball—with a BA and MA. He had a "semi-occasional" position as a reporter for several years with the *Cambridge City Tribune*. He taught science in Cambridge, Indiana, and served as principal of three Indiana high schools (Paris, Illinois, and Greenfield) and superintendent of Greenfield Schools—all as a relatively young man. In 1909, Whitely moved to Los Angeles from Tacoma, Washington, where he was a professor of chemistry and biology at Whitworth College. Some of the information about Whitely is conflicting; he appears to have been renting a home in Tucson City, Pima County, Arizona with his family in 1910, suggesting that he lived there at least briefly before moving to Los Angeles to teach at Manual Arts. See also page 129 of the 1952 edition of the original 1936 volume *The Art Collection*, by Lorenna K. Poulson, produced and published by Everett L. Eaton.

27. "Valley Cities Enjoy a New Era of Progress," *Los Angeles Times* (11 March 1923): V13.

28. "Gardena High Drops Portion of Title," *Los Angeles Times* (31 March 1919): I5; and "Gardena Trips Over Coyotes," *Los Angeles Times* (3 December 1922): I8.

Majoring in Art

1. Olive Hensel Leonard, "Gardena High School Art Collection," *School Arts* (May 1941); see also Richard W. Reitzell, *From a Versatile Brush: The Life and Art of Jean Mannheim* (Moorpark, California: Arroyo Publishing, 2011).

2. Keliher, *Painted Light*, 13

3. "Art Club Reception to Be Held Tonight," *Los Angeles Times* (6 October 1921): II5. In 1915, the California Art Club began sponsoring traveling exhibitions of members' work. These exhibitions, created for the purpose of art education (not sales), were available to any club, school, or organization that requested them.

4. *Laguna Beach Life*, 23 April 1926.

5. George Quesenbery (Class of 1922), "The New Building," *El Arador*, 1922 GHS Yearbook, 7.

6. Fred Hogue, "Pointing the Way," *Los Angeles Times* (17 May 1923): II4.

7. Lorenna K. Poulson, *Art Collection* (1952 edition): n.p.; and Leonard, *School Arts*.

8. "Pointing the Way," *Los Angeles Times* (17 May 1923): II4.

9. Ibid.

10. H. O. Stechen in *California Graphic Magazine* (15 April 1932): 10, from the *GHS Scrapbook, 1928–1932*.

11. "H.S. Seniors Pick Prize Paintings," *Gardena Valley News* (11 April 1940): 1.

12. Richard Tatsch, "The Shops," *El Arador*, GHS Yearbook, 1921, 59.

13. "Looking Through the Lens at Bits of Life," *Los Angeles Times* (2 February 1924): 9; and "Thousands Graduated," *Los Angeles Times* (14 June 1925): B12.

14. However, in Gardena there were still 3,200 acres devoted to berries alone, according to garden and agriculture writer Ross H. Gast, "Early Strawberry Deal Under Way in Gardena Valley," *Los Angeles Times* (15 April 1923): IX2.

15. "Communities Southwest of City Report Increased Activity in Business, Industry Construction, and Development," *Los Angeles Times* (22 March 1925): F10.

16. Laura Wilford-Brown, "Former Farm Lands Changed," *Los Angeles Times* (25 April 1926), E12.

17. Antony Anderson, "Of Art and Artists," *Los Angeles Times* (22 November 1925): C43.

18. Leonard, *School Arts*.

19. "Oral History Interview with Ralph C. Dills," conducted by Carlos Vasquez, October 25, 1989, UCLA Oral History Program, for the California State Archives, State Government Oral History Program. http://archives.cdn.sos.ca.gov/oral-history/pdf/dills-1.pdf.

Art for the People

1. Christopher Reynolds, "Wright Angles," *Los Angeles Times* (11 June 2017): A15.

2. Dijkstra, *California Light*, 35.

3. Some, though not all, sources credit May Longest Puthuff together with her husband for suggesting the annual purchase prize exhibit. It is possible that Hanson Puthuff had recently been invited to exhibit in or jury the Springville High School invitational exhibit and saw the possibilities at GHS for a similar program.

4. Keliher, *Painted Light*, 14.

5. Arthur Millier, "Art and Artists," *Los Angeles Times* (4 March 1928): C30; and "Gardena Holds Painting Show," *Los Angeles Times* (21 April 1929): C9.

6. In today's dollars, $300 is the equivalent of $4,300; $400 is $5,725.

7. *California Design 1910*: 45.

8. "Students Select Pictures in List Picked by Judges," *Gardena Valley News* (3 May 1928): 8.

9. I am grateful to Alexis Curry, Head, Research Libraries and Archives, Balch Art Research Library, Los Angeles County Museum of Art, for sending me a PDF of the catalogue for the sixth annual *Purchase Prize Exhibit*, showing that the painting was a Summer Class Gift in 1928.

10. "News of the Art World," *Los Angeles Times* (10 March 1929): C16.

11. "Gardena Holds Painting Show," *Los Angeles Times*.

12. "Gardena High School Annual Purchase Awards," *The Argus* III, no. 3, June 1928.

13. Gardner L. Kane, "Teaching Youngsters How to Grow Plants," *Los Angeles Times* (28 October, 1928): J5. In 1912, Clayton F. Palmer, a teacher at GHS, defined his vision: "I am going to attempt to make it possible for every child in the grade schools of Los Angeles to know how to grow vegetables to supply his own table and to understand the growing of ornamental plants and flowers and the beautification of the home." Palmer started a successful, longstanding school garden program in the Los Angeles schools. The agricultural center included offices, laboratories, and

classrooms that experimented with and provided stock for the schools. A typical school garden was 200 feet x 60 feet and included a lath house for plant propagation.

14. "Students Select Pictures in List Picked by Judges," *Gardena Valley News* (3 May 1928): 8.

15. Author's interview with Roy C. Pursche, 6 July 2016.

16. Kevin Starr, *Endangered Dreams: The Great Depression in California* (New York: Oxford University Press, 1996): 229; and William H. Mullins, *The Depression and the Urban West Coast, 1929–1933* (Bloomington and Indianapolis: Indiana University Press, 1991): 5, 9, 13.

17. "Is Art Exhibit Worthwhile? Preacher Asks," *Gardena Valley News* (24 April 1930).

18. Arthur Millier, "Gardena Cultivates Art," *Los Angeles Times* (27 April 1930): B9; and Lee Shippey, "Culture Ousts Cuspidors," *Los Angeles Times* (20 April 1930): B15. Sixty-four students graduated in the summer; only seven in the winter.

19. Some of the other prominent artists were Ida Randall Bolles, Jessie Arms Botke, Benjamin Brown, Conrad Buff, Colin Campbell Cooper, Dean Cornwell, Paul Dougherty, William Griffith, Kathryn Leighton, Evylena Nunn Miller, Edgar Payne, and John Hubbard Rich.

20. "High School to Loan Art Masterpiece to Hollywood Bowl," *Gardena Valley News* (13 April 1933); and Leonard, *School Arts*.

21. "Nominating Petitions Circulated," *Los Angeles Times* (9 July 1930): 6.

22. Arthur Millier, "Bringing Art to 'Peepul' Tough Job But Satisfying,' *Los Angeles Times* (3 April 1932): B13.

23. In the late 1940s and 1950s, even private citizens could buy the works of art.

24. "Museum Curator Sings Praises of Art Exhibit," *Gardena Valley News* (23 April 1931).

25. "Fun Night to Benefit Art Exhibit," *Gardena Valley News* (7 May 1931); and "Benefit Play Raises $105 For the Art Exhibit," *Gardena Valley News* (19 March 1932).

26. "Reunion to End Use of School Building," *Los Angeles Times* (18 June 1932):

A6; and "Schools Ready for New Term," *Los Angeles Times* (11 Sept. 1932): A1.

27. Kevin Starr, *Endangered Dreams: The Great Depression in California* (New York: Oxford University Press, 1996): 226.

28. Lee Shippey, "The Lee Side O'L. A." *Los Angeles Times* (31 October 1932): A4.

29. "Gardena's Art Exhibit Will Be Opened Tonight," *Los Angeles Times* (29 March 1932): 12.

30. Also, *El Centinela, Sierra Madre News, El Segundo Herald, Manhattan Beach News, Van Nuys News, Los Angeles School Journal,* and others.

31 . "Gardena's Fifth Annual," *The Art Digest* (1 April 1932); and Peyton Boswell letter to Principal Whitely, *GHS Scrapbook*, 1929–1933; n.p, n.d.

32. "Gardena, California," *The American Magazine of Art* 24, no. 6 (June 1932): 460.

33. "Invite 169 to Display Work at Art Exhibit," *Gardena Valley News* (3 March 1938).

34. Arthur Millier, "Brush Strokes," *Los Angeles Times* (19 March 1933): A4; and Melissa Milios, "Gardena's Roots," *Daily Breeze*, Torrance (19 August 2004).

35. "Art Exhibit to Open April 28th," *Gardena Valley News* (6 April 1933); and "Elaborate Opening of Art Exhibit," *Gardena Valley News* (20 April 1933).

36. Roscoe Shrader letter to Principal Whitely, 8 February 1929, Gardena High School Scrapbook 1929–1933, n.p.

37. Benjamin Brown letter to Principal Whitely, 21 March 1929, Gardena High School Scrapbook 1929–1933, n.p.

38. Leonard, *School Arts*.

39. "Gardena Host to Schoolmasters' Club Saturday," *Los Angeles Times* (13 April 1932): 12; and "700 Attend Opening of Art Exhibit," *Gardena Valley News* (31 March 1932); and "Art Exhibit to Attract Thousands," *Gardena Valley News* (25 April 1935).

40. Arthur Millier, "Schools Now Art Patrons; Correspondent Draws Attention to Significance of Purchase-Prize Exhibitions," *Los Angeles Times* (26 April 1931): B18. Millier also reprinted in its entirety a letter from a C. E. Merriam, most

likely Charles Edward Merriam Jr., which encouraged other high schools to follow Gardena's example. Charles Merriam Jr. is known as the founder of the behavioral approach to political science, an advisor to several U.S. presidents, and a prominent intellectual in the Progressive Movement. His distinguished brother, John Campbell Merriam, was a paleontologist best known for his taxonomy of the fossils at the La Brea Tar Pits.

41. "Art Exhibit Prize Named," *Los Angeles Times* (22 April 1931): 6.

42. Leonard, *School Arts*.

43. "Diplomas Given Out This Week," *Los Angeles Times* (19 June 1933): A2.

44. "Reviews and News of Art," *Los Angeles Times* (24 December 1933): A10.

45. Alberta Munro Whitely letter to Olive Hensel Leonard, 28 November 1933, GHS Scrapbook, 1929–1933.

46. "Will Consider Permanent Plan for Art Exhibit," *Gardena Valley News* (11 May 1933).

47. Other notable artists were Mabel Alvarez, Conrad Buff, Eleanor Colburn, Francis De Erdely, Henri De Kruif, Helena Dunlap, Merrill Gage, Clarence Hinkle, Warren Newcomb, Ruth Peabody, Donna Schuster, Edouard Vysekal, Luvena Buchanan Vysekal, and Max Wieczorek. See "120 Enter Paintings in Art Exhibit," *Gardena Valley News* (27 April 1933): 1, 8.

The New Deal

1. Arthur Millier, "Paychecks Not Gush Give Starving Artist Inspiration," *Los Angeles Times* (4 February 1934): A1.

2. The 1933 exhibit lasted from April 28 through May 14. The public was invited to visit the exhibition every afternoon, including Saturday and Sunday, as well as Monday, Tuesday, and Wednesday evenings. The GHS exhibition received ten notices in the *Los Angeles Times* between March 5 and December 24 of this year, demonstrating its regional importance.

3. Arthur Millier, "Desert Paintings, Gardena Annual, Among Week's Art," *Los Angeles Times* (15 April 1934): A8.

4. Leonard, *School Arts*.

5. Mary Warshaw, "Letter from a Gardena

High School Alumna," 13 October 1997, in *Painted Light*, 11.

6. "High School to Receive Ten Paintings As Gifts From PWA Art Project," *Gardena Valley News* (17 May 1934). While the Don R. Smith and Charles Bensco paintings were most likely created under the auspices of the federal projects, the Payne and Foster were probably created in earlier years, raising questions about how they came to be government property before being donated to the school.

7. "8th Annual Art Exhibit at Gardena High School Open Next Tuesday," *Gardena Valley News* (18 April 1935).

8. "School Art Tradition Upheld Against Odds," *Los Angeles Times* (24 April 1935): A5.

9. Author's interview with Roy C. Pursche, 6 July 2016.

10. Arthur Millier, "Brush Strokes," *Los Angeles Times* (5 May 1935): A7.

11. "33 Paintings from WPA Gift to High School," *Gardena Valley News* (20 February 1936). Principal Whitely also donated four of his own paintings to the school, to be hung in the administration building: a Coachella desert scene; a view of the Colorado Street bridge near the Vista del Arroyo Hotel; and two still life studies of flowers, one of peach blossoms in a blue bowl and one of pink roses in a green vase. See "Paintings by Principal Hung at High School," *Gardena Valley News* (27 February 1936).

12. "Well Known Artists to Show Work," *Gardena Valley News* (2 April 1936).

13. Jane Liebsack email to Jane and Paul B. Youtsey, Jr., graciously shared by Rosemary Best.

14. "Gardena High School Annual Art Exhibit," *San Bernardino Daily Sun* (22 March 1936): 16; and "Prize Art Exhibit Dates Selected at Gardena," *Los Angeles Times* (21 March 1936): 5.

15. "Thousands Visit Gardena to See Art Treasures," Gardena Valley News (8 April 1937); and Arthur Millier, "Brush Strokes," *Los Angeles Times* (26 June 1938): C7.

16. Arthur Millier, "Brush Strokes," (28 March 1937): C4; and "Oil Paintings Acclaimed at Purchase Prize Showing," *Los Angeles Times* (5 April 1937): A17.

17. "Noted Guests Open Art Exhibit Here," *Gardena Valley News* (1 April 1937).

18. "Art Gallery in Laguna in Clear," *San Bernardino Daily Sun* (7 March 1937): 18.

19. "Hamilton Fetes Administrators," *The Federalist* (31 October 1934): 1; and "The Oarsman" (7 February 1940).

20. Arthur Millier, "Brush Strokes," *Los Angeles Times* (24 April 1938): C7.

21. Richard W. Reitzell, *From a Versatile Brush: The Life and Art of Jean Mannheim* (Moorpark, California: Arroyo Publishing, 2011): 84.

22. "Tribute Paid Noted Artist," *Los Angeles Times* (15 January 1939): D11; and "A Record Broken at H.S. Art Exhibit," *Gardena Valley News* (21 April 1938).

23. "Art Talks on Schedule at Exhibit," *Gardena Valley News* (28 April 1938).

24. "Second Prize Picture Chosen by Winter Class," *Gardena Valley News* (12 May 1938).

25. "Invitations Go Out to 156 Artists to Exhibit Work," *Gardena Valley News* (17 March 1938).

26. "New Additions to High School Art Treasures," *Gardena Valley News* (24 March 1938).

27. "Art Exhibit Has Brilliant Opening," *Gardena Valley News* (28 April 1939): 1–2.

28. "Art and Artists School Gallery in South Complimented," *San Bernardino Daily Sun* (5 December 1938): 7; and Leonard, *School Arts*. Both articles say that Stanford borrowed the entire collection; it is unclear if the GHS exhibition was at the museum or the Thomas Welton Stanford Art Gallery.

29. "Friday Morning Club Schedules Talk on Art," *Los Angeles Times* (18 February 1940): D12; and "Exhibits," *Los Angeles Times* (27 October 1940): C8.

30. "Exhibits," *Los Angeles Times* (2 February 1941): C8.

31. "Brush Strokes," *Los Angeles Times* (9 August 1942): C5.

32. "Art Exhibit Proves to Be Big Attraction," *Gardena Valley News* (13 April 1939): 7.

33. The other officers of the Coordinating Committee for Traditional Art were James Swinnerton, vice president, and Fritiof Persson, secretary-treasurer. The group's directors were Louise Ward Watkins, Jack Wilkinson Smith, Jean Mannheim, Deszo Lany, and Kathryn Leighton. See "Left! Right! Left! Right! Go Rival Artists Shows," *Los Angeles Times* (7 April 1940): C8; and "Museum Art Exhibit Planned as Blow to Ultramodern Trends in Painting," *Los Angeles Times* (21 April 1940): A1.

34. "Hundreds Here for Exhibit," *Gardena Valley News* (28 March 1940): 1, 3.

35. "H.S. Seniors Pick Prize Paintings," *Gardena Valley News* (11 April 1940): 1, 8.

36. "Art Parade Reviewed," *Los Angeles Times* (3 March 1940): C8.

The Tools of Combat

1. "One of 143 Canvases in Gardena Purchase Prize Exhibit: School to Buy," *Los Angeles Times* (1 May 1941): A10; and "School Purchases Art at Gardena," *Los Angeles Times* (8 May 1941): A10. The exhibit was open to the public on school days until 5:00 p.m., Tuesday and Thursday evenings, and on Sunday afternoons. The Gardena Art Association assisted the school and acted as "godfather of the exhibit and purchase plan."

2. George Haywood Freeman, "A Comparative Investigation of the School Achievement and Socio-Economic Background of the Japanese-American Students and the White-American Students of Gardena High School," master's thesis, University of Southern California, 1938, pgs. 24, 50. The Japanese students had about 32% participation in extracurricular activities and were high achievers academically, with 39.5% participation on the scholarship society (according to the study they received 11% more "As" overall than the white students); and "Art Exhibit Finest Ever Staged Here," *Gardena Valley News* (24 April 1941): 8.

3. Leonard, *School Arts*. Sadly, the location of these works of art by the Japanese artists is not clear.

4. Arthur Millier, "Brush Strokes," *Los Angeles Times* (27 April 1941): C8.

5. "Art Exhibit Finest Ever Staged Here," *Gardena Valley News* (24 April 1941): 8.

6. On occasion, the students selected a work by a woman who was unwilling to part with her painting for the small sum offered by the students. For example, in 1937, Nell Walker Warner turned down the students' offer.

7. Ryan Reft, "Redefining Asian America: Japanese Americans, Gardena, and the Making of a Transnational Suburb," KCET-TV (22 August 2014).

8. Author's interview with Roy C. Pursche, 6 July 2016.

9. As of December 1941, there were 37,000 ethnic Japanese people in Los Angeles County.

10. "Gardena Youth Studies Food," *Los Angeles Times* (14 December 1942): A14; and "See and Hear Museum Blog," National World War II Museum, New Orleans. http://www.nww2m.com/2012/09/high-school-victory-corps-established/.

11. "Students Give Up Lunchtime to Get Training for War Jobs," *Los Angeles Times* (8 November 1942): 116.

12. "Students Elect Girl President," *Los Angeles Times* (7 March 1943): A2.

13. Arthur Millier, "Brush Strokes: Gardena Annual Show," *Los Angeles Times* (12 April 1942): C5.

14. "500 Art Patrons at Exhibit," *Gardena Valley News* (16 April 1942).

15. "Noted Artists To Show Work At Art Exhibit," *Gardena Valley News* (29 April 1943).

16. Arthur Millier, "Brush Strokes," *Los Angeles Times* (25 April 1943): C5.

17. "Exhibit Winners Selected," *Gardena Valley News* (13 May 1943).

18. "Gardena Students Operate 10-Acre Farm," *Los Angeles Times* (6 February 1943): 16.

19. "Gardena Growers Busy with Asparagus Crop," *Los Angeles Times* (20 May 1945): A2.

20. "Returned Coast Guardsman Sponsors Gardena Play Center," *Los Angeles Times* (15 January 1944): A12.

21. "Continue Prize Art Exhibit," *Gardena Valley News* (9 March 1944): 1.

22. Arthur Millier, "Brush Strokes," *Los Angeles Times* (15 April 1945): C4.

23. Ibid; and "Open Art Exhibit Monday," *Gardena Valley News* (9 April 1945): 1, 8.

Advancing American Art

1. Susan Landauer, *The San Francisco School of Abstract Expressionism* (Laguna Art Museum in association with University of California Press, 1996): 29.

2. James S. Lai and Kim Geron, "When Asian Americans Run: Suburban and Urban Dimensions of Asian American Candidates in California Local Politics," *California Politics & Policy* (June 2006); interview with B. Kaji, 22 July 2004, 11.

3. Author's interview with Eiko Kamiya Moriyama, 19 August 2015.

4. Adrianne Goodman, "Toward Equality: Exploring a World of Difference: On the Street Where You Live: Gardena," *Los Angeles Times* (13 February 1989).

5. "Speakers Argue Over Jap Return," *Gardena Valley News* (26 April 1945).

6. Jean Merl, "Gardena School Alumni Reclaim Neglected Paintings," *Los Angeles Times* (19 January 1999): 1.

7. "Gardena School Holds Annual Art Preview," *Los Angeles Times* (26 March 1946): 7; and "Beaumont, Navy Artist to Speak at Dinner," *Los Angeles Times* (26 March 1946): 2; and "19th Annual Art Banquet Gala Affair," *Gardena Valley News* (28 March 1946): 1.

8. "Students Will Air School Changes," *Los Angeles Times* (13 February 1946): A2.

9. Dick Hyland, "Both Dons, Yanks Claim Victory," *Los Angeles Times* (25 October 1946): 6.

10. Louis Menand, "Unpopular Front," *The New Yorker*, October 17, 2005.

11. Arthur Millier, "Ban Stresses Democracy's Problem," *Los Angeles Times* (20 April 1947), C4.

12. "Art Battle: Conservative Los Angeles Painters Protest 'Radical' Hung in Museum," *Life* (28 May 1947): 40.

13. "Annual Art Exhibit Opens with Banquet in High School Gym," *Gardena Valley News* (17 April 1947): 1, 3.

14. Breasted said that there were about two hundred thousand practicing artists in the United States.

15. "Annual Art Exhibit Opens with Banquet in High School Gym."

16. Author's interview with Rassie Harper, 15 March 2016.

17. Author's interview with Roy C. Pursche, 6 July 2016.

18. "500 Art Patrons Attend 21st Annual Banquet," *Gardena Valley News* (15 April 1998): 1, 3.

19. "School Adds Prize Pictures to Collection," *Los Angeles Times* (11 May 1949): 23. For two weeks, the annual exhibit and the permanent art collection were open to the public every weekday until 5:00 p.m., with late hours (from 7:00 to 10:00 p.m.) on Tuesday and Thursday evenings. Sunday hours were 2:00 to 5:00 p.m.

20. Warshaw, *Painted Light*, 11.

21. "Preparations Pushed for Art Banquet," *Gardena Valley News* (21 April 1949): 1.

22. The exhibition also included Phil Dike's *California Holiday*, now considered to be a masterpiece of Southern California American Scene painting, which would have been a better choice than Withers's *Show Girl*.

23. "Art Exhibit Has Brilliant Opening," Gardena Valley News (28 April 1949): 1, 2.

24. "School Adds Prize Pictures to Collection," *Los Angeles Times* (11 May 1949): 23.

The Writing on the Wall

1. "Annual Art Exhibit Opens with Banquet Tuesday March 14," *Gardena Valley News* (9 March 1950): 1.

2. A brief description of four of the artists, none of whom had any California connection, is instructive. Joe Jones was a Social Realist painter, a former member of the Communist Party, who was awarded five prestigious mural commissions in post offices throughout the Midwest. Frederic Taubes was an experimental modernist who had studied at the Bauhaus; he was also a society portraitist, author of numerous art books, and formulator of a line of painting media and varnishes still in

production. Peter Hurd was a Regionalist painter and prominent muralist of New Mexico. He was a war correspondent for *LIFE* magazine during World War II. Hurd's preferred medium was tempera on gesso panel. He married illustrator N. C. Wyeth's daughter. Umberto Romano was a member of the Gloucester, Massachusetts, modernist group that also included Stuart Davis, Marsden Hartley, John Sloan, Paul Manship, and Milton Avery.

3. "23rd Art Exhibit Wins High Praise from First Nighters," *Gardena Valley News* (16 March 1950): 1, 3.

4. Author's interview with Janet Perdew Halstead-Sinclair, 18 August 2015.

5. "Art Exhibit Banquet to Honor Two Retiring Faculty Members," *Gardena Valley News* (8 March 1951): 1.

6. Author's interview with Rassie Harper, 15 March 2016.

7. "Art Exhibit Banquet to Honor Two Retiring Faculty Members."

8. "Art Exhibit Selections Announced," *Gardena Valley News* (26 April 1951): 1.

9. Jean Merl, "Gardena School Alumni Reclaim Neglected Paintings," *Los Angeles Times* (19 January 1999): 1.

10. Anne Olney-Finnegan email to Paul and Betty B. Youtsey Jr., 8 March 2002. Generously provided by Rosemary Best.

11. "Gardena School Opens Purchase Art Exhibit," *Los Angeles Times* (25 March 1952): 18; and "Bids Out for Festival Night," *Gardena Valley News* (6 March 1952): 1–2; and "Plans Complete for Silver Anniversary of Gardena Art Exhibition," *Gardena Valley News* (13 March 1952): 1–2; and "1952 Art Exhibit Praised," *Gardena Valley News* (20 March 1952): 1; and "Moderns Selected by Seniors," *Gardena Valley News* (3 April 1952): 1–2.

12. "Goulet Memorial Planned," *Gardena Valley News* (26 March 1953): 1, 3.

13. "Set Art Exhibit Opening April 28 at Gardena High," *Gardena Valley News* (4 March 1954): 1–2. For a lengthy discussion of this art controversy, see Sarah Schrank, *Art and the City: Civic Imagination and Cultural Authority in Los Angeles* (Philadelphia: University of Pennsylvania Press, 2009): 80–87.

14. Ibid.

15. "Art Exhibition at Gardena School Part of Annual Purchase Plan," *Los Angeles Times* (2 May 1954): J2.

16. "Gardena High School Construction Pushed," *Los Angeles Times* (14 November 1954): H1; and "Work Will Start Soon on Gardena High School," *Los Angeles Times* (12 July 1954): 17.

17. "Art Exhibit Opening Set for April 24th," *Gardena Valley News* (17 February 1955): 1–2; "Art Association to Form Permanent Organization," *Gardena Valley News* (24 March 1955): 1–2; and "High School Jubilee Combined with Prize Art Exhibit for Gardena Fete," *Los Angeles Times* (24 April 1955): J1.

Aftermath

1. Dick Turpin, "Teachers Pay Decision Due," *Los Angeles Times* (25 May 1958): B1.

2. A note in the 1953 *El Arador* yearbook above a photo of Principal Parisi, who was so ambivalent about the art program, may provide an answer: "With our new principal we have the top staff who are to plan our new high school."

3. Display ad 147, *Los Angeles Times* (10 July 1966): 9.

4. Betty Donahue organized the exhibition, according to a photocopy of a brochure graciously lent by Rosemary Best.

5. "Exhibit at Gardena High," *Los Angeles Times* (9 March 1975): CS3.

6. "Gardena Students Leave Artistic Mark on Buildings, Erase Graffiti in Process," *Los Angeles Times* (7 August 1975): CS6.

7. As a result of these donations, two paintings were restored: *Girl in Brown*, by William Fredrick Foster, and *Beethoven*, by Carlo Wostry (Summer Class 1930 gift).

8. It is Janet Perdew Halstead-Sinclair's belief that the little book was brought to the attention of Dr. Detweiler at California State University, Dominguez Hills, and led to his decision to produce the *Painted Light* exhibition at the university. He already knew about the collection before the efforts of these alumni but had never acted on the knowledge. Lorenna K. Poulson's catalogue, which featured every painting in the collection, was also very useful in the selection of the paintings for the exhibition.

9. Other members of the Gardena High School California Impressionist Art Committee included GHS alumnae Sandra Haas, Frances Kaji, Rosemary Best, and McDaniel and Ann Sutton, who was formerly a member of the Gardena Art Association.

10. The Keck Foundation grant also provided teacher training on the sources and influences of the California Impressionists to Torrance and Los Angeles school districts. Using a *Painted Light* curriculum resource guide, teachers aided their students' understanding of the collection's historical context and the finer points of art criticism. After visiting the gallery, students were guided to create art projects that related to the vision of the Impressionists.

Solutions in High School Art Collections

1. "Art and Artists, Schools Become Art Conscious," *San Bernardino Daily Sun* (6 June 1935): 14.

2. An editorial in the *Press-Telegram* was quoted in the *South Coast News* (24 April 1936): 13.

3. Michelle Cairella Fillmore, former curator, LAUSD Art and Artifact Collections and Archives, sent me this list of schools, gleaned from her study of the most current inventory, in an email on 10 June 2016. In his autobiography, Hanson Puthuff wrote that he had sold paintings to the high schools in Glendale, as well as Marshall, Franklin, Verdugo, and San Fernando high schools. See Hanson Duvall Puthuff, *Hanson Duvall Puthuff, Artist, 1875–1972: An Autobiography with Correspondence and Notes by Louise Puthuff* (Costa Mesa, California: The Spencer Printing Service, n.d.): 24.

4. "Art Exhibits in Nearby Communities Open in March," *Gardena Valley News* (6 March 1941); and "Gardena Art Show To Be Paralleled at Beverly Hills," *Los Angeles Times* (19 April 1936): B11; and "Winning Pictures at Annual Art Exhibit Are Named

by Senior Class," *Gardena Valley News* (15 April 1937).

5. "Art Exhibit Opens Today," *Los Angeles Times* (22 March 1949): A7. According to Kathy Zimmerer McKelvie, Director of the University Art Gallery, CSU Dominguez Hills, Paramount High School may have stopped collecting around 1953.

6. "Three Area Exhibitions Evaluated," *Los Angeles Times* (25 May 1952): E4.

7. Arthur Millier, "Critic Looks Back on 30 Years of Art in L.A.: Colony Now the Second Largest in the U.S.," *Los Angeles Times* (1 April 1956): E6.

8. Leonard, *School Arts*, 9a.

9. Vern G. Swanson, *Springville Museum of Art: History and Collection*. http://www.smofa.org/uploads/files/63/History-of-the-Museum.pdf. The dedication of the George S. and Delores Doré Eccles Wing was held in 2004 during the Thirty-eighth Annual Art Ball and the opening of the *Eightieth Annual Utah Spring Salon*.

10. https://www.glsd.us/domain/564.

11. Ellen J. Landis, *Albuquerque High School Collection* (Albuquerque, New Mexico: The Albuquerque Museum, 1987): 10.

12. Ibid., 15.

13. Ibid., 17.

14. See *Changing Times/Changing Styles: The Ruth Stoever Fleming Collection of Southern California Art* (Newport-Mesa Unified School District, 1985); and Lauren Steussy, "Newport School's Art Collection a Historical Gem," *Orange County Register* (2 October 2013).

other two ethnic groups. There were no African American or Chinese students at the school. See George Haywood Freeman, "A Comparative Investigation of the School Achievement and Socio-Economic Background of the Japanese-American Students and the White-American Students of Gardena High School," master's thesis, University of Southern California, 1938, pgs. 24, 50; and author's interview with Eiko Kamiya Moriyama, 19 August 2015.

4. Ryan Reft, "Redefining Asian America: Japanese Americans, Gardena, and the Making of a Transnational Suburb," KCET-TV, 22 August 2014.

5. Adrianne Goodman, "Toward Equality: Exploring a World of Difference: On the Street Where You Live: Gardena," *Los Angeles Times* (13 February 1989): 8.

6. Ibid.

7. Puthuff, *Hanson Duvall Puthuff, Artist, 1875–1972*: 24.

Conclusions

1. William Hackman, *Out of Sight: The Los Angeles Scene of the Sixties* (New York: Other Press, 2015), 13.

2. "Art Exhibit Finest Ever Staged Here," *Gardena Valley News* (24 April 1941): 8; and Leonard, *School Arts*, 9a.

3. According to the 1938 study, 69% of the 800 white students at GHS stated they had friends among the 200 Japanese American and 100 Latino students, while 82% of the Japanese American students at the school stated that they had friends among the

55.
Gardena Community Art Exhibit displayed in Clark Market, 14990 South Crenshaw Boulevard, 1953. Fred Morrish examines nude painting as Mrs. Morrish drags him away. USC Libraries, *Los Angeles Examiner* Photographs Collection, 1920-1961. Photo by Olmo.

FRESH VEGETABLES..

CARROTS
2 BUN 19

NEW CABBAGE
2 ¢ LB

NICE RED CABBAGE

Checklist

Class of 1919
Ralph Davison Miller
b. Cincinnati, Ohio, 1858
d. Los Angeles, 1945
Valley of the Santa Clara, 1918
Oil on canvas
30 x 40 inches

Class of 1920
Jean Mannheim
b. Kreuznach, Germany, 1862
d. Pasadena, California, 1945
On the Road to San Gabriel, c. 1920
Oil on canvas
48 x 36 inches
Conservation funded by the Historical
Collections Council of California

Class of 1921
Edgar Alwin Payne
b. Washburn, Missouri, 1883
d. Hollywood, California, 1947
Rockbound, c. 1921
Oil on canvas
31 x 40 inches

Class of 1922
Hanson Duvall Puthuff
b. Waverly, Missouri, 1875
d. Corona del Mar, California, 1972
Morning at Montrose, c. 1922
Oil on canvas
28 x 36 inches

Class of Winter 1923
Jack Wilkinson Smith
b. Paterson, New Jersey, 1873
d. Monterey Park, California, 1949
Lingering Snows, 1922
Oil on canvas
32 x 42 inches

Class of Summer 1923
Jean Mannheim
b. Kreuznach, Germany, 1862
d. Pasadena, California, 1945
The Magic Moment, c. 1923
Oil on canvas
28 x 36 inches

Class of Winter 1924
Orrin A. White
b. Hanover, Illinois, 1883
d. Pasadena, California, 1969
The High Sierras, c. 1917
Oil on canvas
24 x 32 inches

Class of Summer 1924
William Wendt
b. Bentzen, Germany, 1865
d. Laguna Beach, California, 1946
Along the Arroyo Seco, 1912
Oil on canvas
40 x 50 inches

Class of Summer 1924
John Hubbard Rich
b. Boston, Massachusetts, 1876
d. Los Angeles, California, 1954
The Brass Bowl (or *Señorita Lusoriaga*), 1922
Oil on canvas
40 x 30 inches

Class of Winter 1925
Franz A. Bischoff
b. Steinschönau, Austria, 1864
d. Pasadena, California, 1929
A Cool Fog Drifting, 1924
Oil on canvas
30 x 40 inches

Class of Summer 1925
Paul Lauritz
b. Larvik, Norway, 1889
d. Glendale, California, 1975
The Mountain Brook, 1924
Oil on canvas
84 x 45 inches
Conservation funded by the Historical
Collections Council of California

Class of Winter 1927
Carl Oscar Borg
b. Osterbyn Ostra, Grinstads, Sweden, 1879
d. Santa Barbara, California, 1947
The Grand Canyon, c. 1927
Oil on canvas
30 x 34 inches

Class of Summer 1927
James Guilford Swinnerton
b. Eureka, California, 1875
d. Palm Springs, California 1974
The Betatakin Ruins, c. 1927
Oil on canvas
60 x 48 inches

Class of Winter 1928
John Frost
b. Philadelphia, Pennsylvania, 1890
d. Pasadena, California, 1937
Desert Twilight, c. 1928
Oil on canvas
27 x 32 inches

Class of Summer 1928
Hanson Duvall Puthuff
b. Waverly, Missouri, 1875
d. Corona del Mar, California, 1972
Mountains of Majesty (or *Hills of Majesty*),
c. 1928
Oil on canvas
36 x 40 inches

Jean Mannheim
b. Kreuznach, Germany, 1862
d. Pasadena, California, 1945
Passing Ships, 1918
Oil on canvas
39 x 34 inches
Collection of GHS/LAUSD, Gift of Library
and Class of Summer 1928. © 2018
LAUSD Art & Artifact Collection/Archive*

Class of Summer 1929
Maurice Braun
b. Nagy-Bittse, Hungary, 1877
d. San Diego, California, 1941
California Hills, 1924
Oil on canvas
36 x 42 inches

Class of Winter 1929
Clarence Hinkle
b. Auburn, California, 1880
d. Santa Barbara, California, 1960
Quiet Pose, c. 1918
Oil on canvas
36 x 30 inches

Class of Summer 1930
Carlo Wostry
b. Trieste, Austria-Hungary, 1865
d. Trieste, Italy, 1943
Beethoven, c. 1905
Oil on canvas
59 x 59 inches

Class of Winter 1931
Dan Sayre Groesbeck
b. St. Helena, California, 1879
d. Los Angeles, California, 1950
Loading the Barge, c. 1924
Oil on canvas
29 x 48 inches

Class of Winter 1932
Kathryn Woodman Leighton
b. Plainfield, New Hampshire, 1875
d. Los Angeles, California, 1952
Chief Bullchild, c. 1928
Oil on canvas
44 x 36 inches

Class of Summer 1932
Benjamin Chambers Brown
b. Marion, Arkansas, 1865
d. Pasadena, California, 1942
Mt. Lowe in Winter (or *Opalescent Morning, Mt. Lowe, California*), 1925
Oil on canvas
30 x 40 inches

Class of Winter 1933
William Henry Price
b. Irwin, Pennsylvania, 1864
d. Pasadena, California, 1940
Towering Peaks, Sierras
(or *Towering Peaks*), 1933
Oil on canvas
39 x 33 inches

Class of Summer 1933
William Frederick Ritschel
b. Nuremburg, Germany, 1864
d. Carmel, California, 1949
Making Port, 1917
Oil on canvas
30 x 40 inches

Max Wieczorek
b. Breslau, Germany, 1863
d. Pasadena, California, 1955
Portrait of Ted Shawn, 1918
Pastel painting on paper
37 x 25 inches
Collection of GHS/LAUSD, Gift of the artist to GHS, 1933. © 2018 LAUSD Art & Artifact Collection/Archive*

Class of Winter 1934
Charles L.A. Smith
b. Auburn, Michigan, 1871
d. Los Angeles, California, 1937
Monterey Pines, 1934
Oil on canvas
39 x 46 inches
Conservation funded by the W.M. Keck Foundation

Class of Summer 1934
Dean Cornwell
b. Louisville, Kentucky, 1892
d. New York City, New York, 1960
Weeping Over Jerusalem (or *Jesus Wept*), 1928
Oil on canvas
34 x 46 inches

William Frederick Foster, A.N.A.
b. Cincinnati, Ohio, 1883
d. New York City, New York, 1953
Girl in Brown, c. 1930
Oil on canvas
51 x 36 inches
Collection of GHS/LAUSD, Gift to GHS, 1934. © 2018 LAUSD Art & Artifact Collection/Archive*

Edgar Alwin Payne
b. Washburn, Missouri, 1883
d. Hollywood, California, 1947
Sierra Trail, c. 1932
Oil on canvas
40 x 50 inches
Collection of GHS/LAUSD, Gift to GHS, 1934. © 2018 LAUSD Art & Artifact Collection/Archive*

Donald Richard Smith
b. Cambridge, Massachusetts, 1908
d. Torrance, California, 1999
Cats at Play, 1934
Oil on canvas
50 x 40 inches
Collection of GHS/LAUSD, Gift of the Public Works of Art Project to GHS, 1934. Courtesy of the Fine Arts Collection, General Services Administration.

Class of Summer 1935
Joe Duncan Gleason
b. Watsonville, California, 1881
d. Glendale, California, 1959
Head Winds (or *Storm at Sea*), c. 1935
Oil on canvas
30 x 40 inches

George Thompson Pritchard
b. Havelock, New Zealand, 1878
d. Reseda, California, 1962
Where East is East, c. 1935
Oil on canvas
30 x 36 inches
Collection of GHS/LAUSD, Gift of the Faculty to GHS, 1935. © 2018 LAUSD Art & Artifact Collection/Archive*

Class of Winter 1936
Robert Clunie
b. Eaglesham, Scotland, 1895
d. Bishop, California, 1984
River Dwellers, 1936
Oil on canvas
36 x 42 inches
Conservation funded by the Historical Collections Council of California

Class of Summer 1936
Walter Elmer Schofield
b. Philadelphia, Pennsylvania, 1866
d. Cornwall, England, 1944
Cornish Inn, c. 1929
Oil on canvas
30 x 36 inches

Stanislaus Pociecha Poray
b. Krakow, Poland, 1888
d. New York City, New York, 1948
Kuan Yin and Lama, 1936
Oil on canvas
48 x 40 inches
Collection of GHS/LAUSD, Gift to GHS, n.d. © 2018 LAUSD Art & Artifact Collection/Archive*

Class of Winter 1937
H. Raymond Henry
b. Woodson, Illinois, 1882
d. Costa Mesa, California, 1974
The Storm King, c. 1937
Oil on canvas
30 x 40 inches

Class Summer 1937
Frank Tenney Johnson
b. Big Grove, Iowa, 1874
d. Los Angeles, California, 1939
The Cowboy (or *Lengthening Shadows*), c. 1936
Oil on canvas
28 x 36 inches

Class of Winter 1938
Alson Skinner Clark
b. Chicago, Illinois, 1876
d. Pasadena, California, 1949
After the Shower, Cuernavaca (or *Cuernavaca*), 1923
Oil on canvas
36 x 46 inches

Class of Summer 1938
Carl Clemens Moritz Rungius
b. Berlin, Germany, 1869
d. New York City, New York, 1959
Along the Slope (or *Moose in Cut Timberland*), c. 1938
Oil on canvas
30 x 45 inches

Class of Winter 1939
Clyde Eugene Scott
b. Bedford, Iowa, 1884
d. Los Angeles, 1959
Mirror of Summer, c. 1939
Oil on canvas
30 x 40 inches

Class of Summer 1939
Armin Carl Hansen
b. San Francisco, California, 1886
d. Monterey, California, 1957
Before the Wind, c. 1912
Oil on canvas
29 x 36 inches

Class of Winter 1940
William Spencer Bagdatopoulos
b. Zante, Greece, 1888
d. Cornwall, England, 1965
Drought (or *Taos Indian*), c. 1932
Pastel chalk on paper
53 x 35 inches

Class of Summer 1940
George Thompson Pritchard
b. Havelock, New Zealand, 1878
d. Reseda, California, 1962
Nearing Home (or *Brothers to the Ox*),
c. 1914
Oil on canvas
34 x 44 inches

Class of Winter 1941
Peter Nielsen
b. Denmark, 1873
d. Santa Ana, California, 1965
Sierra Alta, c. 1941
Oil on canvas
36 x 40 inches

Class of Summer 1941
Leon Lundmark
b. Stockholm, Sweden, 1872
d. Altadena, California, 1942
Symphony of Night, c. 1941
Oil on canvas
29 x 36 inches

Class of Winter 1942
Agnes Lawrence Pelton
b. Stuttgart, Germany, 1881
d. Cathedral City, California, 1961
Desert Royalty, 1940
Oil on canvas
26 x 36 inches

Class of Summer 1942
Emil Jean Kosa, Jr.
b. Paris, France, 1903
d. Los Angeles, California, 1968
Every Cloud Has Its Silver Lining,
c. 1942
Oil on canvas
30 x 36 inches

Class of Winter 1943
Victor Clyde Forsythe
b. Orange, California, 1885
d. Pasadena, California, 1962
Conchita Valley, 1935
Oil on canvas
30 x 42 inches

Class of Summer 1943
Jessie Arms Botke
b. Chicago, Illinois, 1883
d. Santa Paula, California, 1971
Cranes Under a Giant Fern, c. 1943
Oil and gold leaf on canvas
40 x 32 inches

Class of Winter 1944
Leland S. Curtis
b. Denver, Colorado, 1897
d. Carson City, Nevada, 1989
Afternoon Shadow, c. 1944
Oil on canvas
40 x 48 inches

Class of Summer 1944
Maynard Dixon
b. Fresno, California, 1875
d. Tucson, Arizona, 1946
Men of the Red Earth, 1931–1932
Oil on canvas
36 x 41 inches

Class of Winter 1945
Einar Cortsen Petersen
b. Ebeltoft, Jutland, Denmark, 1885
d. Los Angeles, California, 1986
Gray Dawn (or *Seine Fishermen*), c. 1945
Oil on canvas
31 x 45 inches

Class of Summer 1945
Sam Hyde Harris
b. Brentford, England, 1889
d. Alhambra, California, 1977
Desert Design, c. 1945
Oil on canvas
30 x 40 inches

Class of Winter 1946
Marion Kavanagh (born Kavanaugh)
Wachtel
b. Milwaukee, Wisconsin, 1876
d. Pasadena, California, 1954
Mt. Moran, Teton National Park, c. 1946
Oil on canvas
30 x 40 inches

Class of Summer 1946
Arthur Edwaine Beaumont
(born Arthur Edwin Crabbe)
b. Norwich, Norfolk, England, 1890
d. Laguna Hills, California, 1978
Task Force (or *Destroyer Task Force*), c. 1945
Oil on canvas
30 x 40 inches

Class of Winter 1947
Joseph Theodore Waáno-Gano
(born Joseph Theodore Noonan)
b. Salt Lake City, Utah, 1906
d. Los Angeles, California, 1982
Ceremonial Night (or *Indian Nocturne,
Ceremonial Night*), c. 1947
Oil on canvas
40 x 30 inches

Class of Summer 1947
Loren Roberta Barton
b. Oxford, Massachusetts, 1893
d. Claremont, California, 1975
Day's End, c. 1947
Oil on canvas
36 x 40 inches

Class of Winter 1948
Cornelis J. Botke
b. Leeuwarden, Friesland, Holland, 1887
d. Santa Paula, California, 1954
Spring Plowing (or *Spring Planting* or *In the
San Gabriel Valley*), c. 1948
Oil on canvas
32 x 40 inches

Class of Summer 1948
Douglass Ewell Parshall
b. New York City, New York, 1899
d. Santa Barbara, California, 1990
Portrait of a Young Girl, c. 1948
Oil on canvas
29 x 22 inches

Class of Winter 1949
Hugo Ballin
b. New York City, New York, 1879
d. Santa Monica, California, 1956
Saving a Life, c. 1949
Oil on canvas
36 x 42 inches

Class of Summer 1949
Edward Oscar Withers
b. Wellington, New Zealand, 1896
d. Los Angeles, California, 1964
Show Girl, c. 1947
Oil on canvas
40 x 34 inches

Class of Winter 1950
Francis de Erdely (born Ferenc de Erdelyi)
b. Budapest, Hungary, 1904
d. Los Angeles, California, 1959
Return of the Prodigal, c. 1950
Oil on canvas
40 x 30 inches

Class of Summer 1950
Loren Roberta Barton
b. Oxford, Massachusetts, 1893
d. Claremont, California, 1975
The Circus (or *Behind the Scenes,
The Horse Tent*), c. 1947
Oil on canvas
28 x 38 inches

Class of Winter 1951
William Frederick Foster, A.N.A.
b. Cincinnati, Ohio, 1883
d. New York City, New York, 1953
Girl with a Vase, c. 1951
Oil on canvas
48 x 40 inches

Class of Summer 1951
Christian von Schneidau
b. Smoland, Sweden, 1893
d. Orange, California, 1976
Clown Says Grace, c. 1951
Oil on canvas
30 x 42 inches
Conservation partially funded by GHS
Alumni, Classes 1950 to 1953

Class of Summer 1953
Orrin Augustine White
b. Hanover, Illinois, 1883
d. Pasadena, California, 1969
Pilgrimage, 1923
Oil on canvas
25 x 30 inches

Class of Winter 1954
Martin P. Mondrus
b. Los Angeles, California, 1925
The Tribute, c. 1954
Oil on canvas
26 x 36 inches

Class of Winter 1955
Ruth L. Osgood (Salyer)
b. Los Angeles, California, 1920
d. Laguna Beach, California, 2003
Act One, c. 1955
Oil on canvas
24 x 36 inches

Class of Summer 1955
Robert Watson
b. Martinez, California, 1923
d. Poway, California, 2004
Remains, 1954
Oil on canvas
20 x 30 inches

Class of Winter 1956
Richard Carver Haines
b. Marion, Iowa, 1906
d. Los Angeles, California, 1984
Fogbound, c. 1956
Oil on canvas
24 x 20 inches

List of Illustrations

174

29.
Left to right, clockwise: Ephemera from the GHS Scrapbook dated 1929 including the propectus, Carlo Wostry's notice of participation form, the cover of the *Purchase Prize Exhibit Catalogue of Paintings*, and the printed invitation.

30.
Gardena High School library with Purchase Prize Exhibit on display, 1933. William Henry Price's prize winner is in the corner above the bookcases. GHS Scrapbook, 1929–1933.

31.
Teachers and staff in the Gardena High School library, c. 1939. Collection California State University, Dominguez Hills.

32.
Stanton Macdonald-Wright, *Topanga Canyon—Santa Monica for Federal Art Project '37*, 1937. Pencil on paper. 27 x 22 inches. Collection of GHS/LAUSD, Courtesy of the Fine Arts Collection, General Services Administration. Macdonald-Wright was district supervisor of the WPA/FAP for L.A. County at the time.

33.
Charles Bensco, *If Ye Believe*, 1934. Oil on canvas, 50 x 40 inches. Collection of GHS/LAUSD. Gift to GHS, 1934. ©2018 LAUSD Art & Artifact Collection/Archives.*

34.
Gardena Art Association banquet, 1935. Photo by Churchill Gardiner Studios.

35.
A corner of the 1936 art exhibit. Courtesy of the City Clerk's Office, City of Gardena.

36.
Cover of the catalogue of the permanent collection, written by Lorenna Vanderlip Keliher in 1936. Courtesy of the City Clerk's Office, City of Gardena.

37.
Jean Mannheim. *Portrait of Mr. John Henry Whitely*, 1938. Oil on canvas, 44 x 34 inches. Collection of GHS/LAUSD, Gift of Gardena Art Association to GHS, 1938. © 2018 LAUSD Art & Artifact Collection/Archives.*

38.
Many Japanese-Americans were engaged in agriculture on the West Coast. I. Akuchi and Itoyo Minami, both Issei, working in a cauliflower field in Gardena, 1941. USC Libraries, Japanese American Relocation Digital Archive, 1941–1946. Photo by World Wide Photos, Los Angeles Bureau.

39.
Gardena High School annual banquet, *El Arador*, 1941.

40.
Students farming on a ten-acre tract at Gardena High School, 1942. Collection Simon K. Chiu.

41.
(detail) Art banquet, *El Arador*, 1953.

42.
Purchase Prize Exhibit in Crump Memorial Hall, *El Arador*, 1954.

43.
Edward Reep, *Quiescence*, c. 1952. Class Gift Summer 1951. The painting disappeared in the 1950s.

44.
Guy Maccoy, *Composition 1951*, 1951. Class Gift Winter 1951. The painting disappeared in the 1950s.

45.
Ruby Usher, *Twelve O'Clock*, c. 1951. Class Gift Winter 1952. Destroyed in a campus fire in 1975.

46.
Art banquet, *El Arador*, 1953.

47.
Emil Kosa, Jr., *Portrait of Mr. Frank Goulet*, 1955. Oil on canvas, 38 x 32 inches. Collection of Gardena High School, Class Gift Summer 1956.

48.
Gardena High School art gallery, built in 1955 (2015 photograph).

49.
GHS graduates, *El Arador*, 1952.

50.
(detail) Robert Irwin, *Ibizi 56*, 1956. Oil on canvas, 26 x 48 inches. Ruth Stoever Fleming Collection of Southern California Art, Newport Harbor High School.

51.
Robert Irwin, *Ibizi 56*, 1956. Oil on canvas, 26 x 48 inches. Ruth Stoever Fleming Collection of Southern California Art, Newport Harbor High School.

52.
GHS campus, *El Arador*, 1952.

53.
Van de Kamp's Bakery. One of numerous businesses in Gardena exhibiting art as a result of the prominence of the GHS annual exhibit, 1953. (United Press Photo)

54.
GHS campus, *El Arador*, 1952.

55.
Gardena Community Art Exhibit displayed in Clark Market, 14990 South Crenshaw Boulevard, 1953. Fred Morrish examines nude painting as Mrs. Morrish drags him away. USC Libraries, *Los Angeles Examiner* Photographs Collection, 1920–1961. Photo by Olmo.

Back cover: (detail) John Hubbard Rich, *The Brass Bowl* (or *Señorita Lusoriaga*), 1922. Oil on canvas, 40 x 30 inches.

Index

Page references in italics refer to illustrated material.

GHS Art Collection, Inc.